WE ARE HERE

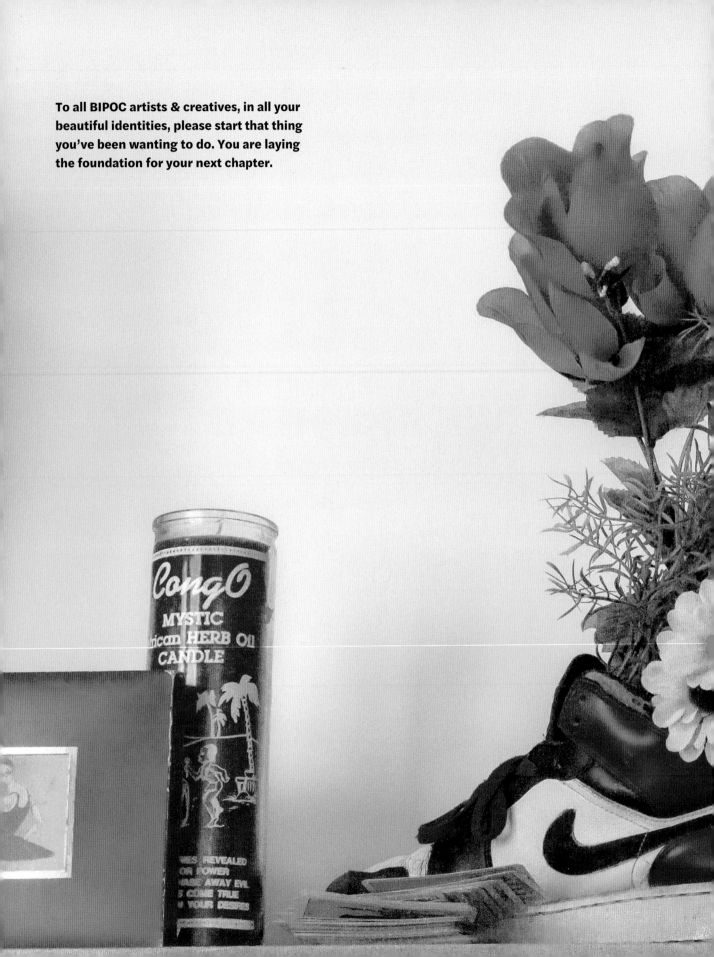

To all BIPOC artists & creatives, in all your beautiful identities, please start that thing you've been wanting to do. You are laying the foundation for your next chapter.

WE ARE HERE

Visionaries of Color
Transforming the Art World

JASMIN HERNANDEZ

Principal photography by Sunny Leerasanthanah

Abrams, New York

CONTENTS

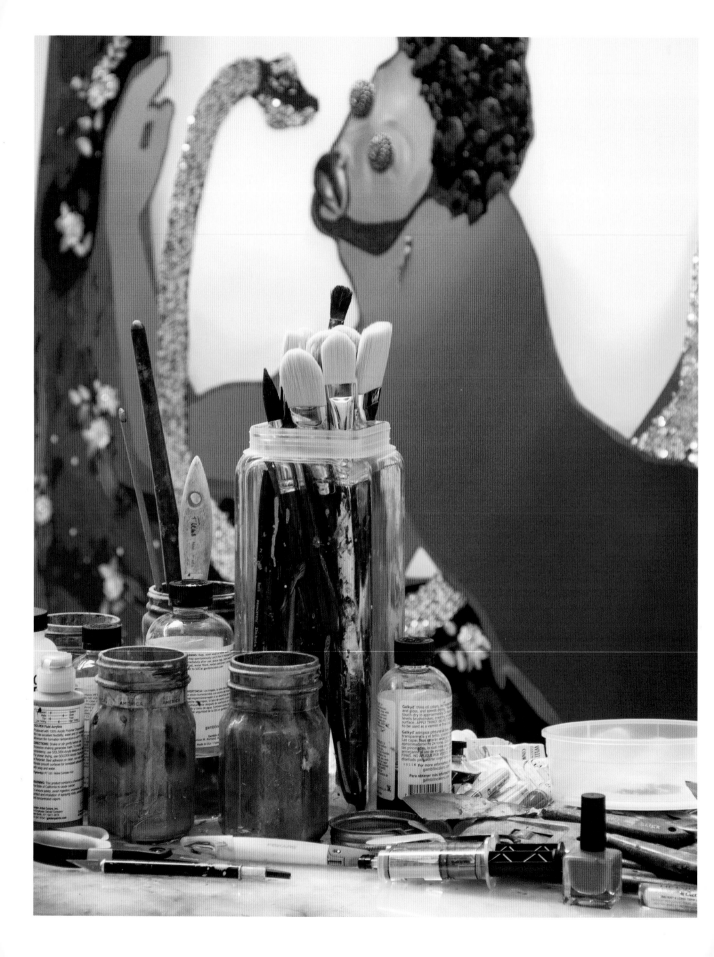

FOREWORD

by Kasseem "Swizz Beatz" Dean
Creative, Disruptor, and Founder of The Dean Collection

My genuine passion for art and collecting were activated by immersing myself in the community itself. From the time that I had begun connecting personally with artists and creative professionals in the field, I realized how powerful the experience of art—from behind-the-scenes to opening day—truly is. It is a gift to not only be able to collect the work that inspires me, but to also build an extended family from the creators of the work and the people responsible for bringing it to light.

The individuals featured in *We Are Here* reflect a larger community of people who do not take no for an answer. They constantly disrupt and challenge us to think deeper and be better for ourselves and for each other.

As I continue my own journey in disrupting and continuing to build platforms that support artists and creatives, my hope is that the next generation will feel empowered to be even bolder in seeing the possibilities demonstrated by these visionaries of our time.

◀ A detail of a work in progress titled *Togetherness (Eclipse)* (2019) by Devan Shimoyama photographed at his studio in Pittsburgh. Shimoyama is an artist collected by Dean in The Dean Collection.

INTRODUCTION

by Jasmin Hernandez

I'm the founder and editor-in-chief of the well-loved indie art website Gallery Gurls, which celebrates womxn, BIPOC, and QTPOC, yet I have zero professional experience in the art world. I've never worked for a top gallery or an important museum, and I don't have a fancy graduate degree in art history or visual arts criticism. I'm a former fashion show producer and photo editor with an insatiable appetite for contemporary art and a voice that is unorthodox, frank, and intentionally not rooted in academia. My mission with Gallery Gurls, since founding it in 2012, was straightforward. As a Black woman, I want to solely cover womxn, BIPOC, and QTPOC in the art world in the most accessible way possible, with curiosity and Wi-Fi being all that is required.

My attraction to fashion and art is organic and pure, and started very early. Growing up as a poor, first-generation Afro-Dominican, artsy girl in Queens, it was just the three of us—my Dominican single mom, my younger brother, and myself. My mom cherished literacy, so the only abundance in our household came in the form of books. There were wall-to-wall shelves filled with trashy novels, historical fiction, artist monographs, and photography books, and I read them all incessantly. When I was twelve, my world was forever changed when my mom gifted me a subscription to *Sassy* magazine, a budding feminist's dream. I'm an eighties baby and nineties teen, so

my universe was shaped by the hours spent locked in my room plastered with Spice Girls posters, poring over issues of *Vibe*, *The Source*, *Elle*, and *Vogue*, and devouring MTV, VH1, BET, and E! twenty-four seven.

I visited a museum for the first time in 1997 at age seventeen to see a Gianni Versace exhibition at the Metropolitan Museum of Art. Versace, who was tragically killed that year, was my favorite fashion icon and this was my chance to see his dazzling designs up close. My high school fashion teacher—a Colombian Nina García doppelgänger—encouraged me to see art in Manhattan and keep a journal that detailed how I felt about it. In many ways, this was a precursor to my blogging and writing that would happen a little over a decade later. So I kept observing, consuming, discovering, and interacting with art, and eventually I got it into my head I would pursue a creative career and apply to art school.

During my four years at Parsons School of Design, studying fashion and marketing among mostly rich white kids, my art education primarily focused on dead white men—Monet, Manet, Seurat, Picasso, Man Ray, de Chirico, Ernst, and Warhol. One rare exception was a surrealist women artists class I took my junior year, where I was introduced to Claude Cahun, Leonor Fini, Lee Miller, and Meret Oppenheim, and where I first fell in love with Frida Kahlo. While the class was unforgettable, it failed

◀ Jasmin Hernandez photographed at A/D/O by MINI.

9

to include any Black womxn. I soaked all this up while habitually visiting all the major New York museums—the Met, Guggenheim, Whitney, MoMA, and the New Museum—especially once I discovered suggested admission and weekly free nights. I yearned for Blackness in art and fashion, but I wasn't learning much about famous BIPOC artists or fashion designers in class or finding them on museum walls. It was magazines like *Trace* (where I was an intern), *Honey*, and *Suede* (which would come years later) that fed me that Black invigorating creativity I desperately craved.

As a twentysomething in the 2000s, it was exhibits like Kara Walker's 2007 solo show at the Whitney that gripped me. I'm pretty sure that was the first time I ever saw a solo exhibit by a Black female artist. Seeing a Basquiat retrospective in 2005 at the Brooklyn Museum had that same visceral effect, too. By 2009, Kehinde Wiley was already a king, an artist whose work shook me to my core, so going to see his *Black Light* exhibit at Deitch Projects was an unmissable event. Over the years, my attachment to art grew deeper and deeper, and no one was going to make me feel like an Afro-Latinx girl from a low-income working-class background didn't belong in culturally privileged spaces. Even during all those years when you could count on one hand how few BIPOC were present at packed art openings in Chelsea. I simply wouldn't allow it.

By 2012, it was time to write about art. I had seen enough, lived enough, traveled enough, and had formed an aesthetic. I'd gazed at Klimts at the Belvedere in Vienna, mentally wrestled with Francis Bacon's dark canvases at El Prado in Madrid, and swooned over Dawoud Bey's images of Harlem at the Studio Museum in Harlem.

Most of all, I loved vibrant, figurative work by Black and Brown artists—that's what resonated with me. That's what Gallery Gurls was going to be about. I abandoned my personal blog that I started in my late twenties in 2010, my tiny little corner of the Internet dedicated to musings on contemporary art, fashion, and pop culture. Instagram was crucial at this point; it became a major research tool for finding new artists both globally and locally in New York City. So I roamed Instagram, at first seeing artists' work on a tiny screen and then seeking it out IRL at a gallery, museum, or in their studio. Whatever their work made me feel in my gut, I spit out onto a published post. My words were raw and pure; I didn't over-think it. But the art world wasn't just being shaped by artists, it was also being shaped by independent curators, cultural produc-ers, and art entrepreneurs who were young and BIPOC just like me. It was essential to capture them, too.

We Are Here: Visionaries of Color Transforming the Art World is a graduation of sorts, both for myself and for many of the fifty featured subjects. Many of us met through social media in the early 2010s, followed each other online, and formed relationships IRL. I went to their openings, featured them on Gallery Gurls, and wrote about their work for big mainstream publi-cations. We attended each other's panels or spoke on panels together, discussing topics like equity, access, and representation in the art world. We collaborated and supported one another. We all came up together. I'm a blogger and writer, and now debut author. They've become agents of cultural change through their art and activism. Everyone grinded, and this book is the evidence.

I selected an impressive array of BIPOC and QTPOC artists and art influencers to

be a part of *We Are Here*. They are from all over the world and are mostly based in New York and Los Angeles. A multitude of stories are told here, since there is no single, definitive path to making it in the art world. Some are PhD candidates or have dual BFA and MFA degrees, others have a single degree, are college dropouts, or attended zero college at all. This is an intergenerational group of artists and creatives, from baby boomers to millennials, including established icons, unsung heroes, rising stars, and those on the come up. They are painters, photographers, sculptors, installation artists, collagists, performance artists, filmmakers, multidisciplinary artists, digital artists, fashion illustrators, and so on. Including emerging curators, gallerists, and art entrepreneurs was also vital; while artists make impactful art, these influencers get their art out into the world.

My eye is always seeking out intriguing art in both typical and unexpected places. I looked beyond prominent artists repped by big galleries and into other worlds, like the ballroom community and QTPOC nightlife. These are worlds that have shaped me since I was a teen in the nineties in New York City, immersed in QTPOC spaces, going to voguing balls, legendary nightclubs, and kiki-ing at the Christopher Street Piers. This book would not be complete without exhibiting this cultural influence, without showcasing a spectrum of QTPOC folx.

Lastly, it was paramount for me that this book prioritized BIWOC, specifically Black womxn. There was no question about it, and we are the most represented in this book. It's a love letter to us, to Black female artists and creatives. I wanted to see us, to celebrate us. Despite all the societal hoops of fire Black womxn have to jump through—on top of being othered, despised, dismissed, undervalued, and having our culture appropriated—Black womxn continue to innovate and drive creativity.

The artists and art influencers in the pages of this book have set the tone for this new decade. In each interview, these subjects lay bare their emotions, ambitions, and desires. Their language and purpose is very clear—to make the art world more equitable across the entire art ecosystem. Which means more Black and Brown artists on museum walls and in gallery spaces, amplifying a QTPOC narrative, taking institutional decision-making positions to enact change, hiring BIPOC curators to create BIPOC-driven exhibitions, commissioning BIPOC art writers with great writing opportunities, hiring BIPOC editors to edit our stories, building up strong networks of BIPOC art collectors, and making cultural spaces more welcoming and less intimidating for Black and Brown audiences to enjoy art.

Mainstream and art world media are now paying attention, catching up, and covering BIPOC and QTPOC artists more frequently, but a tangible, collected cultural history is needed. *We Are Here* is a document of Black and Brown voices in the art world, visualized by a Black woman, with the intention of making visible those who are often erased. We've been here, we are here, and we will continue to be here. The hyper-visibility of Black and Brown artists and culture-makers that we're seeing isn't a trend. The guard has shifted, and no one, including myself, is asking for permission.

AYANA EVANS
Performance Artist & Professional Troublemaker

Over the last several years, the New York-based provocative performance artist Ayana Evans has built a remarkable career through savvy and unorthodox methods. The Chicago-born Evans has been disrupting art spaces since 2012 with her project *Operation Catsuit*, which went viral on YouTube. Through her public interventions and performances, where she displays impressive physical acts, Evans investigates daily life as a Black woman, exploring how her race and gender are intertwined. Evans is a rulebreaker and a Black feminist art superwoman.

When did you know that you finally made it?

To me, making it means I own property, have over a year of savings, and people literally scream when I walk into a museum. I have none of that now. Don't get me wrong, there have been distinct milestones, one being when I was commissioned to do a two-day performance with the Barnes Foundation. My parents flew in for the eighty-person public performative dinner that followed a ten-hour performance throughout the city of Philly. The curator had to tell me to increase my own budget to make all that happen! I had lowballed myself. I was so used to being underpaid by museums and galleries, I did not know to ask for a full honorarium separate from my production budget. That was the first time those two things were offered to me. I am eternally grateful that the team at the Barnes Foundation, particularly the head curator, took care of me financially when I didn't know what to ask for. Moral of the story: know your worth.

What is the best piece of advice that has always stuck with you?

Keep going. There was a point when I was just starting to get shows and too many emails, and I said to a friend who was helping me decide my next steps, "I'm tired. I think I need to rest and not do a show for a while." She looked me in the eye and said, "I'm sorry, but now is not the time. You have to keep going." I'm not saying you should never rest, but you have to know when to keep going.

◀ Giving Hot Girl Summer vibes in her signature neon green zebra-print catsuit, Ayana Evans is photographed in front of *Sparkle Installation* at The Elizabeth Foundation for the Arts in New York City.

"What if being too much was
your superpower and no one
told you that?"

How has the Internet and social media been pivotal to your career?

I'm odd for a contemporary artist in that I basically come from YouTube, so social media has helped me immensely. I began by crashing art shows in my neon green zebra-print catsuit and church heels, with my friends filming it as best they could on their phones. I would post what happened on YouTube and even respond to every comment—I felt the work was also in discussing the issues of race and gender that surrounded that project. Then the first video went viral. (A viral art project amounts to about one hundred thousand views, not one billion. So let's be clear that video was "art famous," not regular famous.) Eventually Esther Neff asked me to screen one of my videos at her performance space, Panoply Performance Laboratory. That snowballed into other gigs.

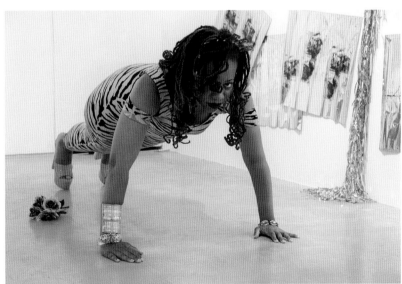

◀ The screen prints that appear in Evans's *Sparkle Installation* are based on images from past performances.

▲ Evans always gives it her all in her autobiographical performances.

I feel like I am my own superhero these days. I have an outfit with a recognizable pattern that I've been wearing since 2012. Plus, I'm obsessed with wearing two crowns at a time lately and sometimes rock over-sized pink heels and an angry pussy bikini (it has angry cats all over it and the textile was made specifically for me by Diane Hoffman). I do whatever I want when wearing my uniforms, so it feels like I get to be my own superhero right now.

I believe in presenting myself visually. I went to FIT after graduating from Brown, where I was able to take classes at Rhode Island School of Design. I also had a hand-bag line for seven years, so you can imagine I love fashion! I like to play with ideas of respectability politics through fashion. This mostly means rejecting ideas of respectability politics through my fashion choices. The catsuit was designed by Tiffany Rhodes, who is the founder of the line Butch Diva. I see wearing a neon green, zebra-print, skintight catsuit as a way to announce I am proud of my curves, that I want my presence felt and seen in art spaces. I used to dress to hide my small waist and big butt. Wearing the catsuit is my way of saying fuck that.

I should also say that my catsuit is a color theory choice. This is where my MFA in painting shines through. I thought the neon green combined with my skin tone, plus a red lip and a white gallery space, was a beautiful color combination.

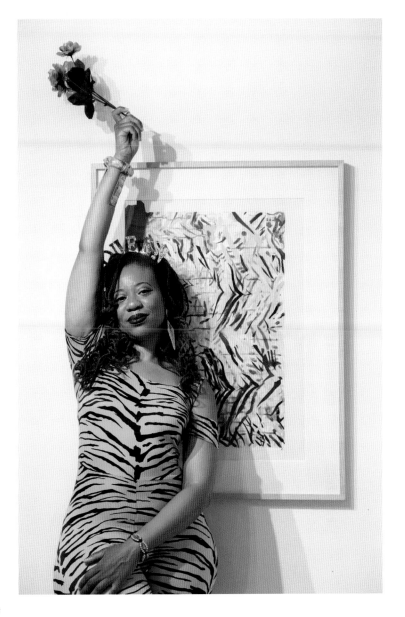

The catsuits I own are also very comfort-able and durable. So I am bold, tough, and comfortable in what I wear! I think that's magical, especially for a woman of color as we are often told by society that we are too much. Who determines what is too much? What if being too much was your super-power and no one told you that?

◀ An eye-catching detail of Evans's *Sparkle Installation.*

▲ Evans strikes a pose in front of her watercolor monotype *Process: abstracted catsuit.*

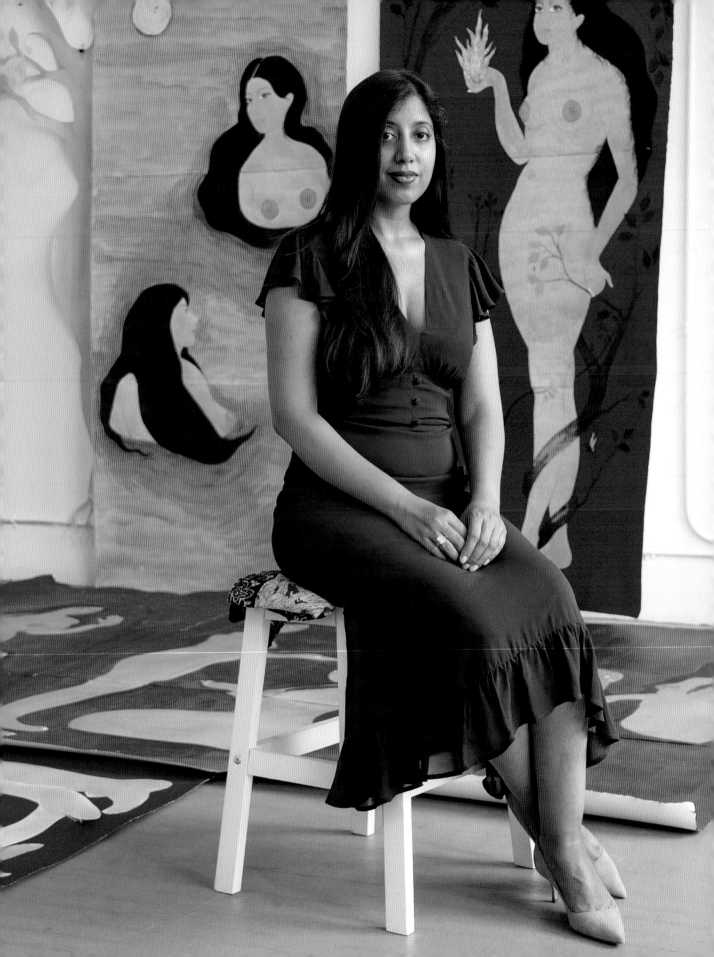

HIBA SCHAHBAZ

Contemporary Artist

Hiba Schahbaz's paintings are a feminist force of nature. Entering her sunny Brooklyn studio is like stepping inside a secret lair, an immersive cave of female wonders. Life-size womxn—Brown, nude, long-haired, and all simply gorgeous—greet you with their stunning deep-set gaze. And they are all her. Schahbaz is a Pakistani-born artist, raised in Karachi, educated in Lahore, but has called New York home for almost a decade. Schahbaz's work is aesthetically transformational; first working in Indo-Persian miniature paintings before creating wall cutouts, she now creates grand oil paintings. The experience for the viewer is transformational, too, as they are confronted with an unforgettable, Brown, magical woman.

What is the best piece of advice that has always stuck with you?

When I was just beginning to work as an artist in New York, art critic Jerry Saltz told me, "Your *only* job in this life is to make art, to make your art the most *yours* that you possibly can, to make your art singular, undeniable. I *only* care about your art; I don't even care about you. Art first; all else follows . . . Trust the power inside of you; if it rips anything, it will rip the fabric of the world . . . not *you*."

Years later, I feel I am beginning to understand what he was saying, and why he pushed me so hard to put art before anything else. Without that fire and passion and complete investment, there's no greatness, no satisfaction, and no meaningful change.

I'm only just beginning to understand my creative power and how limitless I am—how limitless we all are.

How has the Internet and social media been pivotal to your career?

I moved to New York later in life, as an immigrant, and I didn't know much about the art world. Being on Instagram facilitated my understanding of Western culture as well as the contemporary art world. I met so many people working in art online before meeting them in person. I find this in-between space a great place to make connections. It's also very democratic, allowing creatives to communicate who they are on their own terms, be more independent as artists, and maintain our power.

◀ The regal Hiba Schahbaz in her dreamy Brooklyn studio, surrounded by her seductive self-portraits.

When are you happiest?

I'm happiest when I'm painting and just vibing in my studio, following my creative process. I'm happy when I'm peaceful, when I'm meditating, sitting in solitude staring at the moon or water or mountains. When I'm hugging someone or being hugged—I love the feeling of connection and acceptance and being one with the universe.

What is your favorite color?

Red has been my favorite color for as long as I can remember. I feel an emotional connection to it, it gives me comfort and energy. I unintentionally surround myself with it. I carry my mother's red shawl with me even when it clashes with my clothes. I wear a lot of red dresses, even my sweatpants are red. It's also a color I use a lot in my art, both red and variations of it. I compulsively buy red paint every chance

I get so I don't run out of it. There are always red paintings in my studio.

Your self-portraits are unapologetically Brown and nude. Why is that important?

It feels right for me to be vulnerable, honest, and accepting of myself in my paintings. Although my work is not intended to be realistic, my self-portraits are a reflection of my body and my emotional experiences, which are those of a Brown woman. I paint what I feel and what I know so that I can be at home within myself.

As a Muslim feminist artist, how does your art empower womxn? Especially WOC?

It's my dream to be able to create something that can inspire and empower other women. Women, often women of color, write to me from different parts of the world, saying that they see themselves reflected in my work.

▼ Painterly details in Schahbaz's studio.

▶ A close-up of Schahbaz's work in progress, an untitled garden-inspired oil painting.

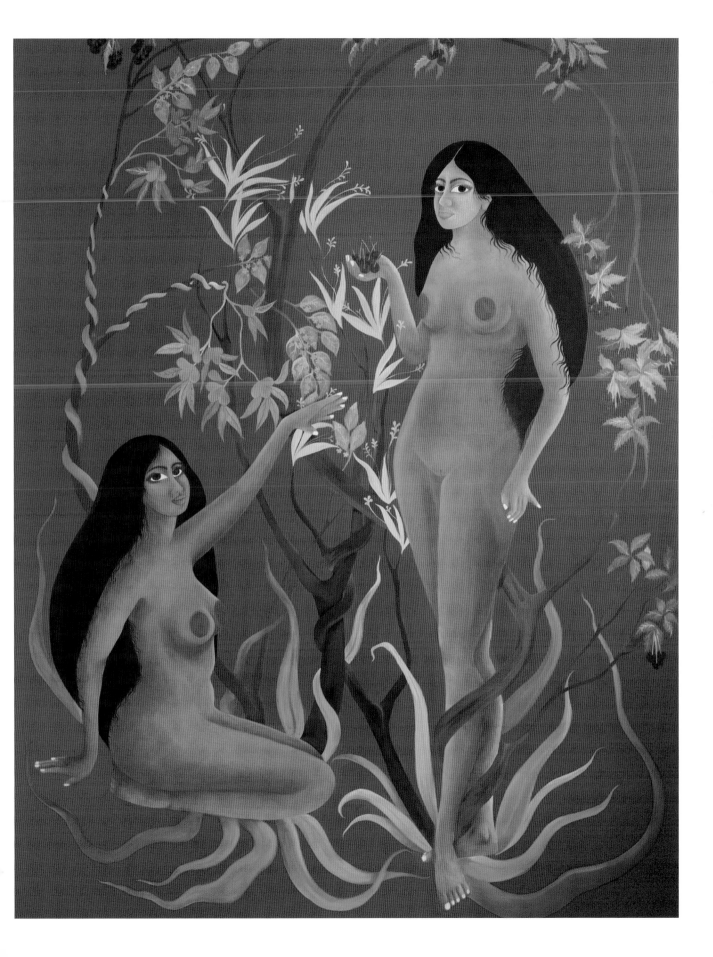

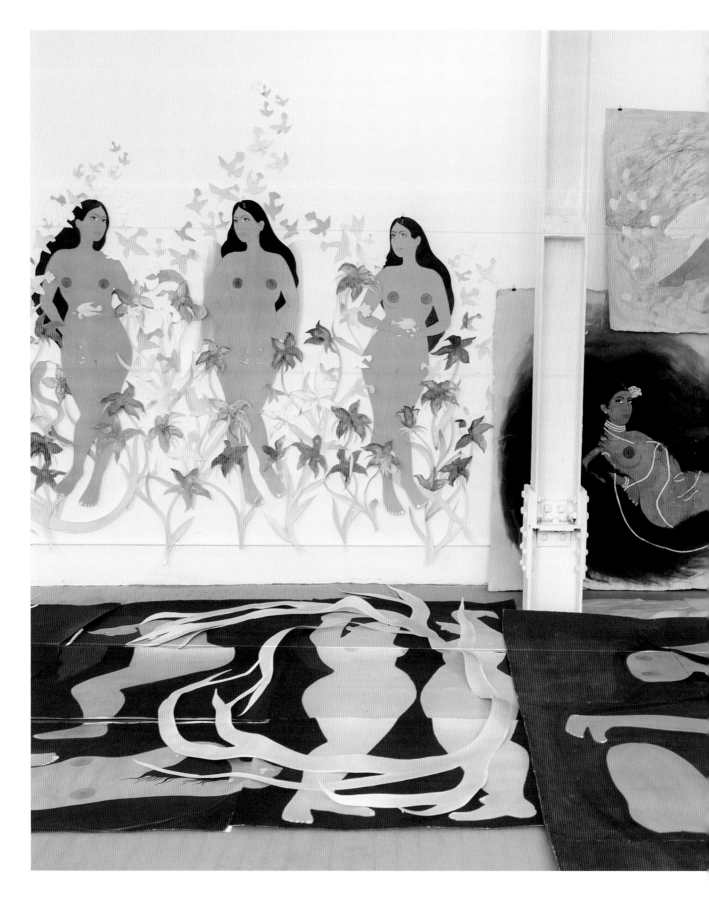

"I paint what I feel and what I know so that I can be at home within myself."

Sometimes this is a physical reflection, but it's also often a spiritual or emotional one. It's important for women and girls to see themselves represented in art from the perspective of a woman, specifically from a lens that does not impose a false sexuality or otherness on them. Self-acceptance, a healthy body image, and celebrating womanhood are important for women to grow, heal, and live fully.

Femininity and nature are so closely married in your work. Why?
When I'm in nature, I feel very connected to myself and to my environment. I feel happy and peaceful when I'm surrounded by so much beauty and magic. I think most of us feel very connected to the earth or certain elements of it, like the moon or the ocean. My paintings reflect my inner life, which feels very much like a garden, or sometimes, a very turbulent sky.

◀ Schahbaz's breathtaking mix of studio paintings, works on paper, watercolors, and cut-outs, including *Self-Portrait as Olympia (after Manet)* (2016–19).

▲ Two female-centric works, *Self-Portrait in Dreamland* (2019) and *Untitled* (2015).

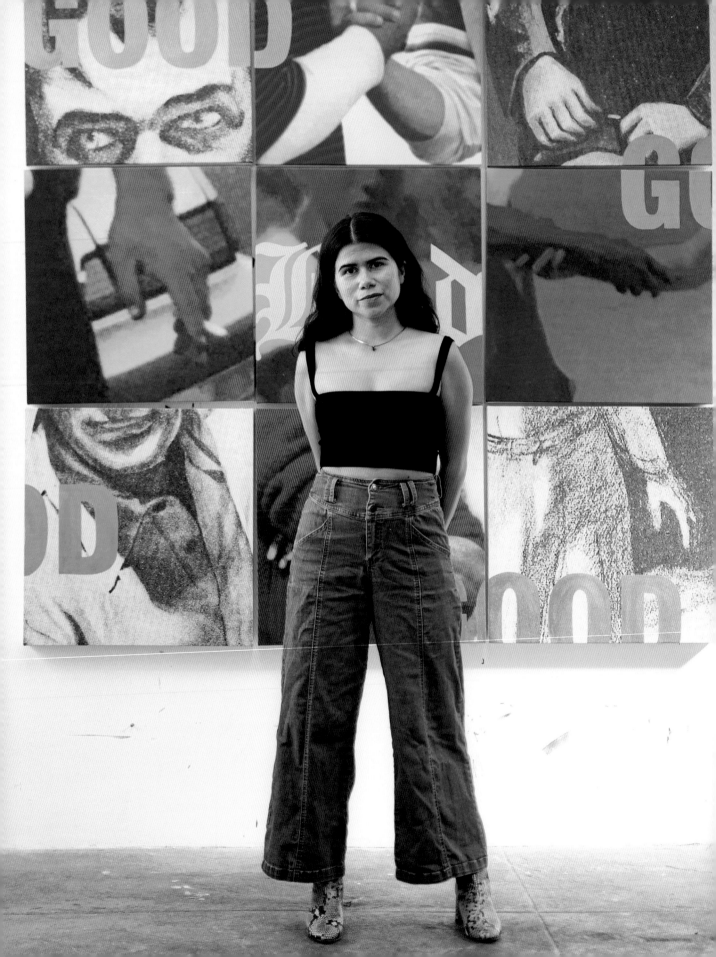

GABRIELLA SANCHEZ

Contemporary Artist

For Gabriella Sanchez, her own writing, along with visual references and her personal photographs, are the catalysts for her paintings. The Pasadena native, Los Angeles-based, Chicanx artist fuses her background from graphic design and pairs it with her collage-like, acrylic paintings that are bursting with color. Sanchez's paintings contain an intoxicating mix of super-cool elements—black marker scrawls collide against sophisticated fonts, all enveloped by pastel pinks, rich blues, and verdant greens. The titles of Sanchez's canvases evoke double entendres and once you visually dive into her art, they unlock multiple entendres for the viewer to decode.

When did you know that you finally made it?

For me, making it means longevity so I think I'll feel like I've made it when I'm maybe sixty and can look back and be like, "Damn, I really did that." The moment I was able to stop doing other side jobs, when I could pay my rent and bills from my paintings, was definitely a monumental point.

What is the best piece of advice that has always stuck with you?

Follow your own vision. Make what you actually want to make and just keep going. Also, the belief that an artist is a divinely gifted, somewhat aloof being is garbage.

◀ The simply stylish Gabriella Sanchez poses in front of her painting *It's All Good* (2019) in her Los Angeles studio.

What kind of art world do you want to see in the future?

I'd like to see an art world that is more accessible on all levels. That means multiple access points and routes into the art world. Everyone should feel like they have the right to engage with art. Just like everyone has a favorite type of music, everyone should have a favorite type of art. That's the type of art world I want to see. That's the type of art world I need.

Describe yourself in three words.

Bright. Sharp. Insatiable.

Your artwork stems from your personal essays, with your own words flowing onto the canvas. Can you talk about this process?

I really like this quote by R.B. Kitaj, "For me, books are what trees are for the

landscape painter," except I'd exchange "books" for "words." For me, painting is directly connected to language and communication. I always start with writing and reading. Sometimes my writing takes the form of one-line notes that later work their way into my paintings or full essays. Sometimes that writing will lead to even more reading and researching. This cycle can repeat itself until I feel like I've exhausted that avenue and have filled myself to the brim with my internal dialogue. Then with all of that in mind, I go through my visual references from my past work and personal photo archives, pulling images that inspire.

▼ Bright pencils and buckets of paint in Sanchez's studio.

▶ (top) A row of works hanging in Sanchez's studio, including *Homme or Homes* (2019). (bottom) Sanchez surrounded by her work in her cozy and chic Los Angeles studio.

When it comes time to paint, I've had my concepts so tightly wound in my mind that I like to let it flow out naturally. It's important to me to allow a level of intuition into my painting process because I think that's what gives it more of a resonating life. The planned out conceptual part of the work is the foundation the instinctive visual choices can build upon.

Talk to me about your graphic design background—do you feel it's a powerful tool to talk about politics and identity? Graphic design became a way for me to fund my life and art practice. I worked as a graphic designer for a few years after college. During that time I saw firsthand the politicization of visual cues and the unspoken rules and strategies of psychographics being used in commercial design. There was a clear delineation that became apparent to me in graphic design between what was seen as "standard" and what was seen as "other," which always connected to aesthetics associated with communities of color. This is when I first became interested with the idea of displaying the same word in varied font styles with heavy connotations to see how the meaning was changed, broadened, or restricted.

"Just like everyone has a favorite type of music, everyone should have a favorite type of art."

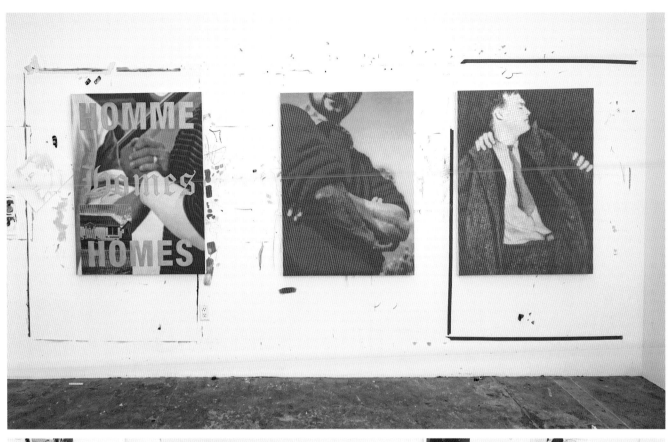

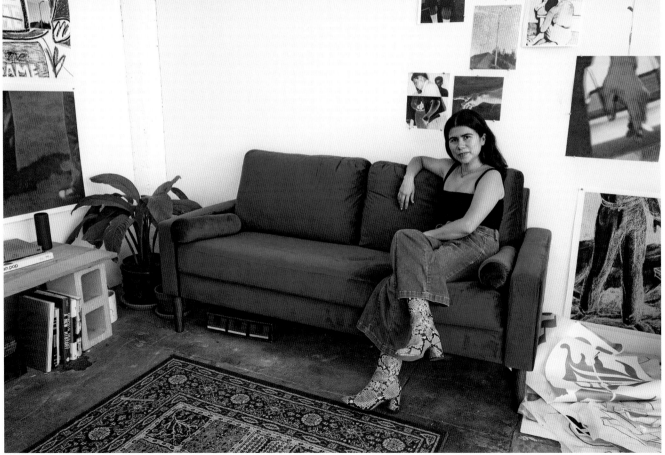

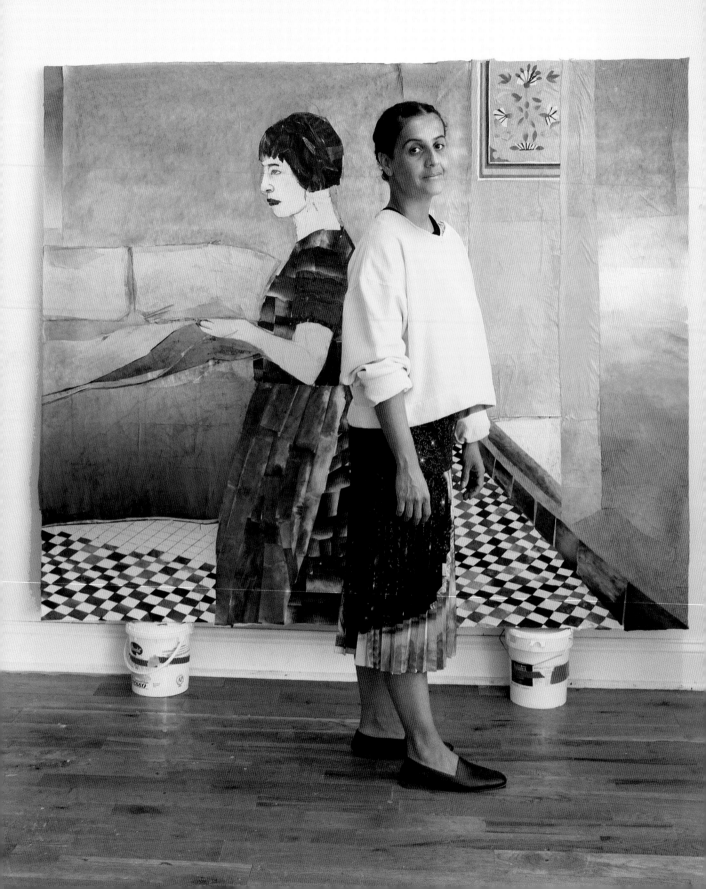

MARÍA BERRÍO

Contemporary Artist

In María Berrío's large collaged-based canvases, the Colombian artist invites the viewer into her surrealist universe—a specially crafted universe ruled by nature, beautiful creatures and female tribes. Her grandiose canvases, which use an assortment of fine Japanese paper, recount tales of sisterhoods who use compassion, maternal instincts, and fierce intelligence to govern. Born and raised in Bogotá, Berrío spent her idyllic childhood on her family's rural farm but has now been based in New York for close to two decades. The urban-dwelling Berrío carries those special links from her earlier years in nature, manifesting them in her art in the most awesome of ways.

What is the best piece of advice that has always stuck with you?
A professor once asked me if I wanted to be an artist, and to take a week or so to really think about it before I answer. This helped me realize that this decision would determine the rest of my life. Becoming an artist is a lifelong commitment, it's not something to be rushed into. After thinking it over, I was able to return to my professor and tell him yes with absolute conviction. This professor took me seriously and gave me the time and space to take myself seriously. Suddenly my dream to become an artist was not only a decision, but also a commitment to my mentor. This commitment is one I think about often as I navigate my career.

What kind of art world do you want to see in the future?
I want to see an art world that actually reflects the diversity of humanity. Unfortunately, art continues to be a privilege reserved for a select few. If museums were free, if the government funded public art and education, and if artists were paid fairly, the field would be a more inclusive place.

Describe yourself in three words.
Sensitive, strong, and a great dancer.

Who is your favorite fictional character?
Cleo from the movie *Roma*, played by Yalitza Aparicio.

◀ María Berrío in a sunny look in her bright Brooklyn studio, next to a lifesize work in progress.

The landscapes in your work are so lush and rich. How did growing up in Colombia influence that?

I spent most of my childhood on my family's farm, surrounded by plants and animals. My parents let us roam among the trees; it was a really special way to grow up. At this point, I've lived in New York for nineteen years, longer than I ever lived in Colombia. I thrive on the energy and chaos of the city, but my paintings remain rooted in nature, where things are serene and mysterious.

There is a unique bond between female subjects and creatures in your work; they seem to be in communion with one another. What does this mean?

I take inspiration from South American folklore and religious narratives. In these stories, animals are often symbols of hope and power, used to teach and guide people. In the logic of my paintings, there is no division between what is human and what is found in nature. In this world, humans and animals must coexist, they have complex relationships that go beyond that of master

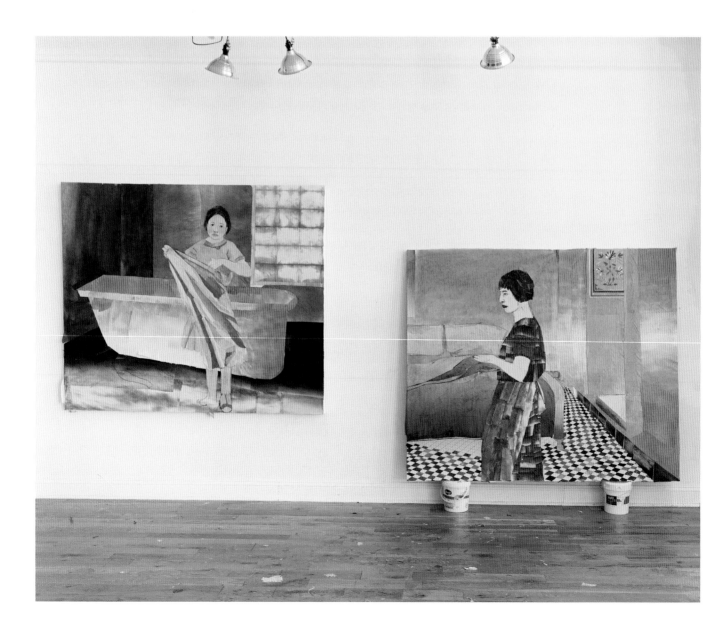

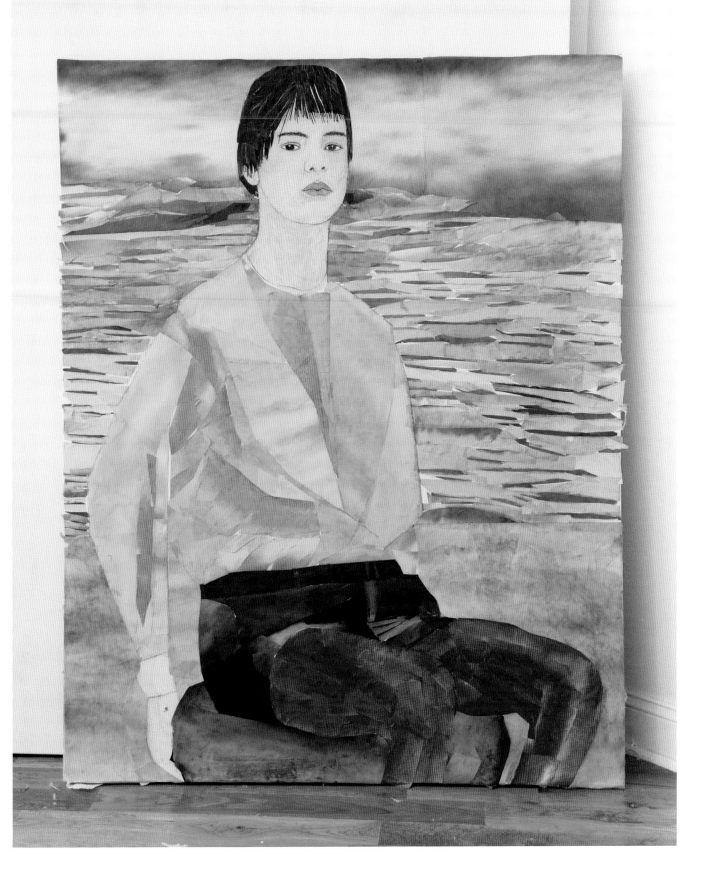

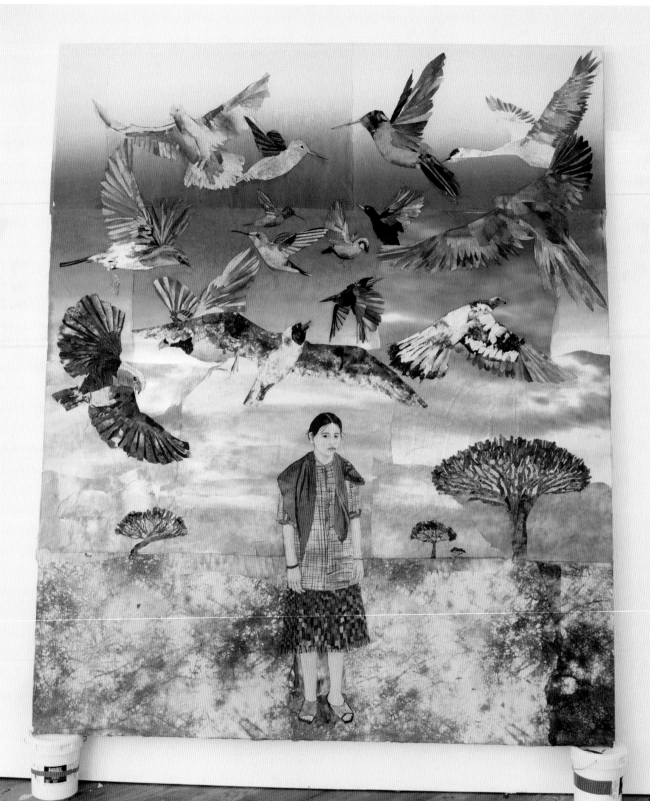

Femininity and nature are strong themes in Berrío's collage-based works, as in this work in progress.

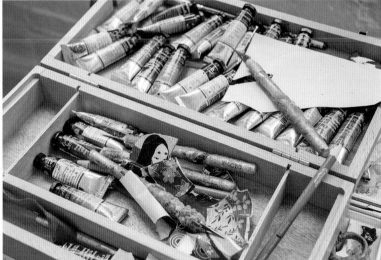

"I hope my work serves as a reminder to be open to this sisterhood, to not let the pressures of society divide us."

and pet. This serves as a reminder of how much there is to learn from other lifeforms, and points to the precariousness of a society designed to keep us apart from nature.

The idea of sisterhoods are so primary in your work. Why is this important to you?

The world pits us against each other in a million insidious, toxic ways. Living under this pressure, women share a distinctive internal world and an understanding. When I was traveling in Turkey with my family, there was a beautiful historic mosque we wanted to check out. Since I didn't have a veil, I had to wait outside with my baby while my husband went inside. A local woman was also waiting outside the mosque with her baby. Even though we didn't exchange words, we exchanged stories with our eyes, because womanhood is beyond language. I hope my work serves as a reminder to be open to this sisterhood, to not let the pressures of society divide us.

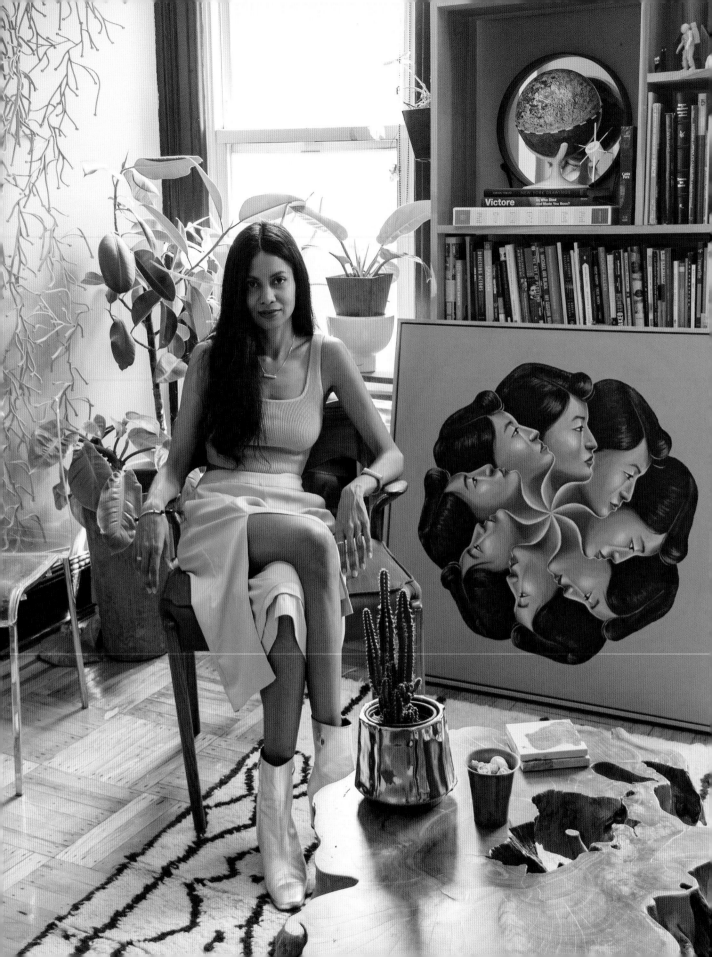

SHYAMA GOLDEN

Contemporary Artist

In the digital realm and with her physical oil and acrylic paintings, Shyama Golden's global perspective, her exotic landscapes, and her representation of pop icons of color come alive in the most imaginative ways. Golden saw the world early on; she was born in Texas, raised in Sri Lanka and New Zealand, lived in San Francisco, Brooklyn, and now calls Los Angeles home. Golden made the successful jump from graphic designer in the corporate world to full-time illustrator and painter, working solely for herself. Golden's seamless digital patterns have been displayed in Times Square, her illustrations have graced magazine pages and book covers, and her paintings exhibited in solo shows in New York. It's so satisfying to see a Brown woman in the art world be so damn limitless.

◄ Shyama Golden sits beside her acrylic painting *Recursive* in her former live/work space in Brooklyn, where earth tones meet pretty pastels.

How did art first enter your life?

I didn't grow up with art in the traditional sense. The earliest "art" I was exposed to was electron microscope photography. My parents worked as scientists and researchers, so they brought images home from work and hung them up as art. We went to natural science museums rather than art museums, but my parents encouraged my interest in creating art, while still worrying that it meant I would be poor forever. Like all children, I started creating my own art as soon as I could hold a pencil, but my first memory of it is in the form of storytelling. I adored the detailed illustrations in storybooks and loved to write and illustrate my own. They weren't very good, but I didn't care. I just loved making them and there's something very pure about that.

Why do you do what you do?

There is a satisfaction that comes from creating my own world; it feels like a superpower that would be a shame not to use. Beyond that, the connection it gives you to other people is something that's hard to put into words—it's an exploration of my own humanity and what connects us all.

What is the best piece of advice that has always stuck with you?

It has been said many times, but you have to have a life in order to make art. Art comes from your life, not from thinking really hard about what to paint.

How has the Internet and social media been pivotal to your career?

When I was in grade school during the golden era of Geocities and non-ironic GIFs, I read *HTML for Dummies* and taught myself the basics of having a cyber presence. I was terrible at JavaScript or any kind of coding, but became obsessed with the freedom of making something out of nothing and putting it out into the world. Instagram in particular has been the most useful in connecting me with new opportunities. Embracing technology is especially important to underrepresented people. I'm no longer solely at the mercy of a panel of judges who might not get what I'm about.

What kind of art world do you want to see in the future?

A more inclusive one! Artists of all genders, abilities, and backgrounds belong in our art history books. The stigma behind an artist doing commercial work is also a bit dated. We should be allowed to do what's needed to make money for health care and other necessities and not be judged for it, as long as the work aligns with our values.

What is your favorite color?

Perhaps gold, but I'm not really good at favorites. If gold isn't a color, I'll say honey mustard, and if that isn't a color, it's at least a good dipping sauce. I'm not shy about color though, so I'm much more interested in groupings of color reverberating off each other than any one individual color.

▶ Golden in her former live/work space in Brooklyn in front of various pieces, including the acrylic painting *Road Trip*.

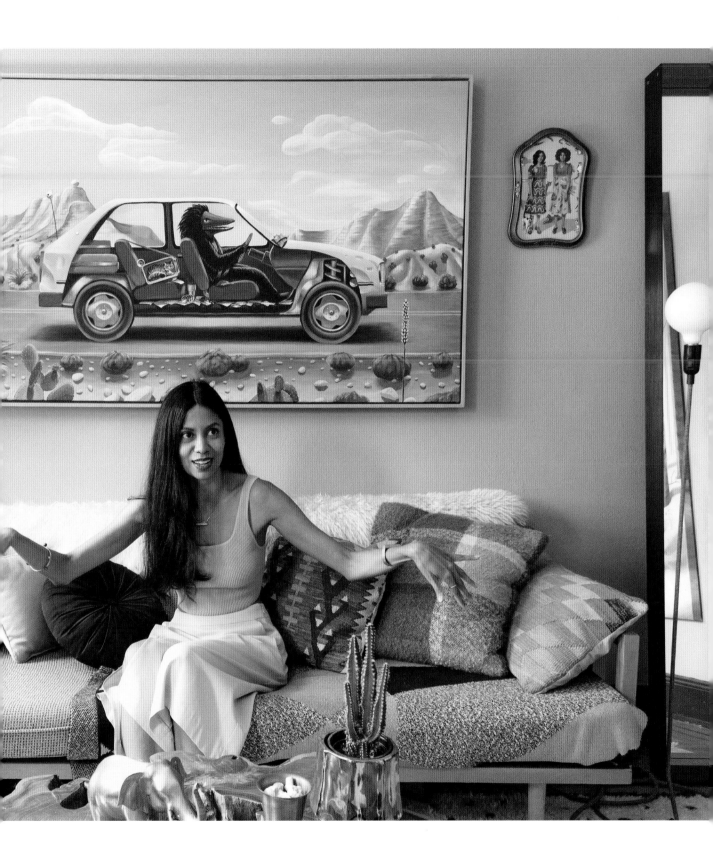

What are pleasures you find in creating your digital illustrations and your oil and acrylic paintings?

Each medium has its advantages. If the concept needs motion or a seamless repeating tile, a digital painting lends well to that. If it's part of a body of work that I want people to view in person at scale, then it might be better as an oil or acrylic painting. There's a freedom when you can be prolific and it only occupies virtual space in your life. I physically paint only the few ideas that require it. Oils have always been my favorite medium due to their luminosity, but if I want to build up dimensional effects on the painting, acrylic is the way to go. I might combine several ways of working, such as doing a digital study, then roughing out an acrylic underpainting and adding a final layer in oil.

In your own words, your work focuses on "intersectional identities and hyphenated Americans." Why is this important to you?

The term "hyphenated Americans" always struck a chord with me. I thought it was interesting to ask the question of who is called an American and who needs a hyphenated addition to that descriptor. I want to shift this idea of what an American looks like toward something more inclusive and honest, but I don't do this to be politically correct. This is a past, present, and future reality the country hasn't fully come to terms with. James Baldwin said it best, and I quote this from a Q&A in one of his audio recordings: "As long as Americans imagine that it is a white country, then there is no hope. So it's up to you."

If you look at any of my work, I often use variety to get that feeling of abundance and complexity that I'm after. My family

is from Sri Lanka and, while I was born in Texas, I lived in Sri Lanka and New Zealand as a child. Those things make my identity a bit nebulous. In my *Yakka* series, I use Sri Lankan devil dancers as actors in scenes of Americana to try and work through this feeling of worlds colliding.

Looking at the bigger picture, there are artists right now doing the work of representing those of us who are missing from history books and art museums. That's a movement I'd like to contribute to.

◀ Detail of Golden's iconic *Catsquatch* oil painting.

▼ A close-up of Golden's *Feminine Mirage*, painted with acrylic on panel from her *Mirror Constructs* series.

"There is a satisfaction that comes from creating my own world; it feels like a superpower that would be a shame not to use."

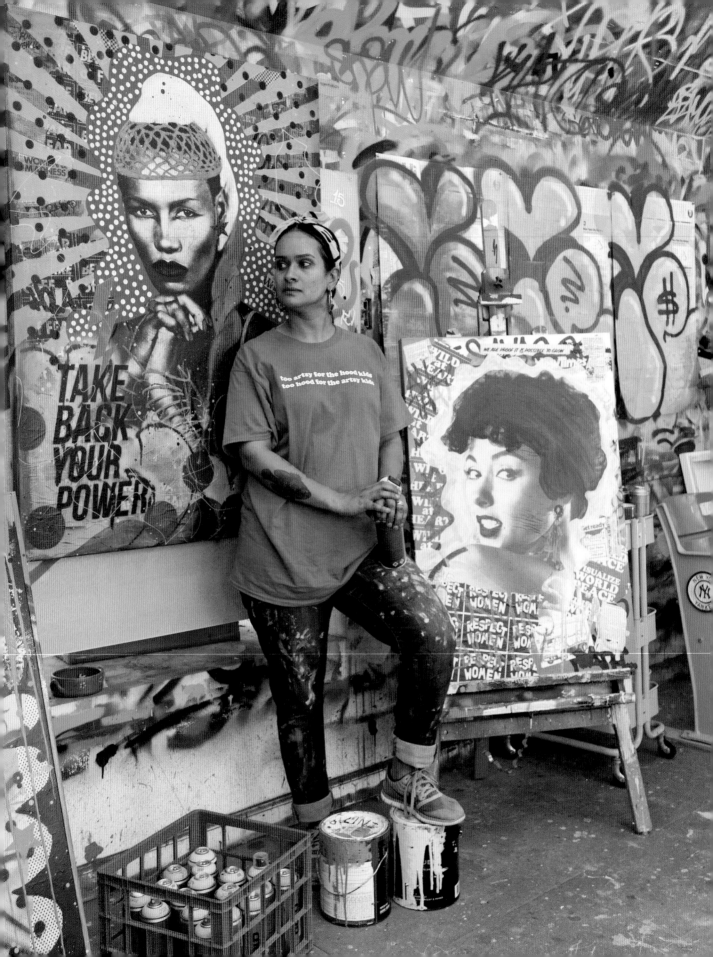

INDIE 184

Visual Artist

Indie 184's art visually grips you and won't let go. The Puerto-Rican born, New York-raised, Afro-Latinx artist of Dominican descent creates fresh and vibrant murals and paintings with one clear message: the elevation of womxn. Indie 184's passion for color, fashion, graphic design, pop culture, and feminism shine through in her kaleidoscopic portraits of some of my fave icons like Sade, Grace Jones, and Rihanna. The painter, muralist, and graffiti artist is literally a reflection of the very art she creates—a self-made female entrepreneur and mother who, through sheer grit, ambition, and hardcore tenacity, simply made it.

How did art first enter your life?

My first memory of art was when I was four years old. Dominican and American culture was my introduction to visual art. I watched a lot of television shows, movies, and pop music videos. We moved from Puerto Rico (my mom is from the Dominican Republic), and we first settled in Far Rockaway, Queens. We lived in a three-family house and had an open door policy where all sorts of characters would be welcome to our family dinner parties and birthdays. During that time, like any other kid, I was exploring art through day care and would continue to hone my craft at home. I was an electric wild child; however, since my mom was focused on surviving, she did not know how to keep nurturing my passion for art. We did not visit museums or galleries, but as we moved around New York, I was exposed to all kinds of mysterious schoolyards and street graffiti. The most significant encounter was at the New York Public Library and discovering *Subway Art* and *Spray Can Art*. That's when graffiti art started to make sense to me, and through graffiti I learned so much about marketing, design, organization, self-empowerment, and fearlessness. Graffiti became the gateway to the art world for me.

When did you know that you finally made it?

I felt like I made it when I created my first graffiti piece with a couple of old-school legendary graffiti writers in a public park in the South Bronx. Prepping for the wall and completing my first production piece was exhilarating and satisfying. Graffiti culture provided an outlet and community; it fulfilled my self-esteem and cravings to produce art. Independence, self-empowerment, having a goal, and working towards that passion truly makes me feel like I made it. Also being able to raise my kids, and travel with a liberating work life.

◀ Indie 184 in her Hudson Valley studio, surrounded by her fabulous feminist icons remixed with color.

What is the best piece of advice that has always stuck with you?

Julie DesJardin, my women's history professor at Baruch College, told me, "There is no right or wrong way to be."

What kind of art world do you want to see in the future?

In the future, I visualize the art world bridging the vast gap within gender and race inequality. Diversity in galleries, museums, and publications such as rewriting institutional curriculum and books in art history courses. Artists who have passed away decades ago are like today's rock stars, with auction sales in the millions and loads of merchandise and retrospectives. It's important to also support living artists both local and global! I'd love to see the art world embrace and celebrate more indigenous, LGBTQIA, Caribbean, Latino, and African-American artists with the same shine that everybody else gets.

Describe yourself in three words.

Fun, inventive, and bubbly.

Who is your favorite fictional character?

Superwoman is my favorite all time fictional heroine. Her story really resonates with me. She inspired me to write my own comic book *Indie Destroys*, which is based on my graffiti adventures and life as a mom balancing family and the art world!

What is your favorite color?

Right now I am truly obsessed with electric blue and teals, combined with a pastel color. These colors are very symbolic for me. For years I was attracted to reds and pinks. My moon is in Aries (sigh), which is ruled by Mars, the planet of war. According to astrologers red is supposed to be my "power color," but I felt like having so many red objects caused chaotic energy at home. So when I took a trip alone to Athens, blue was

▼ Indie 184 at work in the studio, where her obvious love for color shines.

▶ Dynamic mixed media canvases, from left to right: *Jump In, Self-Portrait* (work in progress), *Read My Lips 2*, and the Chimamanda Ngozi Adichie–inspired *Let Yourself Be.*

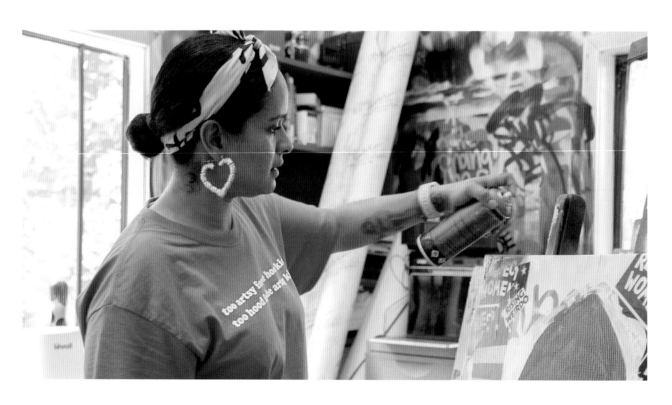

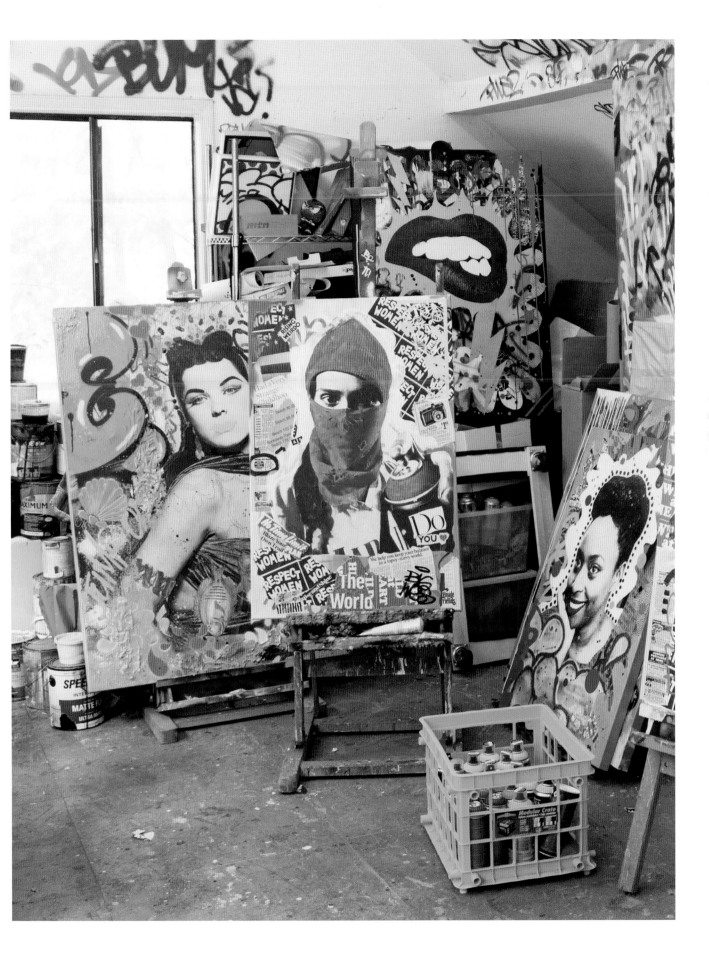

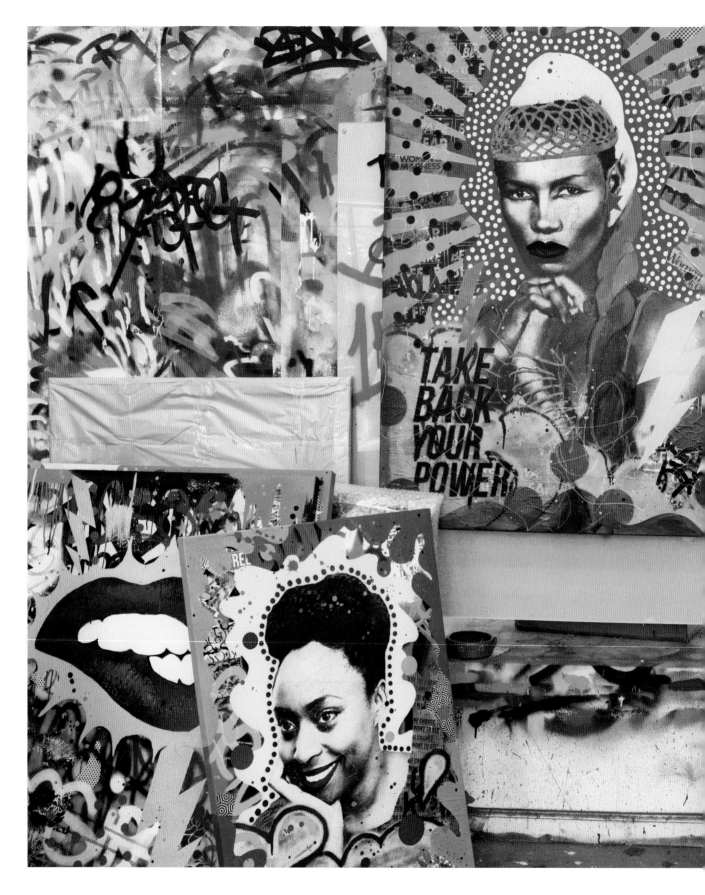

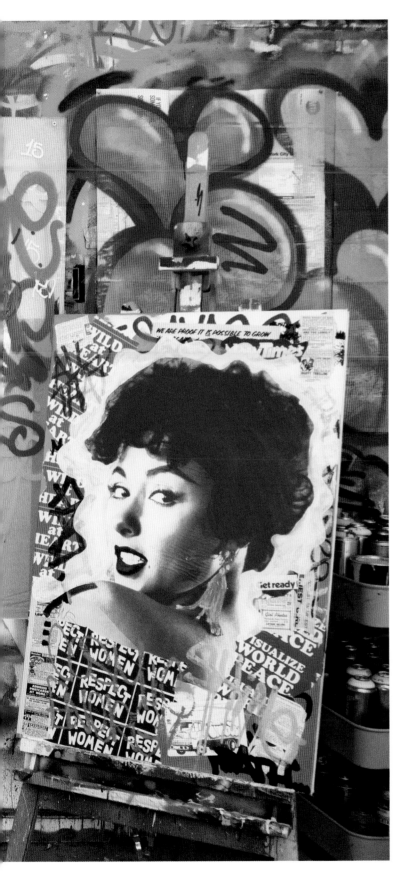

everywhere. Then in Santorini, I instantly fell in love with the blue that covered the domes and buildings there. A year later my kids and I visited the Blue Lagoon Island in the Bahamas, the ocean water was the most exquisite teal I have ever seen. I get color inspiration everywhere, from the 99 cents store in the Heights to the multicultural neighborhoods in Lisbon.

Your paintings and murals center on female pop culture icons. Can you talk about combining feminist icons with your vibrant graffiti influences?
My work is inspired by a collection of childhood experiences; especially since I was raised by a single mom, I represent female figures as protagonists. Throughout my academic career, I got tired of the same old teachings, of the traditional patriarchal courses in history. That was until my ten-year return back to college when I took a women's history course. That class forever changed my perspective. I'm so intrigued by the female icons I feature in my work. I take some influences from their lives, but the content is based on whatever challenge I may be facing. When I first started painting, I dabbled in stencil art and by mostly doing graffiti pieces in the street. I studied black-and-white photography, learned graphic design, and worked as an accessories designer for a fashion licensing company. So I've mixed my love for graphic design, pop culture, and photography into a style that expresses a visual story of empowerment.

◀ More of Indie 184's mixed media canvases, from left to right: *Read My Lips 2*, *Let Yourself Be*, the Grace Jones–inspired *Take Back Your Power*, and a Rita Moreno–inspired work in progress.

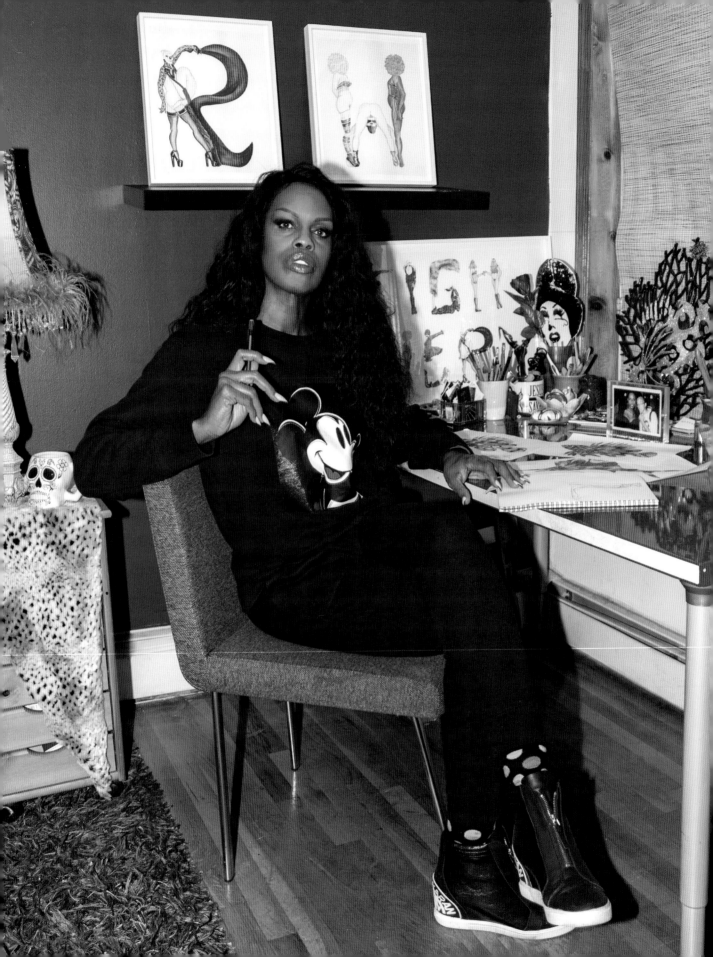

CONNIE FLEMING
Model, Runway Coach & Fashion Illustrator

Connie Fleming, a statuesque and ravishing beauty, has spent over three decades in fashion and art, undoubtedly influencing pop culture. The New York-based model, runway coach, and fashion illustrator of Jamaican descent leaves an indelible mark as a Black trans woman who claimed space and soared in both art and fashion. Fleming's fashion pedigree is untouchable; she's been photographed by Steven Meisel and Francesco Scavullo, walked the Paris runways in the late eighties and early nineties for Thierry Mugler and Vivienne Westwood, and appeared in George Michael's music video "Too Funky." Fleming's influence continues in her work illustrating for fashion brands, exhibiting her art, and sharing her truth as a breast cancer survivor. Fleming is a phoenix with an intriguing and enduring legacy that reigns supreme.

When did you know that you finally made it?

I think that my hard work is still bearing fruit and I still have a ways to go, especially as an artist. I still need to feed my eye, gather more info, experience more culture, people, and places. Then I'll feel somewhat like I've made it.

Who is your favorite fictional character?

Well it's a toss up between Bugs Bunny and Mickey Mouse. I drew both obsessively as a kid. Being an only child, they were my friends and taught me to see life with a sense of beauty, wonderment, and optimism.

How has the Internet and social media been pivotal to your career?

It's been an amazing research tool. Also, it's given me a great platform to show my work and connect with clients and fellow artists. It's also a double-edged sword that allows one's content to be out in the world and out of your control. As a model and personality, it has introduced me to the world far and wide. Stuff that I've forgotten about or didn't think made it to the digital age are there to be beheld. OMG!

◀ Connie Fleming in her primary-colored workspace in artist Kevin McHugh's apartment in New York City.

"My visibility confronted all these prejudices and revealed them for what they truly are—small, tiny, evil excuses."

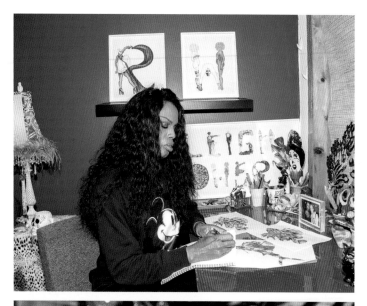

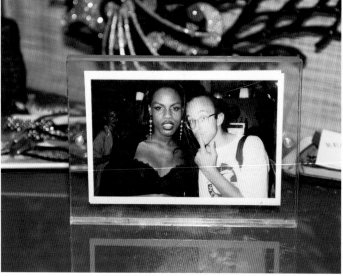

You're a New York nightlife icon, and being a New Yorker is a big part of your life. How does the city inspire your fashion illustrations and art?
The melting pot that is New York constantly informs the heart and soul. You can turn a corner and be in a totally different culture with its own sights, smells, and sounds. Although some of the street culture elements have lessened, it's still present with a driving energy of all expressions. It's a total feast for the eyes that challenges you to think with your soul. The color sensibility of Little India mixed with a cheongsam from Chinatown on a girl from Flatbush is total perfection and inspiration.

You're a boundary-breaker in the fashion world with staying power. When you think about your legacy, what are some important moments you reflect on?
Being a Black trans female was and still is considered psychotic, subversive, criminal, and the perfect excuse for extermination. My career came about at a time when these accepted mores were beginning to be challenged. Fortunately, I was sought after and worked with artists that didn't see me as a freak or a joke. They saw talent and ability. So being in heavy rotation on MTV, BET, VH1, the Paris runways, and in the pages of high fashion glossy magazines were all important. My visibility confronted all these prejudices and revealed them for what they truly are—small, tiny, evil excuses.

▲ A photograph of Fleming and her friend Keith Haring, taken by Tom Eubanks at the Pyramid Club in New York City in 1989.

▶ (top) Original, individual illustrations of *R* and *W*, which are part of the *Leigh Bowery* print from Fleming's *Name Droppers* series.

(bottom) Fleming's work desk overflows with color and texture. Clockwise from left: *Leigh Bowery* from Fleming's *Name Droppers* series; a

Lauren Pine mask by Jojo Americo; fish sculpture by artist Kevin McHugh; a photo of Fleming with Keith Haring; watercolor sketch drawn by Fleming.

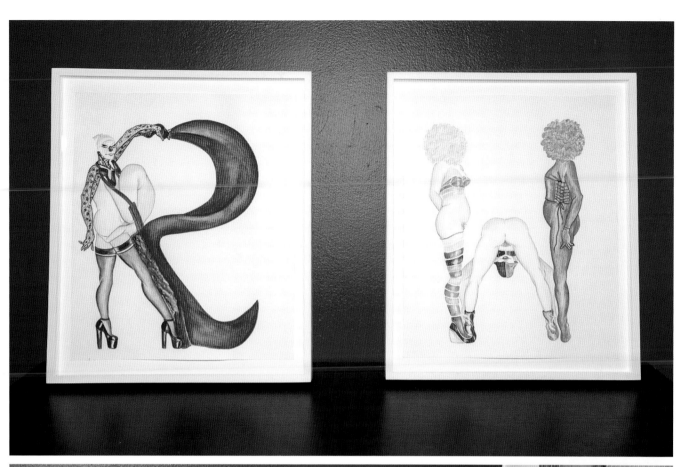

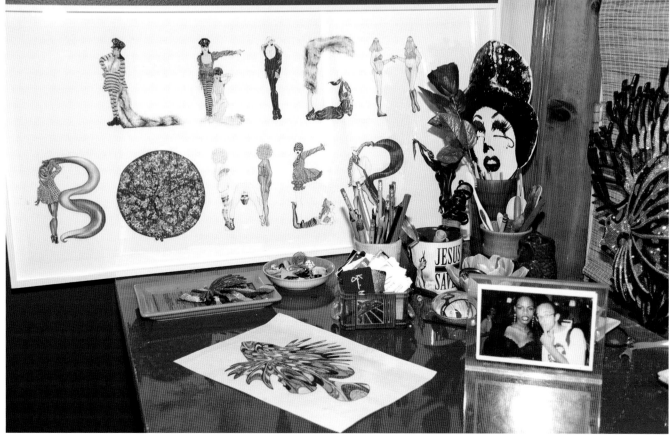

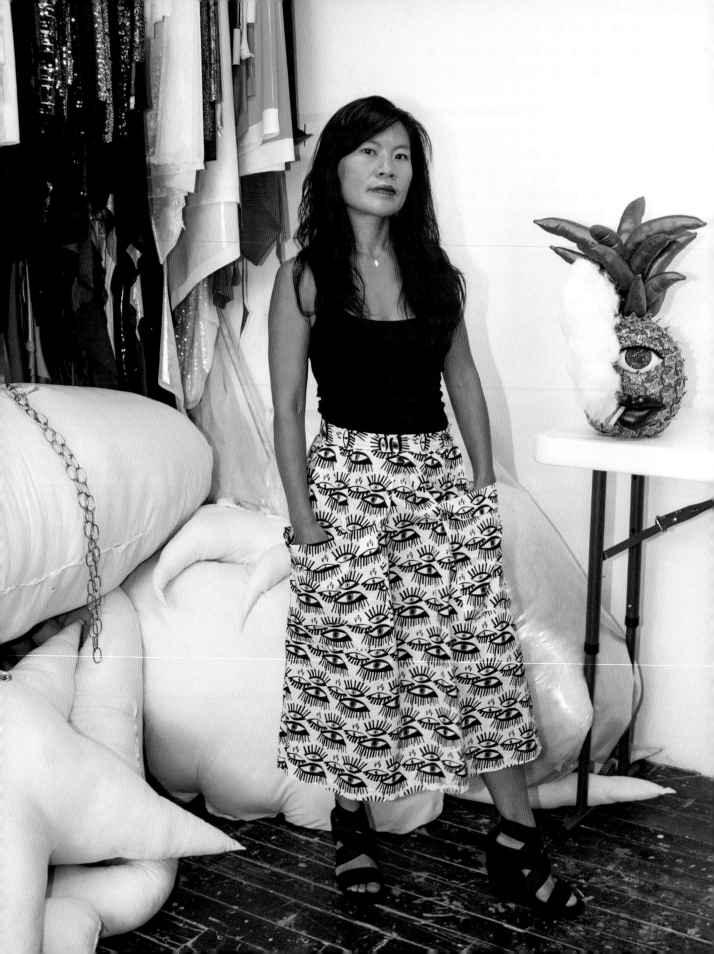

HEIN KOH

Contemporary Artist

Ice-blue teardrops dripping from tall flowers. A shiny fuchsia tongue hanging out of a cheeseburger. A trio of one-eyed hearts. Hein Koh's out-of-this-world soft sculptures are a feast for the eyes. One just can't get enough. The Brooklyn-based artist, wife, and mother of young twin daughters creates wild and vibrant art inspired by her kids' toys that carries fun, sexual undertones. The Yale MFA alum employs materials that are utterly glam—sequins, spandex, vinyl, and glitter—and Koh's sculptures burst with sultry colors and textures, evoking a visual orgasm. Influenced by pop art and surrealism, Koh is a Korean American feminist artist boldly investigating beauty, sex, and femininity.

How did art first enter your life?

Art was always a part of me. I remember building tall towers with blocks in preschool and painting self-portraits in kindergarten. I had a great art teacher from first through eighth grade, Mrs. Kriegel, who was hip, creative, and taught us about pop artists like Warhol and Haring. She really recognized and nurtured my talent all those years. My mom also signed me up for after-school art classes with a local Korean artist who taught me how to paint with acrylics and draw still lifes with pastels. When I started high school, I became much more academically-oriented and I felt I didn't have time for art classes, so I quit of my own accord. It wasn't until college that I reconnected with it.

◀ Hein Koh in her Brooklyn studio next to her sculpture *Smokin' Pineapple,* with a rack of glitzy fabrics and textiles hanging behind her.

When did you know that you finally made it?

I can't say I've had a moment when I thought I've "made it." I still feel like I'm emerging. However, being asked to show at Rockefeller Center was definitely a pivotal moment in my career. I felt like I finally owned a piece of New York City, after moving here twenty-one years ago. It was an honor to show my work at such an iconic New York City landmark with so much history.

What is the best piece of advice that has always stuck with you?

From experience, I have learned resilience is maybe the single most important factor when it comes to gaining success. Everyone gets rejected. I've been rejected a million times, but those who are able to pick up the pieces and keep going, despite adversity, find their way to success.

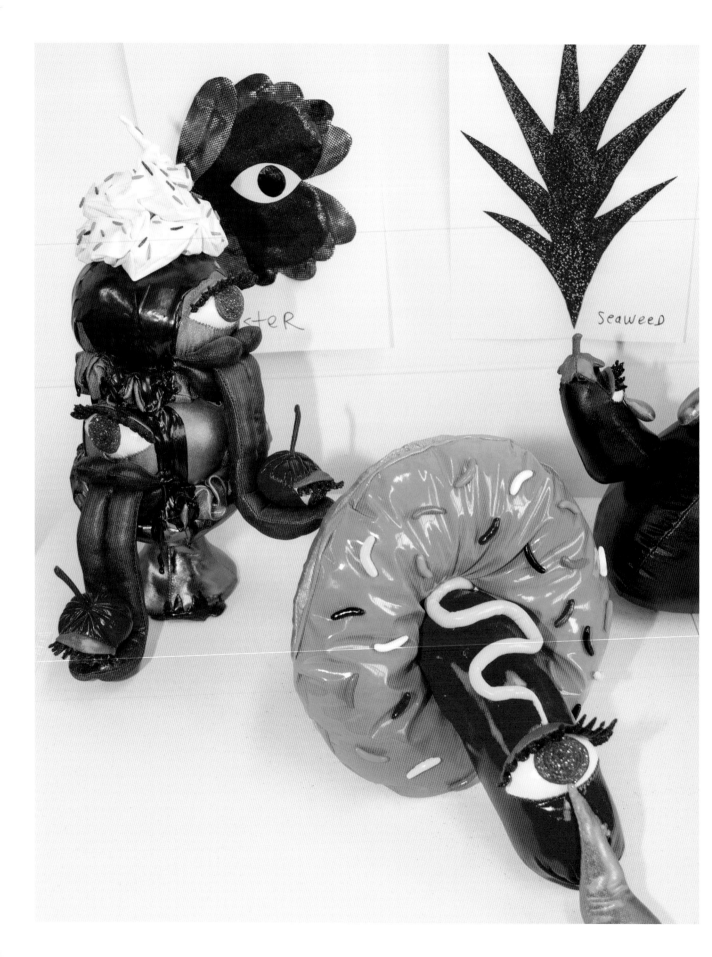

How has the Internet and social media been pivotal to your career?

Once I started getting more involved with Instagram, posting work and engaging with an art community, I made a lot of great connections, even good friends, and was offered a lot of great opportunities. I can't say I would have the career I have now if it weren't for Instagram. It increased my exposure exponentially and allowed me to build my career before I was showing a lot in galleries.

Your sculptural aesthetic is both surreal and cosmic. Where does this inspiration come from?

My inspiration comes from a number of different sources, some known and others unknown. I like the idea that I don't totally understand my own work—one's work should be a bit of a mystery, even to the creator. It's an amalgamation of many different experiences that make up who I am today. In recent years, my four-year-old twin girls have definitely had a huge impact on my work. I'm surrounded by color and glitter all the time, so that inevitably entered my work. I have also been influenced by one of my favorite childhood shows, *Pee-wee's Playhouse*, Tim Burton's films, and rave culture, which was so important to me in the mid-nineties. It all ties together in my work.

The shapes in your work are so soft and sensuous, like parts of a woman's body. Can you talk about this?

I never set out to make "feminine" work. It just naturally comes out of me, as a woman. Now that I have two daughters, I am sure my work is even more feminine. They helped me embrace femininity more than I ever have before. I never really

cared much for the color pink until my girls got me into it.

How do you think your art impacts womxn, especially young girls?

My work is unabashedly "girly," so it appeals to a lot of women and young girls. I'd like to think they feel they have a voice through my art, while so much of art history reflects the viewpoints of straight white males. I want young girls to know there is a place for them in the art world, that they too can make their dreams come true.

◄ Koh's soft and surrealist sculptures, from left: *Double Decker*, *Relationships*, and *Together But Separate*. Sketches for a Bronx Children's Museum commission are hung on the wall.

▲ Koh's tongue-in-cheek *Corn Taking Ecstasy*.

Extravagantly bright fabrics and textiles in Koh's Brooklyn studio.

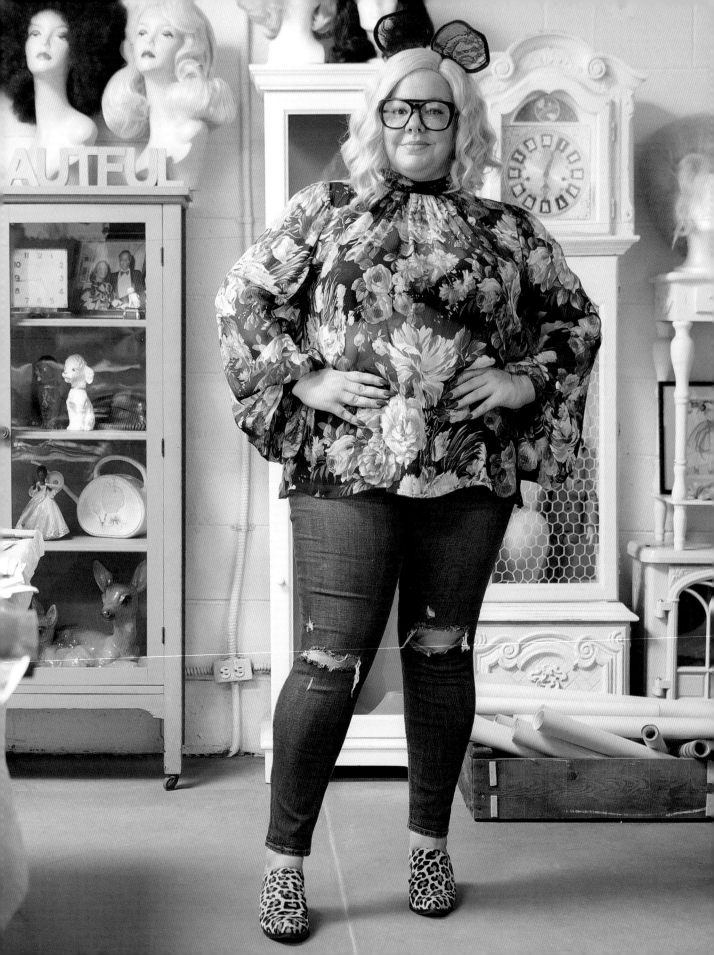

GENEVIEVE GAIGNARD

Contemporary Artist

"I'm Every Woman." Whether sung by Chaka Khan or Whitney Houston, this is the essence Genevieve Gaignard exudes in her captivating portraiture and installations. Gaignard traverses many identities and looks in her self-portraits—a demure churchgoer in her Sunday best, a coquettish Southern belle, or a grand dame in a vintage fur and auburn bouffant, holding a long slim cigarette. Every woman Gaignnard inhabits is self-assured, curvaceous, and dressed fabulously, while effectively unpacking clues on race, feminism, and identity. Born in Massachusetts, a Yale MFA alumna, and now based in Los Angeles, the biracial photographer and installation artist constantly remains provocative and badass.

What is the best piece of advice that has always stuck with you?
"Take an Uber, there's no good parking in Hollywood!"

How has the Internet and social media been pivotal to your career?
If I had to point to a specific moment in which social media had the largest material impact on my career, it would be the SPRING/BREAK Art Show in 2016. That exhibition was my first exposure on the East Coast outside of grad school and 2016 was an emerging moment for immersive "selfie" environments. The publicity I received due to people taking photos in my rooms was insane and completely unexpected. That experience had this beautiful democratizing effect, where folks outside of the art world ended up at the fair because posts they saw made it clear that my installations beg for participation.

Describe yourself in three words.
I would say mercurial (I'm subject to swift changes), messy (you should see my studio), and instinctive (my gut tends to serve my practice well).

When are you happiest?
I'm happiest when I'm working on a project and my decisions start affirming one another, snowballing toward a manifestation of my vision. For example, after weeks and sometimes months of collecting objects for an installation, I get to a point when I know I have everything I need and can start playing. It's an empowering transition.

◀ Genevieve Gaignard, an ultimate style chameleon, in her fashionable studio in Los Angeles.

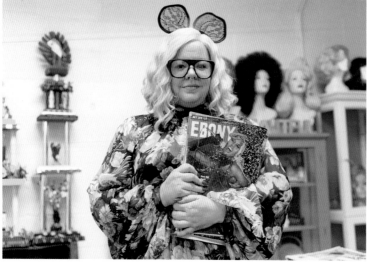

audiences into my installations before destabilizing them with less innocuous imagery. There's a safeness in the signifiers of a girl's childhood, and these often come in Laura Ashley-esque hues and patterns. My goal isn't to trick people, but rather to get them thinking about the painful, complex, and even exuberant histories that lurk beneath a Black girl's experience of the world—even in the relative security of the home.

The act of physical transformation and blurring racial lines is key in your photography. Why is it crucial to explore all these identities?

As a biracial woman, I navigate the world by how others see me. Playing up context clues through discrete hairstyles or facial expressions, postures or living spaces, I present not only the multiplicity of my own experience, but also the viewer's expectations of my characters. My personas can either comply with or resist the audience's worldview, and my iterations of self become graphable data for others to confront their own unexamined patterns of thinking.

Aside from personifying characters, you create worlds for them in your beautifully detailed installations. Why is this significant?

I straddle disparate worlds, so my characters have to as well. I think my installations are strongest as psychological spaces that expose the viewer's own assumptions about the type of person that would "live" in such an environment. Installations can end up being less about me and more about the audience and their own conflicts.

Who is your favorite fictional character?

Mrs. Doubtfire. Someone should have dressed as her at the 2019 Met Gala—a camp legend!

What is your favorite color?

I personally don't have a favorite color, I tend to build my own looks around my nail color on any given day. In terms of my practice, however, I gravitate towards whimsical pastels—pale pink, lavender, baby blue. These colors are deceptive tools, luring

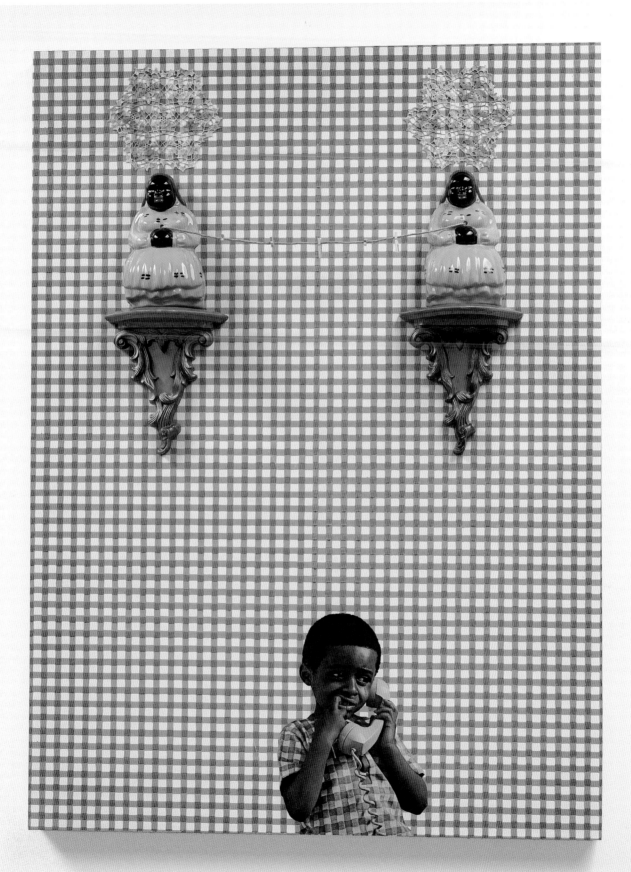

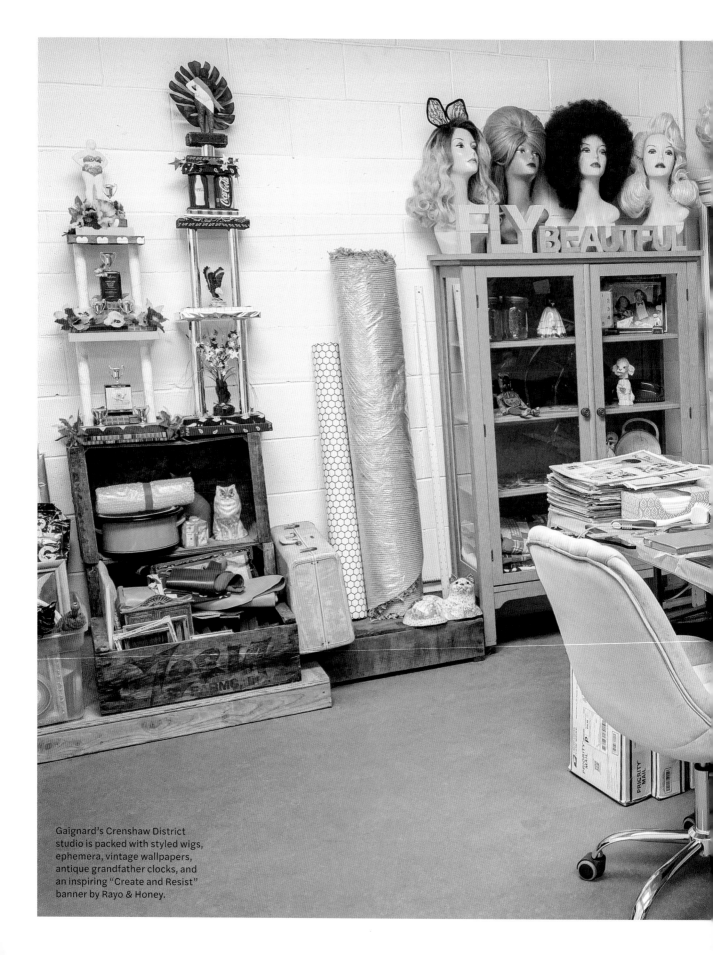

Gaignard's Crenshaw District studio is packed with styled wigs, ephemera, vintage wallpapers, antique grandfather clocks, and an inspiring "Create and Resist" banner by Rayo & Honey.

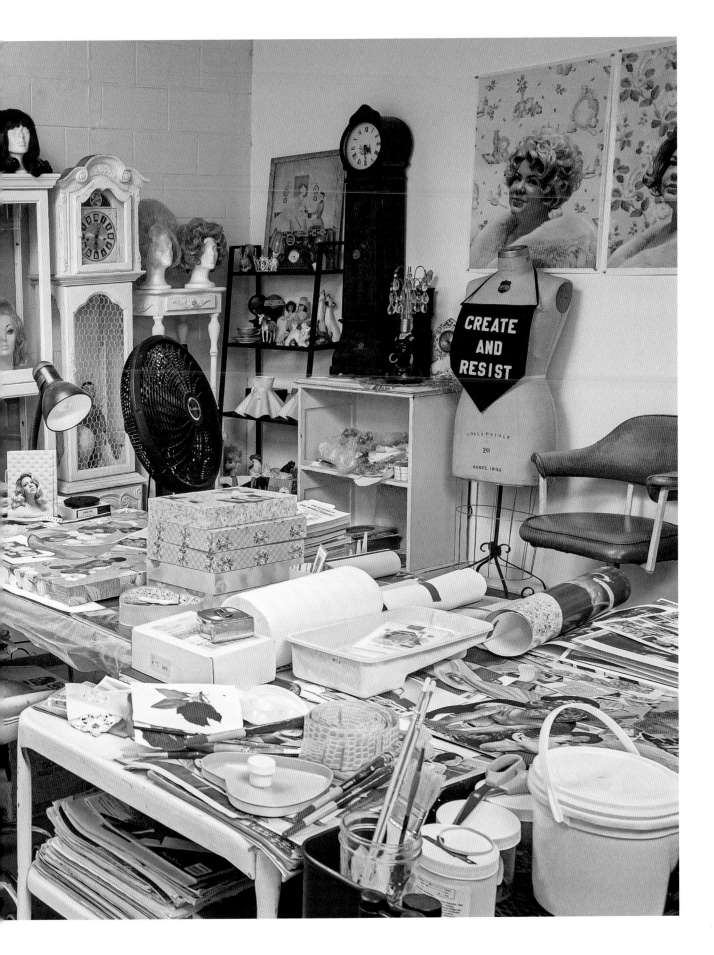

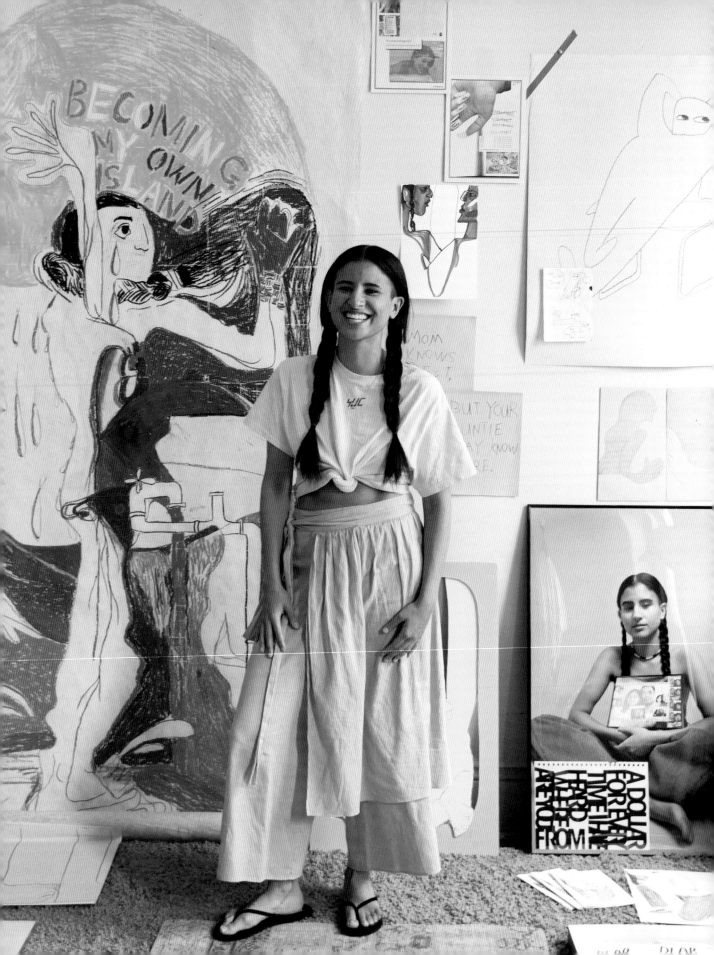

KT PE BENITO

Contemporary Artist and Programs & Operations Assistant at Queer|Art

KT Pe Benito's revelatory and intensely nuanced art unpacks layers of their personal journey as a biracial, nonbinary artist of the Filipinx diaspora. The Boston-born, New York-based interdisciplinary artist investigates their first-generation, immigrant-descending, queer identity in the US by turning their lens on the Pe Benito family, with a focus on their family matriarch, their late grandmother. In the work _Entries to Faustina (Growing out of colonialism for my grandmother's sake)_, bright beams of yellow pop throughout the installation, supported by intimate drawings, writings, collages, and a pensive self-portrait. A Cooper Union graduate, Pe Benito makes art, yet equally supports and advocates for queer, trans, and nonbinary artists through their work with Queer|Art. These are all of the ways that young artists like Pe Benito make the world move forward.

◀ KT Pe Benito in their former live/work space in Queens, New York, standing in front of their oil pastel, _Becoming My Own Island_ (2019), and excerpts from their multimedia installation _Entries to Faustina (Growing out of colonialism for my grandmother's sake)_ (2018).

How has the Internet and social media been pivotal to your career?

I have to recognize that the Internet makes the histories of queer artists of color accessible. I couldn't have learned about so many of them at this point in my life and education without it. As I continue to think through the validity of visibility, wages, and social capital we produce on these platforms, I'm grateful for the dedication that artists of color have in producing an expansive and intersectional creative culture. For a while, I was using social media as a place to publish my writing and post documentation of my art, but the censoring of our bodies via "community guidelines" and navigating artist copyrights has pushed me to change what I post. I'm now more invested in generating a multiplicity of online personas to resemble the multiplicity of my myself.

What kind of art world do you want to see in the future?

I don't think I want an art world to exist. For a while, I've struggled within the constraints of professionalism, and training to have the technique and language to speak about art. I'm grateful for that, but I also know art is for everybody and it comes from everybody. I met the choreographer and dancer keyon gaskin within the last year. In a printed program for one of their

performances, their bio read, "keyon gaskin prefers not to contextualize their art with credentials." It moved me to see this refusal to participate in art becoming a business practice. I want us to decolonize art so it can tell the truth.

Who is your favorite fictional character?

Based off of a historical figure from the racist franchise, Disney, Mulan is the first fictional hero that pops into my mind. Growing up as a young, queer, Filipinx-white hapa, I felt a lot of confusion as to which gender and cultural cues I'm supposed to follow in this body. Am I supposed to be straight and aspire to marriage? Am I even a woman in the context of what I'm told a woman is supposed to be? Seeing Mulan confront patriarchy and its binaristic gender roles was freeing for me. There has been, and there still is, an expectation for me to marry a Filipino man because of Catholic and Christian values that run in my Filipino and white extended families. Mulan struggles with belief systems, family, guidance, and autonomy like I do, while creating a reality through her own person and gender presentation, challenging and surprising herself in her own capabilities.

What is your favorite color?

Definitely yellow. It's already shown up in my artwork and performances as major themes because I can feel it all over me when I work with it. While I'm invested in its history as a derogatory term, joy sums up the dedication I have to the color. At EFA Project Space, Lukaza Branfman-Verissimo had an installation in a group exhibition entitled *Curriculum* where she displayed a stack of prints of the *As Bright As Yellow Manifesto*. This manifesto stuck out to me because it summarized yellow as resistance, as safer spaces, and as the existence of people of color. I want that urgency of yellow to always vibrate in my life.

Your installation, *Entries to Faustina (Growing out of colonialism for my grandmother's sake)*, is deeply personal, examining family history and your identity as a nonbinary Filipinx person. What self-realizations did you walk away with that surprised you?

I walked away from this project affirmed that I do not and will not share a

▶ A selection of Pe Benito's drawing, painting, and collage works (2016–19), and excerpts from their 2018 multimedia installation *Entries to Faustina (Growing out of colonialism for my grandmother's sake)*.

resemblance with anyone in my family. This might be a dismal response, but making my art has always come with these isolating realizations. I think it's because my family doesn't understand how I'm nonbinary or what it's like to be mixed, Filipinx and white. I guess I noticed this because my project included a lot of interviews and discussions with extended and immediate relatives about identity formation, which revealed where their biases and phobias are. I was hoping that sharing the knowledge of how Faustina Pascua lived her life would make me feel closer to my family, but instead I feel estranged, seeing how much white, ableist, heteronormativity is internalized by them based on what came out of our conversations.

With your role at Queer|Art, what are ways that you advocate for queer, trans, and nonbinary artists of color that are meaningful to you?

Even though a big chunk of my day-to-day at Queer|Art is emailing queer artists and art professionals for outreach and collaboration, I strive to remind myself why it is important to center queer, trans, and nonbinary artists of color in our work. Historically, we have been the forerunners of art and culture-making, fashion, movement-building, and real social change. However, we are constantly told that as queer, trans, and nonbinary people, and as people of color, that our input doesn't matter and neither does our livelihood, so we end up doubting ourselves and forget our worth. So I advocate that our influence and futurity matters.

"I want us to decolonize art so it can tell the truth."

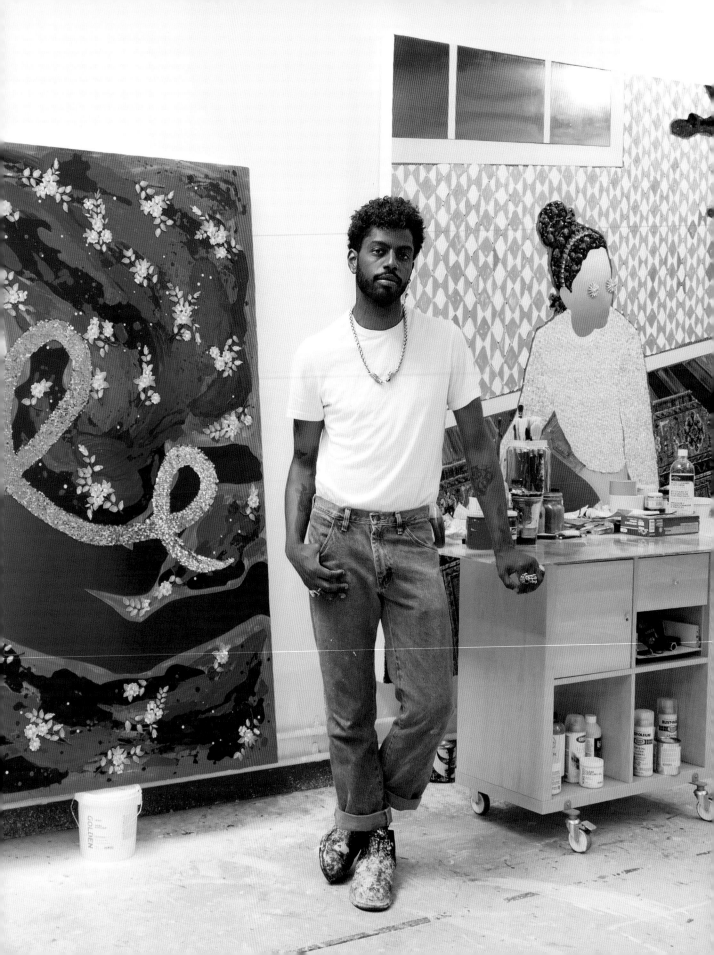

DEVAN SHIMOYAMA

Contemporary Artist & Assistant Professor of Art

Devan Shimoyama is a Philadelphia-born, Pittsburgh-based artist who features Black queer men as the protagonists in his lavish, mixed-media paintings. Black queer subjects primp, pose, or simply relax in quietude while outside in nature or inside domestic spaces. Shimoyama's world is an opulent one; his canvases are bedecked with materials like rhinestones, glitter, beads, and latex. In his collaged paintings, Black queer men and boys have a space within hyper-masculine barbershops. He memorializes fallen African American boys at the hands of police in his various sculptural hoodies and swing set installations accentuated with sequins and silk flowers. Shimoyama beautifully establishes a feeling of sanctuary within his work.

When did you know that you finally made it?

I always update the terms and conditions of what it means to have "made it," providing new goals to reach for myself and my artistic practice. But the first time I believed I made it would have to be the moment I accepted that there would be no alternative for my career and decided to change majors from science to art in undergrad. That commitment to an art practice irrevocably changed the course of my life.

What is the best piece of advice that has always stuck with you?

My professor Brian Alfred told me, "Do you really want to do this? Then you've got to work harder than you have before. Dedicate time and learn to love being in your studio." It helped me treat my studio as a place that saved me from boredom, an incubator that transforms idle thoughts through creative practices.

How are you actively changing the art world?

Through teaching, I've been able to aid in the sculpting of emerging young artists. Teaching has also been an exchange in which my own practice has progressed and grown in unexpected ways over the last five years.

Describe yourself in three words.

Sagittarius. Brown. Introvert.

◀ Devan Shimoyama in front of two vibrant works in progress in his Pittsburgh studio, located on the Carnegie Mellon University campus.

Who is your favorite fictional character?

Currently, one of my favorite fictional heroines would have to be Onyesonwu, the protagonist in Nnedi Okorafor's *Who Fears Death*. She is a result of misogynistic violence (a child conceived by rape), and she undergoes another violence to her body by way of a ritualistic, juju-tainted clitoridectomy, which sets her on a journey of learning magic and taking agency over such violence. She heals herself and other young women with the resulting magic.

comfort, beauty, and strength, such as costume jewelry, glitter, and rhinestones from both drag queens and women dressed in their Sunday best for church.

Your aesthetic is inspired by drag culture, fashion, and fantasy. Why has this been important in your work?

Drag culture traditionally exists in safe spaces for queer and othered communities. It's a performance art form that celebrates three of my favorite things—illusion, fantasy, and fiction. These constructed fantasies often deal so much with surface, synthetic

▲ (left) Artistic details in Shimoyama's studio. (right) Detail of work in progress, *Auntie's Ribs and Macaroni Salad* (2019), mixed media on canvas.

▶ Detail of work in progress, an untitled hoodie sculpture exploding with vibrancy and shine, including silk flowers, jewelry, and rhinestones on linen.

In your barbershop paintings you explore masculinity by featuring Black queer men as stars. What made you want to tell these stories on the canvas?

Inspired by Kerry James Marshall's painting *De Style* and Pepon Osorio's *En la barberia no se llora*, I found myself constructing a fantastical version of a place in which I had never felt particularly welcome as a queer person. In those works I use visual cues that nod toward individuals who represent

glamour, and beauty, which reminds me so much of beautiful Black church ladies and other amazing Black women in my life. It also reminds me of hip-hop culture's aesthetic and fashion with large, flashy jewelry and clothing. Drag culture mirrors so much of its daytime counterpart, where many people don't even realize they're active participants in such displays of gender performance.

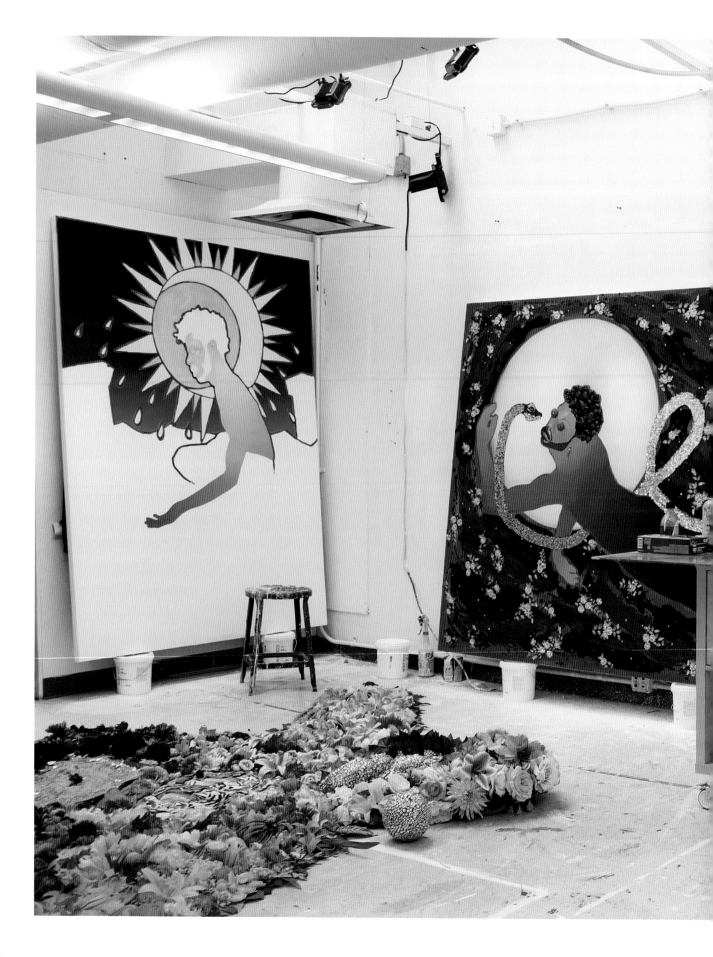

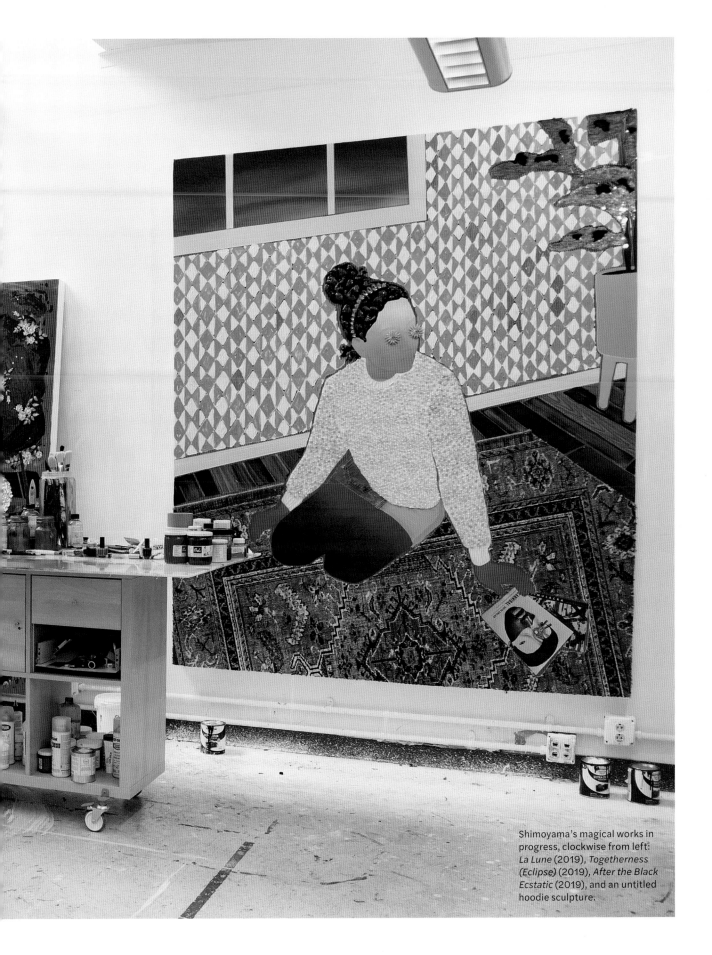

Shimoyama's magical works in progress, clockwise from left: *La Lune* (2019), *Togetherness (Eclipse)* (2019), *After the Black Ecstatic* (2019), and an untitled hoodie sculpture.

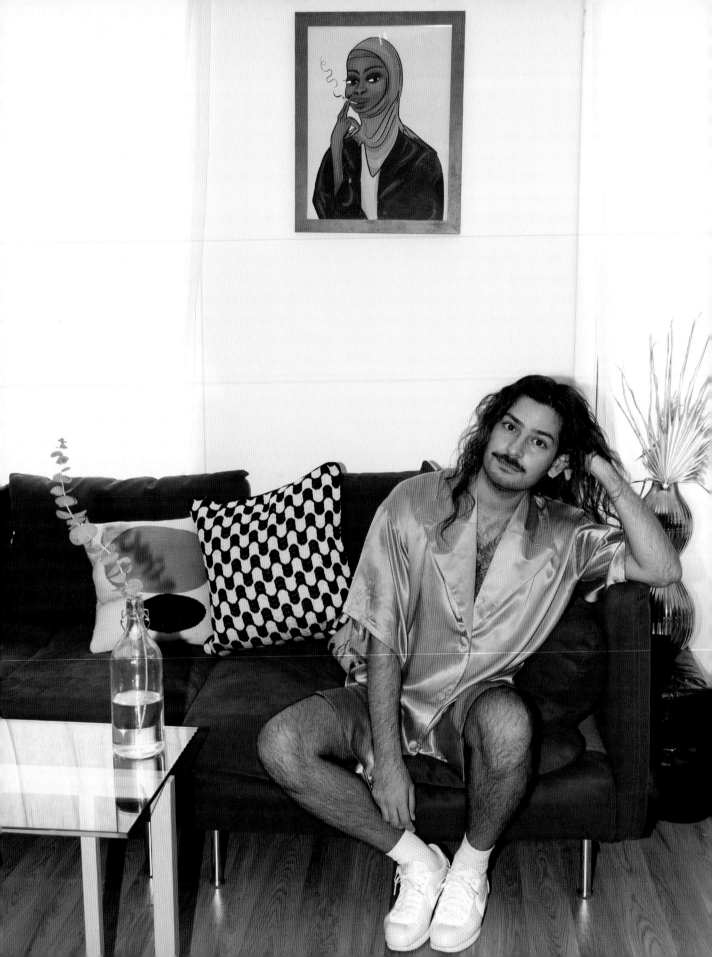

MOHAMMED FAYAZ

Illustrator & Community Organizer

Mohammed Fayaz's illustrated universe is a world that is Black, Brown, queer, trans, and simply spectacular. Fayaz depicts QTPOC in his art with humor, warmth, vulnerability, and booming authenticity. His subjects are incredibly real and accessible. It feels like you can talk, touch, laugh, kiki, and dance with them. The Queens-born and Brooklyn-based creative is also a part of Papi Juice, a QTPOC art collective that creates safe spaces in nightlife, serving as its art director and social media guru. Through the various expressions of his art—event illustrations for Papi Juice, magazine editorials, special commissions, exhibiting in museums—Fayaz is breaking ground and setting the tone for QTPOC's visual representation.

What is the best piece of advice that has always stuck with you?

The best advice I've ever received is "the work has to be good, always." I know that sounds easy, but it has really helped me clarify the type of work I'm making, who the work is for, and whether it actually meets my standards or if I'm just signing off on something to be done with it. This has led to many late nights poring over details or a certain color, or having to redraw entire limbs or characters. It's been worth it every single time. The work has to be good, always.

How has the Internet and social media been pivotal to your career?

As a college dropout, I can definitely attest to the power of social media in its ability to help me circumvent all the typical art, media, and publishing gatekeepers I would've

otherwise had to navigate ten or twenty years ago. Being able to leverage things like Tumblr or Instagram to share my work is really freeing, in that I can share my work and let it be carried as far and as wide as it wants. I've definitely leaned into the importance of having a social media presence to expand both my portfolio and clientele. I think by now we all know the pitfalls and traps of social media, so identifying those for what they are and keeping it moving is the best way to engage with these platforms.

How are you actively changing the art world?

I strongly believe that if you have a talent you're passionate about, there is an underlying skill present that can be honed and developed. If you know you have something to say with your very special, unique, and

◀ Mohammed Fayaz is pretty in pink in his Brooklyn home, in front of one of his illustrations.

inherently individual voice, there is unlimited potential in what you're capable of. If I can be a blueprint for one queer, nonbinary, or trans person who sees themselves in me or my work, then I would feel extremely complete.

When are you happiest?
On the dance floor with a cutie and the DJ is playing our damn song. It can be a room of a thousand people and I can feel the world slow down just for us.

What is your favorite color?
The deep, rich orange of turmeric (*haldi* as we call it in Urdu). I'd always thought turmeric was a bright yellow until my first time in India as an adult when I realized just how rich the color actually is. It's earthy and bright all the same, and I can always feel its kick on sight.

In your illustrations, you beautifully center QTPOC youth sharing intimacy and appearing carefree and joyful. What responsibility do you feel in presenting your community to the rest of the world?
I feel an enormous responsibility when choosing to depict this community, especially when portraying groups and cultures I'm not a part of. I want my work to depict the original intent of the phrase "people of color" (originally "women of color" as coined by a group of Black women activists at the National Women's Conference in 1977). It's not about being born non-white, but rather living in solidarity with other people of color in our joint and separate struggles. I see this living as extending past the streets and traditional activism, and seeping into our kitchens, our bedrooms, our dance floors, our backyards, and beyond. It exists, it's happening, and I see a responsibility to document it so they can never tell us it didn't happen.

Papi Juice is a QTPOC art collective immersed in nightlife and community activism that you joined in 2014. What have been some dope and standout moments?
Quitting my job last year to be a full-time Papi is something I never would've dreamed of, but once I made room for our baby to take up more space, it gladly followed my lead. Some of my ultimate highlights would be Princess Nokia stage diving at our three-year anniversary, booking over twenty-seven artists for our World Pride function, and having seven of our pieces included in a survey of contemporary queer art at the Brooklyn Museum in 2018. Honorable mention goes to our Halloween party in New Orleans—bounce music will have you shaking down in ways you didn't know you could.

▼ A full view of Fayaz lounging in his living room with bold accents.

▶ (top) Fayaz's rich body of work for Papi Juice, museum projects, commissions, and more. (bottom) Fayaz's collection of fashion accessories, trinkets, and beautiful objects.

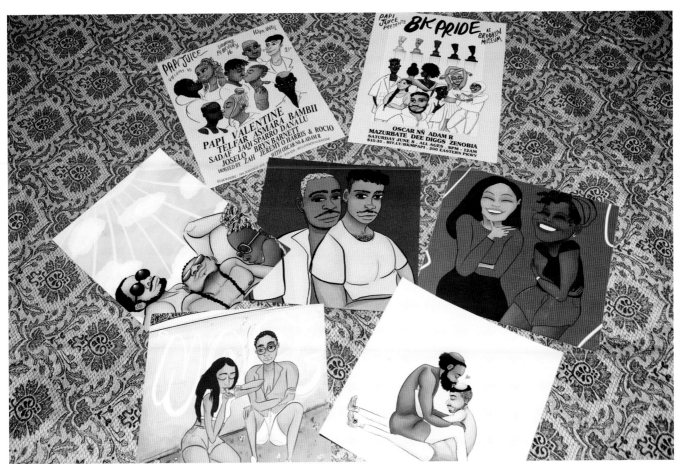

RAMIRO GOMEZ

Contemporary Artist

Ramiro Gomez is a young, queer, Chicanx painter who lives and works in Los Angeles, and prioritizes the voices of invisible Brown immigrant laborers. Born in San Bernardino to Mexican parents, his father a trucker and his mother a school custodian, Gomez is an organic voice raised with these lived immigrant experiences. During his time as a live-in nanny in Los Angeles' poshest hoods, Gomez observed the social separations between wealthy employers and their employees and processed those uneasy sentiments. Gomez responded by staging acrylic cardboard cutouts of everyday gardeners and janitors around West Hollywood and Beverly Hills, and by painting workers into glossy ads from luxury shelter magazines. Using a clever and bold approach, Gomez's position is confrontational and unwavering about immigration and race in the US.

When did you know that you finally made it?

There definitely was a switch that happened where I went from painting as a hobby on the side to making it my main focus, and that was probably around the time of my first solo show with the Charlie James Gallery in 2014. The Museum of Contemporary Art San Diego acquired my *No Splash* painting from that show, and the feeling of success came soon after when I was able to take my parents to see the painting on display next to an Ed Ruscha work.

How has the Internet and social media been pivotal to your career?

When I was working as a live-in nanny, I had a lot of emotions throughout the day that I needed to find an outlet for. It wasn't easy dealing with twins, the family dynamics, and the isolation inherent in the job. I would listen to music while working, singing and dancing with the kids at random moments. I tended to change the lyrics to songs to describe my job routine, and so I decided to create an anonymous Twitter account called @TheMannyDiaries where

◀ The stylish and stunning Ramiro Gomez in his Los Angeles studio.

I would post my reinterpreted lyrics. I'd take a pop song like, "Look At Me Now" by Chris Brown, and say, "look at me now, ey, I'm changing diapers."

This eventually led me to start the blog Happy Hills, where I added my magazine collages and domestic labor paintings. It was helpful that Instagram came around then because it certainly expanded my reach, and continues to do so as I maintain my focus on labor and paintings. It's been great to receive photos from friends and other folks that come across scenes in their daily lives that remind them of my work. It's very important to me to create consciousness of labor, and so my daily Instagram feed acts as both a sketchbook and platform to reach folks around the world.

How are you actively changing the art world?

My first time exhibiting was with the gallery P.P.O.W. at Art Basel Miami Beach 2017; a large painting of mine depicting nannies working at Madison Square Park in New York anchored the gallery's booth. The display of the painting was only the first part of my project, *Just For You;* I also actively painted the janitorial staff and other laborers at the Miami Beach Convention Center I observed. It was incredibly fulfilling to then go out and give my small paintings to the laborers themselves, surprising them in the mundanity of their work day. There are many invisible barriers that are inherent in the art fair model, but bringing the custodians into the booth, letting them actually pause and see the art they are maintaining, and drawing them into the conversation is a fulfilling part of my practice. I made many connections and activated the space in dynamic ways. Janitors were hearing about my painting gifts and were coming in to pose for me as well. When I exhibited in P.P.O.W.'s booth the following year, with paintings about the Expo Cleaning Services workers, some had unfortunately not returned, emphasizing the precarious and ephemeral nature of the job. By no means do I take that as clear proof of my role in changing the art world, but I do realize that the act of bringing in a custodian to pose for me amidst the Art Basel crowd, or see a janitor proud to see a fellow coworker elevated to a painting, stop in briefly, and give a kiss and hug to the gallery owner is a power I'm harnessing.

▼ An inspiring corner in Gomez's studio, filled with books and various works in progress.

▶ A cool close-up of a work in progress.

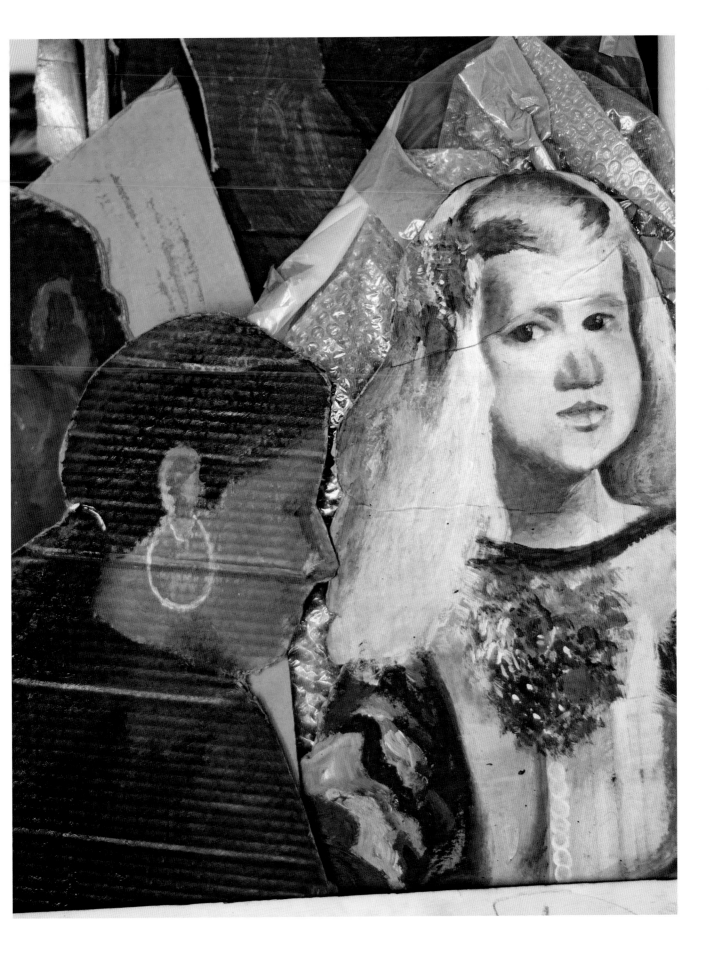

When are you happiest?

I'm happiest around animals. I grew up obsessed with National Geographic and other animal documentaries, and feel my full sense of wonder and awe. Whether I'm watching at home, at a zoo or aquarium, or out in nature, nothing compares to the feeling I get when I come across them. My favorite animal is the orca, which I've never seen in the wild, but it's a dream that will be beyond thrilling to my soul once I do experience it.

Who is your favorite fictional character?

The *Mighty Morphin Power Rangers* really drew me in and inspired my creativity growing up. There was something about the show's battle between good and evil, of friends coming together, and the inherent struggle to maintain a secret identity, which I particularly identified with as a closeted gay first-generation child of Mexican immigrants. Of all the *Power Rangers*, my favorite was Billy the Blue Ranger, played by David Yost, especially once I heard he himself maintained his gay identity a secret on the show. A further secret was that I also really loved Kimberly the Pink Ranger. The two sides of my personality, the masc and the femme, is something I'm currently going through. I'm learning to embrace the parts of me that I tended to hide.

◀ (top) Gomez plays with his palette of pretty hues. (bottom) Gomez sits in his studio surrounded by his art, which highlights Brown immigrant life and labor in the US.

> **"They remind me of my own family members, the conversations and experiences I had with them on the job shaped my urgency to paint them."**

What is your favorite color?

I'm really drawn to the color blue. It's melancholic in nature, it's the serenity elicited by water. I particularly favor Yves Klein Blue, midnight blue, and the darker tones of Picasso's Blue Period.

Why did you decide early on to highlight Brown immigrant workers in your depictions of Los Angeles in your art?

Los Angeles is so expansive and multicultural, which is very rarely depicted on screen in Hollywood movies or television. As a live-in nanny working in Hollywood Hills, West Hollywood, and Beverly Hills, it's always strange to see the transition between the people that live there and those that only work there. They remind me of my own family members, the conversations and experiences I had with them on the job shaped my urgency to paint them. To work with a housekeeper from Puebla, Mexico, with a degree in economics who cleans houses in Los Angeles due to many factors, is a difficult thing to process. It feels like stories are written and movies are made about everything except the very employees of the industry. To me, they are the center—the stars—and so I choose to focus on them, to drive these stories forward and record their contributions in art history.

DAVID ANTONIO CRUZ

Painter & Performance Artist

David Antonio Cruz's art is emotionally charged, overflowing with sex, intimacy, and remembrance. A Philadelphia native of Puerto Rican descent based between Brooklyn and Boston, Cruz unapologetically centers QTPOC narratives both in his paintings and performance art. In his paintings, Cruz reveres slain TWOC, who appear royal and resplendent in domestic settings. He presents gender-fluid POC subjects holding, cherishing, and embracing one another in his colorful canvases. The Pratt and Yale alum draws inspiration from queer icons like Mario Montez and Federico García Lorca. Cruz investigates the various intersections of queerness, gender, and race—all of it—from the complicated, to the beautiful, to the heartbreaking.

When did you know that you finally made it?
I'm always moving that line or marker. Every day I'm a little closer to the things that I want for today and for the future. And every day I am a little further away from the things I wanted and dreamt of yesterday.

What kind of art world do you want to see in the near future?
Art that includes all of us, is about us, dreams of us, and lives as us without the need for labels.

Describe yourself in three words.
Warm, dreamer, and intense.

When are you happiest?
I'm happiest when I'm in my studio painting. I love the process, the materiality, and the act of creating something new.

Who is your favorite fictional character?
I love broken characters, those that are longing for something they have seen or could possibly imagine.

What is your favorite color?
My favorite colors this season are Egyptian purple and radiant pink. They are both dense, yet warm and full of many possibilities.

◀ David Antonio Cruz in a performative stance while wearing a Joey Terrill Maricón t-shirt at Project for Empty Space in Newark, New Jersey.

In your paintings, you honor TWOC and queer bodies of color. How do you depict nuance of these communities through your work?

The *returnofthedirtyboys/girls* and the *wegivesomuchandgivenothingatall* series not only seek to lay bare the glaring systemic violence against the queer and trans community, but also strive to revive the individuality, beauty, and humanity of each slain victim while addressing race, class, and homophobia. The work is framed through fashion, pop culture references, and queer and subversive language to create a world that belongs to us—a place to tell our stories and our history, a place to be seen and heard.

How do you explore identity and representation in your work as a queer Latinx performance artist?

My work is always filtered, and constructed through a queer, Black, and Latinx lens. Language, queer Black and Brown culture, and history are a crucial part of my work. The operatic performances borrow from queer texts, plays, and films to construct visible queer narratives and to expose forgotten histories. The performances fuse multiple texts with pop culture references and personal narratives of coming out. The multilingual performances clash high art against queer slang, playing with language, music, and double entendres particular to Latino and Black underground gay culture.

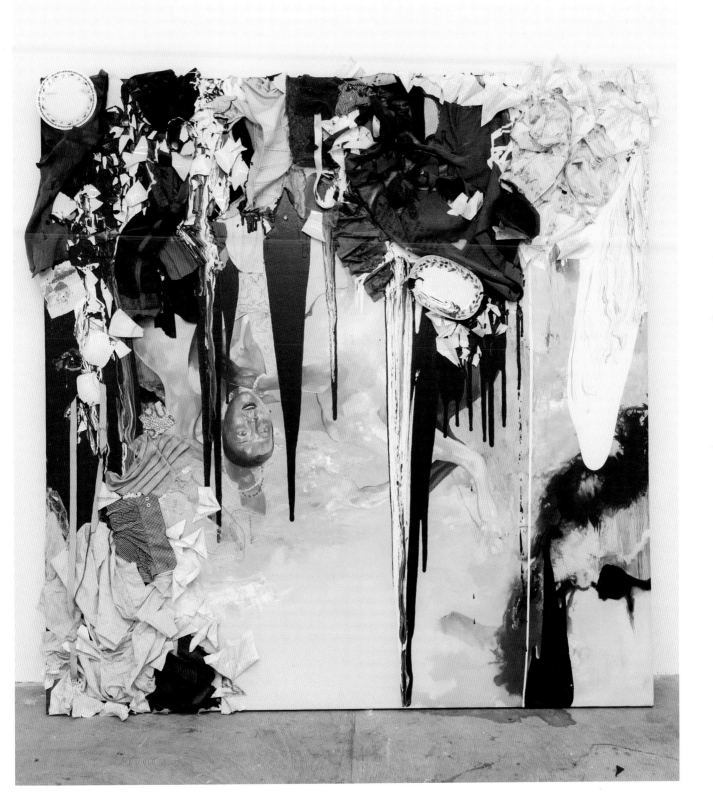

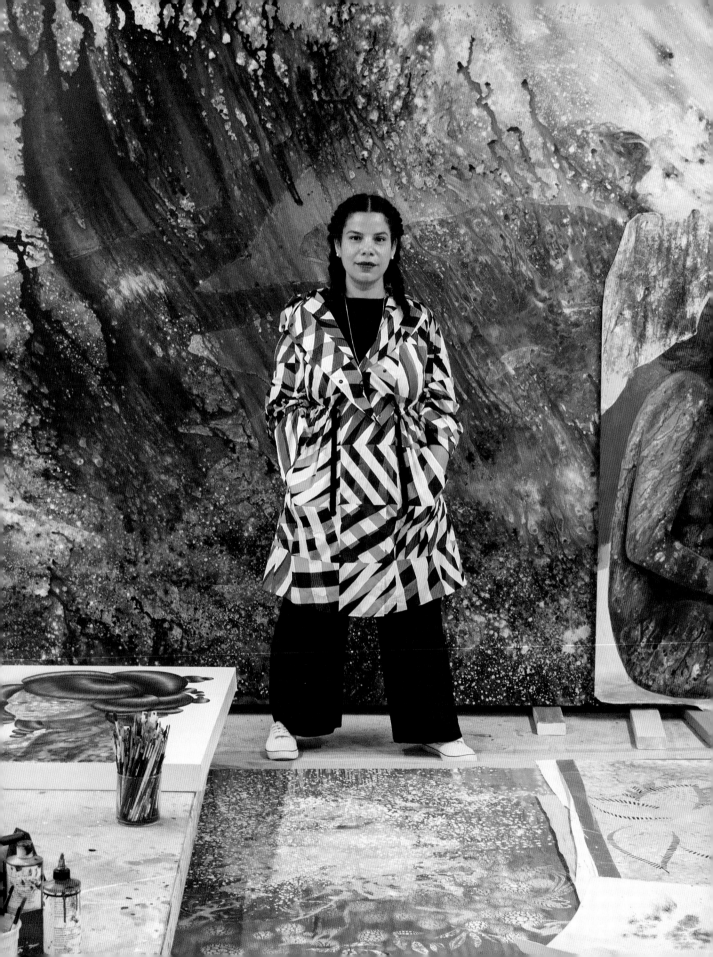

FIRELEI BÁEZ

Contemporary Artist

Firelei Báez creates epic art about epic Black womxn. The narratives in her art orbit around histories of radical Black womxn known and unknown, yet bold and intrepid. The Dominican-born artist of Dominican and Haitian descent carries a rich personal Caribbean connection, raised in Dajabón, Dominican Republic, followed by Miami, and surrounded by the womxn in her family. For the New York-based Báez, her personal journey plays out in her art—Caribbean folklore, Afro-diasporic storylines, uplifting Black womanhood, and the nuance of overlapping identities. Báez, an Afro-Latinx artist, through her paintings, murals, and installations, has cultivated a dynamic voice for the complexity of Black womxn.

When did you know that you finally made it?

For me, making it means full immersion into the thing you love. I don't think there is such a thing as officially making it in the art world. The closest feeling to that is reaching a point where I'm able to dedicate one hundred percent of my time to the craft I love without needing a thousand side hustles. I have had the privilege of being a full-time artist for the past five years.

What is the best piece of advice that has always stuck with you?

Not to wait until I feel one hundred percent ready to launch new ideas or to put myself forward as a candidate for projects. Women in particular are taught to be overly cautious. There were so many projects I held myself back from because I wanted to be a thousand percent sure, then I would see these

◀ Firelei Báez in her Bronx studio, wearing an Akris jacket, surrounded by her epic art, all works in progress.

super-chill guys—who were probably thirty percent sure—put themselves in the running and be carried through by their networks. The daily honing of one's craft, a constant readiness, will many times carry you the rest of the way. I now make sure to be a part of support networks, to help other artists carry their ideas through. Sometimes doing this can be as simple as being transparent, just sharing your process so they don't have to reinvent the wheel or be as intimidated by the process.

How have the Internet and social media been pivotal to your career?

It has certainly sped up the cycle of consumption of new series. I'm not sure yet if this has been for good or bad. It definitely keeps me on my toes. I appreciate the generosity of the medium, whether constructed or not, in sharing process and inspiration, not just the big heroic moments.

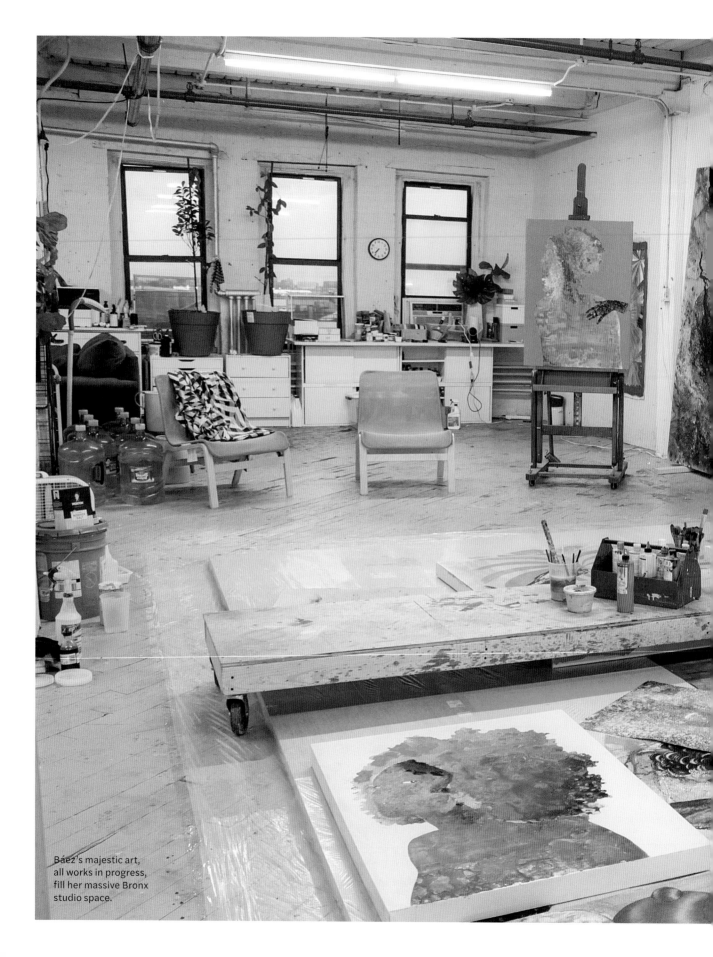

Báez's majestic art, all works in progress, fill her massive Bronx studio space.

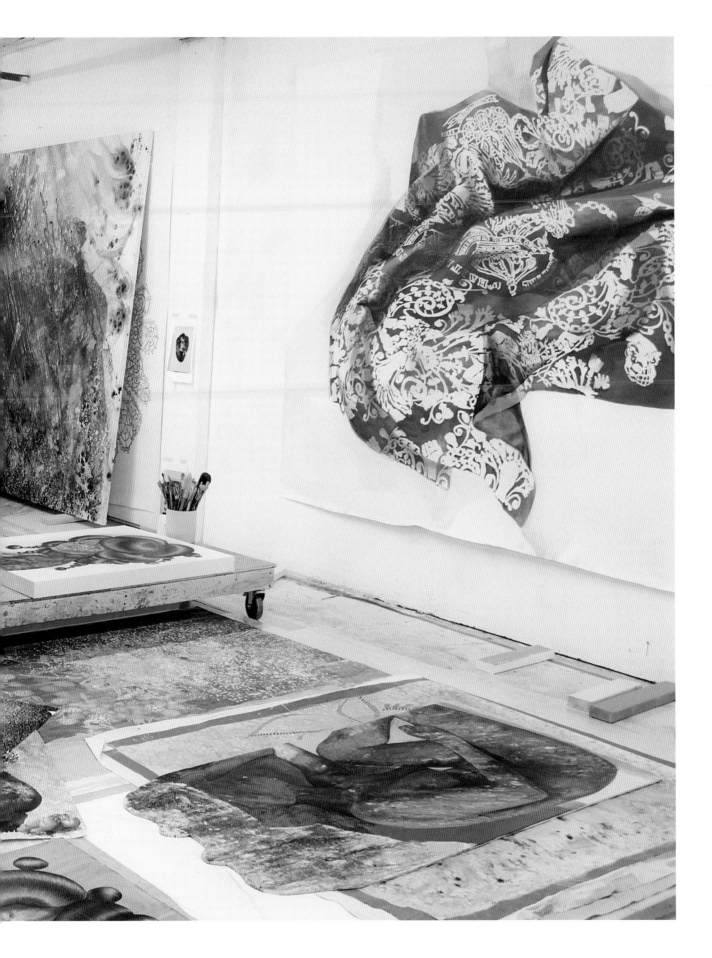

What kind of art world do you want to see in the future?

There are many art worlds already coexisting within strict hierarchies. I would love to see work by Latinx artists who were either born or raised within the US be more acknowledged and celebrated as Latinx. As things are now, many such artists have had to reduce their rich, multivalent identities or are boxed into other more known labels. Think of Basquiat, Carmen Herrera, Teresita Fernández, or Gordon Matta-Clark.

Who is your favorite fictional character?

It's actually a nonbinary character named Jodah from Octavia E. Butler's *Imago*, a novel from her *Lilith's Brood* series.

▼ Color is key in Báez's kaleidoscopic feminist paintings.

▶ More of Báez's wondrous works in progress, which consistently center Black womxn.

"I would love to see work by Latinx artists who were either born or raised within the US be more acknowledged and celebrated as Latinx. "

You've created a magical universe that revolves around Black womxn, Caribbean folklore, and female empowerment. Why did you combine these elements in your work?

These were a matter of fact during my upbringing. I wanted to celebrate and share the power and beauty found within that with the rest of the world.

So much of your art centers on forgotten, yet pivotal Afro-Latina and Afro-Caribbean womxn in history. What are the stories that push you to create your work?

Usually those that echo the badass women that surround me. For instance, I was originally drawn to the history of the Tignon sumptuary tax law in 18th century Louisiana after processing the shock of the recent military ban on protective hairstyling for Black female ensigns. I wanted to really dig deep into this national urge to police women's—in particular, Black women's—bodies, even when they are risking life and limb for their country.

The Tignon laws were put in place during the late 1700s to essentially outlaw free Black women's bodies by forcing them to cover their hair with headscarves. This signaled that, despite their independent wealth and agency to free their family members, they were not part of the elite but closer to the house slave. These women responded by turning this symbol of oppression into an emblem of beauty and power, so much so that it became a fashion statement in Europe and a staple of stylish outfits in the Caribbean for several centuries. I want to highlight that fierce creativity and clearly link our inherited arsenal of tools for resilience and self-healing with the ways we can pass these same tools on to future generations.

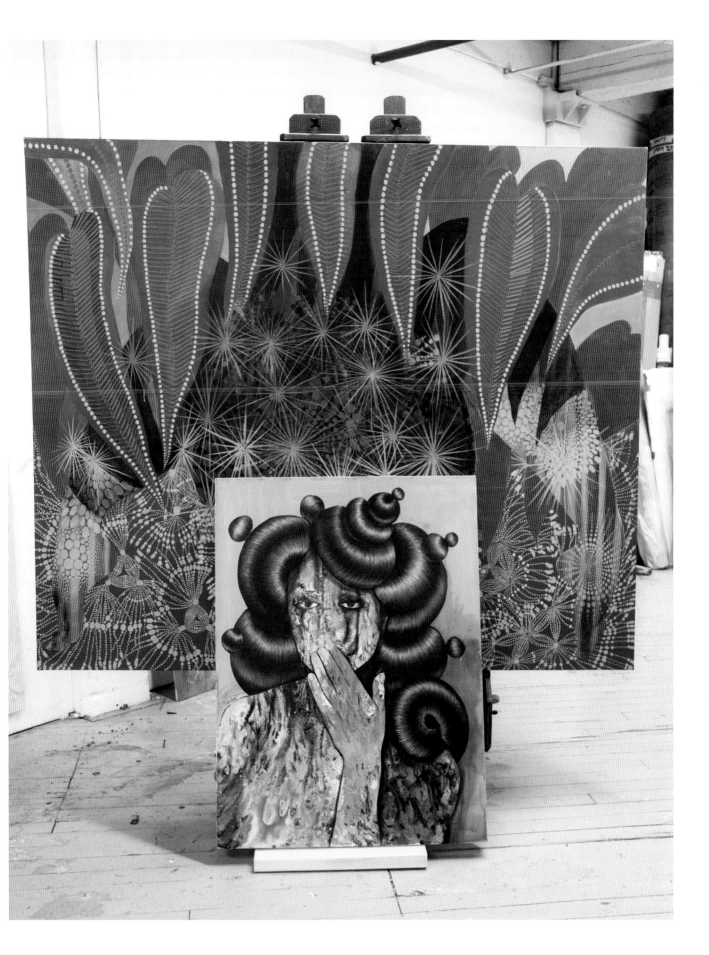

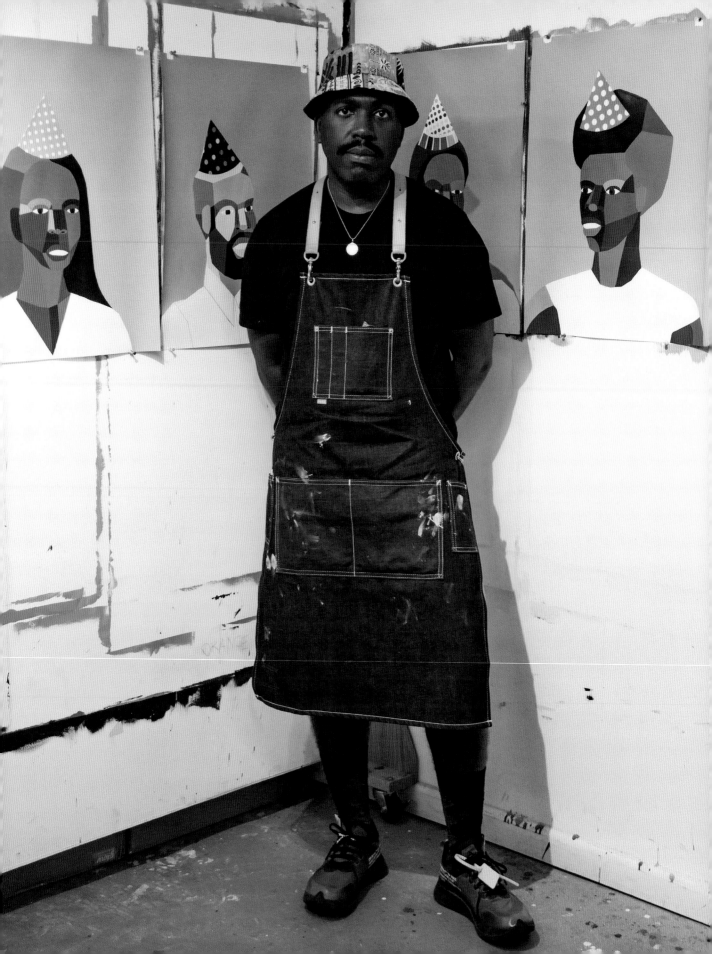

DERRICK ADAMS

Multidisciplinary Artist

Derrick Adams is a prolific powerhouse artist. A simple and undeniable fact. Adams excels in all of his numerous disciplines: painting, photography, performance, video, sound, mixed-media collage, and multimedia sculpture. The Baltimore native and Brooklyn-based artist creates art across many mediums with a consistent focus—the beauty and celebration of Blackness. Adams enraptures the viewer with his use of vibrant patterns and bright textures, all while unpacking important ideas involving Black pop culture, African American history, and Black cultural wealth. Winning many well-deserved accolades, Adams is a critically acclaimed and influential global artist, pushing the cultural needle with every new body of work. What a time to be alive and experience Derrick Adams's art.

When did you know that you finally made it?
It's hard to quantify. I have a big new studio and I'm selling work, but I'm too deep in it to make an observation on my progress. As my friend musician Dayo says, "You gotta grow till the day you die."

What is the best piece of advice that has always stuck with you?
I've received a lot of good advice, but the most affirming came from Elizabeth Catlett. I met her at her book signing in 1992 at Morgan State College and she told me to "make art every day."

Describe yourself in three words.
Never not ready.

Who is your favorite fictional character?
Mariska Hargitay's character Olivia Benson on *Law & Order: Special Victims Unit*. She's opened my eyes to the many ways people are victimized. I love her support of victims and their rights, and her determination to right a wrong.

What is your favorite color?
Gray has many qualities. I picture it between all colors.

◀ Derrick Adams in his Brooklyn studio, in front of his joyful Black portraits, mixed media on paper, all works in progress (2019).

▲ Detail of a 2019 work in progress, a mixed media collage on paper titled *A Little Off the Shoulder*.

▶ Adams in front of 2019 work in progress, *A Little Off the Shoulder*, a mixed media collage on paper.

Your art celebrates Black joy and exuberance, enjoying leisure, summertime activities, and so on. Why has this been key?

I felt it was important to show that as a culture, regardless of the many obstacles we face, we also know joy.

You've created work based on the legacy of fashion designer Patrick Kelly and have collaborated with the influential brand Pyer Moss. Can you talk about art, fashion, and Blackness in your work?

We are a community rich in every area of creativity, fashion included. So for me, clothing is simply another medium.

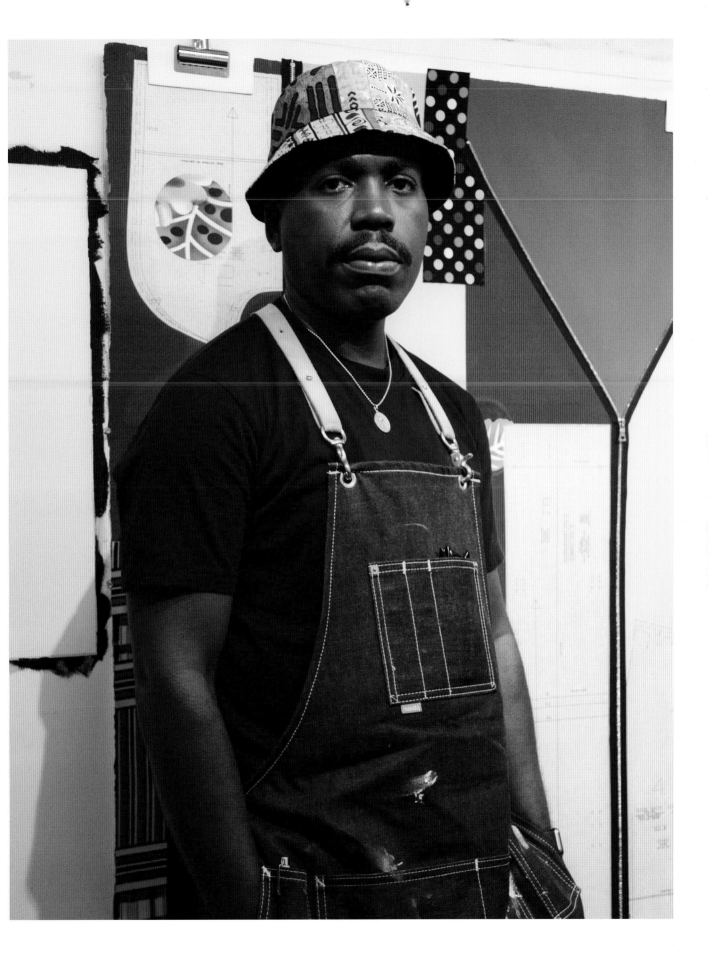

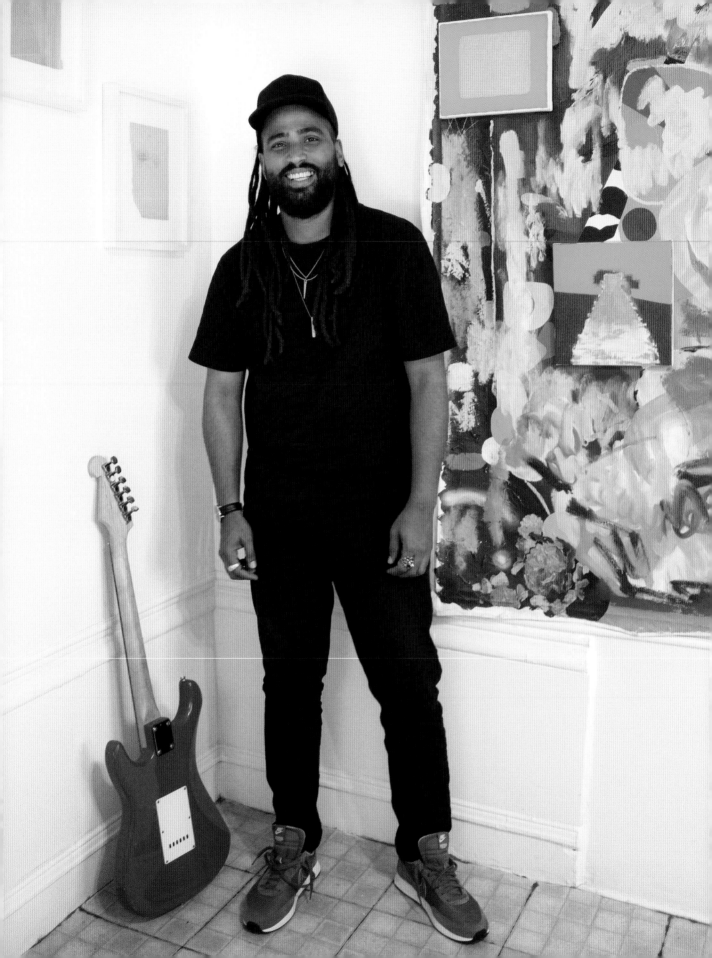

DANNY BÁEZ

Co-Founder and Galleries & External Affairs Director of MECA

Dominican-born Danny Báez navigates the art world with panache, humor, and uptown swag. The New York-based curator, art fair entrepreneur, and cultural producer collaborates across a slew of creative projects with a Latinx and Latin American focus. Báez earned his stripes in the New York art world as a studio assistant for the Thai artist Rirkrit Tiravanija, followed by several years at the influential gallery Gavin Brown's Enterprise. Báez spent nearly a decade honing his art career at GBE, jetting off to global art fairs in Miami, Mexico City, and Buenos Aires. Today, the Santo Domingo native and Tony Rodríguez are the founding duo behind the MECA art fair. Founded in 2017, this young, ambitious, and eclectic art fair in Puerto Rico has a deep focus on Latinx, Latin American, and Caribbean artists.

When did you know that you finally made it?

I firmly believe that the moment you feel you have "made it," your brain automatically shifts into the comfort zone, falling deep into a monotonous cycle of obsolete ideas. Or the lack of it. I don't feel comfortable thinking that I made it already. Even after MECA became a real thing, when the first edition went well and we were able to do a second one, the day after the closing of the first two, I was thinking to myself, "What's the next challenge? I have to do something else. How can we improve the art fair system and make this project something different than the rest?"

What kind of art world do you want to see in the future?

Diversity. Sounds tiring, clichè, and honestly boring, but it's the plain truth. Diversity is a must. Not only for non-white artists to get more exposure, but for more inclusion in administrative roles, too, at museums, art schools, galleries, art fairs, residencies, and so on.

I don't think about the future, to be honest. I prefer the now, the present moment is the time to create change. The future is not a tangible thing and the past is already a memory. We need to work in the now to positively affect the next.

◀ Danny Báez in his home in Washington Heights, New York City, in front of his personal art collection, including two small works by Mateo Zúñiga and a detail of a José Delgado Zúñiga painting.

Describe yourself in three words.
Persistent. Joyful. Friendly.

When are you happiest?
I'm elated when I bring a friend, acquaintance, colleague, collector, or anyone else to an artist's studio. Seeing people's reactions to the work of artists I really admire and believe in makes me smile, inside and out. Spending time talking face-to-face with my friends gives me genuine happiness. Seeing my nephew and nieces, too. Watching Real Madrid win games also brings me a very special feeling of happiness.

What is your favorite color?
My favorite color is the full and complete absorption of visible light which is commonly known as black. An achromatic color.

As the co-founder of MECA, what has been your proudest moment so far?
Seeing my friends show love, appreciation, and undivided support not only to me but to the whole fair is my proudest moment. Also, having all those amazing galleries come down and participate means a lot to me. Once you get your dearest people and selected circles to engage with something you're doing, and it's happening outside the place they all live, it honestly feels like a small giant victory.

As an Afro-Latinx creative, what do you bring to the art world conversation?
Disbelief? And I mean that in a very positive light. The fact that I possess certain looks is the conversation itself. Systematically speaking, a person that hails from where I come from or studied what I did isn't supposed to even be in this field, or at least not this immersed. I bring a different point of view and a certain assurance that people who look like me don't have to only be an artist in this industry. We can also be part of the market, institutional, and curatorial conversation, too.

Through your work with MECA and curating exhibitions, how are you making the art world more inclusive?
Latinx, Latin American, and Caribbean artists get the exposure they deserve at an elevated level at MECA and galleries, while bridging their proximity to collectors, institutions, and audiences that are not so familiar with their work. This is how I'm going to ensure that inclusion is eventually nothing but the norm—not a rarity or something we need to demand constantly.

▼ Báez's art collection includes work by Hugo Montoya, Juan Uribe, Adriana Martínez, and fun objects such as various pins by CARNE, a Darth Vader figurine, and a MECA t-shirt.

▶ A portrait of Báez by a New York City subway artist and work by his artist friends—including Hector Madera González, Eric Saunders Malavé, Benjamín Báez, Adriana Martínez, and Juan Uribe—and family members, including his mother Betty Pérez and his niece Evanny Báez.

"I bring a different point of view and a certain assurance that people who look like me don't have to only be an artist in this industry."

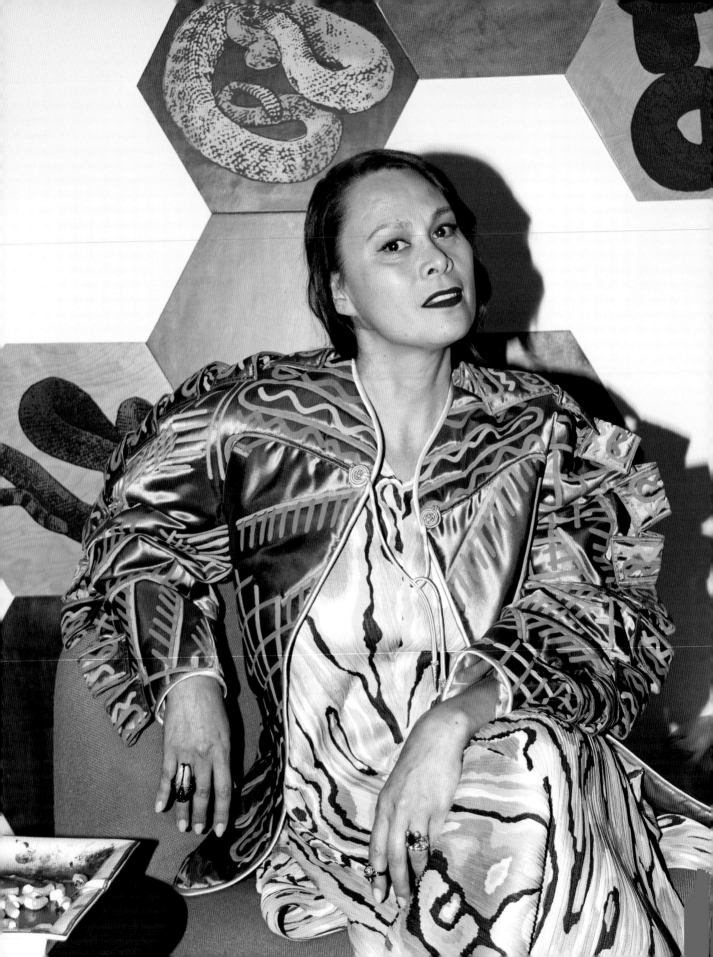

NATALIE KATES
Founder, Style Curator Inc. & Co-Founder, LatchKey Gallery

Natalie Kates, the New York-based founder of Style Curator Inc. and co-founder of LatchKey Gallery, maneuvers through the art world with singular style, savvy, and relentless creativity. Born in Vietnam to a Vietnamese mother and an Irish-American father, the Texas-raised Kates moved to New York in her early twenties and cultivated a dazzling career in both art and fashion. Formerly a modeling agency director, Kates pivoted into art, becoming an art collector with an enterprising eye for emerging street artists and young artists. Kates's art market acumen, expertise in guiding artists, and philanthropic art endeavors are straight-up bonafide.

◀ Natalie Kates wears a vintage Zandra Rhodes jacket and Issey Miyake dress in her New York City apartment. Objects around her include a chair by Giancarlo Pirerri for Castelli, a CJ Chueca ashtray sculpture, and a Rattlesnake Rec-Room installation by Jason Urban.

When did you know that you finally made it?
My lifelong dream is to spearhead an artist residency program and foundation. All of my projects, curations, and endeavors within the arts ecosystem bring me closer and closer to this end game. I feel that only once we give back, passing on our expertise and knowledge to the next generation, can we say we've really made it.

What is the best piece of advice that has always stuck with you?
The best piece of advice comes from a quote someone posted on social media, which is now my computer's screen saver, "Remember when you wanted what you currently have."

How are you actively changing the art world?
First, by putting my money where my mouth is, meaning acquiring and collecting underrepresented emerging artists. Second, in my role as a curator, by bringing emerging artists to market for the first time through curated exhibitions with corporate partnerships, such as the Core Club and nonprofits like the ARTWALK NY Annual Art Auction, benefiting the Coalition for the Homeless.

Who is your favorite fictional character?
The titular Auntie Mame from the 1955 novel by American author Patrick Dennis. I fancy myself as the eccentric Auntie Mame to the artists I work closely with, complete with madcap adventures while navigating the sometimes zany art world.

"I feel that only once we give back, passing on our expertise and knowledge to the next generation, can we say we've really made it."

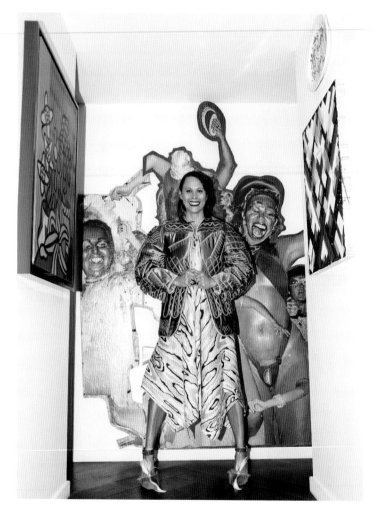

▲ Art from left to right; a LILKOOL painting, an installation by Assume Vivid Astro Focus, a ceramic plate by Curtis Kulig, and a Maya Hayuk painting.

▶ (top) Art from left to right: painting by Pat Phillips, painting by WK Interact, two sculptures by Nano 4814, Hermes birkin sculpture by Shelter Serra, piece by Zoe Buckman, piece by Ben Frost, sculpture by Roxy Paine, and Elmo & Cookie Monster toys by KAWS. (bottom) Art from left to right: yellow wall sculpture by Noa Ginsburg, paintings by Faile/Aiko, Gaotano Pesce sculpture on table, black sculpture by Gabriel J. Shuldiner, and stained-glass light sculpture by Beau Stanton. Small painting by Logan Hicks, piece by Richard Prince, crochet bike by OLEK, piece by Damien Hirst, and light sculpture by G.T. Pellizzi.

What is your favorite color?
My favorite color is orange. I'm a Buddhist, and this color is the essence of wisdom, strength, and dignity.

What have been some proud moments over the years with your curatorial platform Style Curator Inc.?
I feel I am an anomaly; I was raised on an army base and had no access to art, let alone artists, and didn't step foot into a museum until I was in my twenties when I moved to New York City. My first career was in the fashion world, which in the early 2000s was starting to cross-pollinate with the fine art world (i.e. Marc Jacobs's collaboration with Takashi Murakami). I created the platform Style Curator Inc. to bridge these two creative worlds, and that was the beginning of some of my proudest moments. Like the art show Plasmatik with Galeria-Melissa (a Brazilian designer shoe company) and Haute Dish (a set of dishes turned into fine art pieces by different artists) for Housing Works' Design on a Dime benefit.

You are no stranger to supporting street artists and emerging artists. Given your wealth of experience, what is your approach as the co-founder of LatchKey Gallery?
The art world is changing so fast and we are forced to evolve and reinvent to stay ahead. The LatchKey Gallery adventure began when I was approached by my good friend and colleague Amanda Uribe to create a nomadic contemporary art gallery that seeks to reimagine the brick and mortar via intimately curated exhibitions, salon series, and events that are partnered with various spaces around New York. It felt like the natural next step, given my inclination to always move on the edges of what the art world will be next.

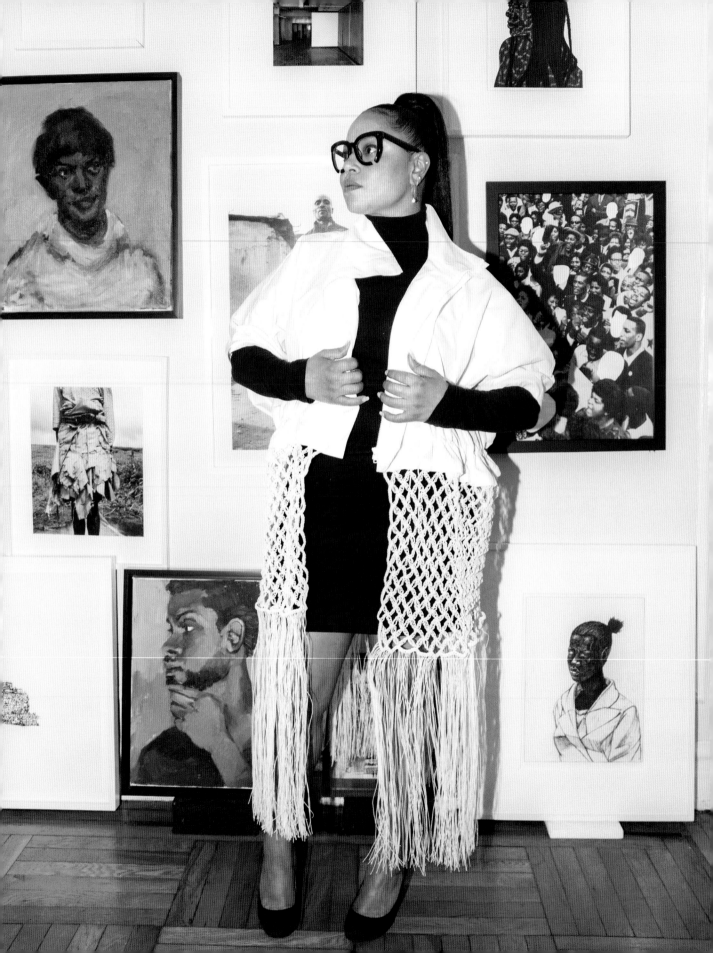

JOEONNA BELLORADO-SAMUELS

Director, Jack Shainman Gallery & Founder, We Buy Gold

Curator, culture builder, and fashion stunner, Joeonna Bellorado-Samuels has been slaying the art game in her decade-plus career. Raised in San Francisco, the current Brooklyn resident serves as director of Jack Shainman, a prolific blue-chip gallery with a mostly POC roster, including greats like Nick Cave, Hank Willis Thomas, and Hayv Kahraman. A few years ago, Bellorado-Samuels ventured solo to launch We Buy Gold, a nomadic contemporary art space, furthering and focusing on POC and QTPOC artists. The art world can be both glamorous and grueling, and Bellorado-Samuels—an arts supporter, leader, and collaborator—navigates intelligently and passionately.

What is the best piece of advice that has always stuck with you?

One of my mentors told me early on to never be afraid of arriving with my full self and taking up space wherever I go. We all have a right to be here—specifically the right to be here without feeling diminished. So that bit of wisdom, which came from someone who had quite literally made space for me, has always stuck with me.

◀ Joeonna Bellorado-Samuels in her Brooklyn home. Her art collection includes Mel Bochner, Leslie Hewitt, Toyin Ojih Odutola, Hank Willis Thomas, Kerry James Marshall, Lynette Yiadom-Boakye, and Jackie Nickerson.

How has the Internet and social media been pivotal in your career?

It's fun and helps me keep track of where I've been and what I have seen. Journaling is simply too much of a commitment for me. That said, as a tool, social media allows me to discover more laterally than I would otherwise be able to do. I'm able to cover more ground in a wider landscape and eavesdrop, if you will, on the interests, expressions, and projections of others in a way that is manageable for an introvert like myself.

Describe yourself in three words.

I could never say it better than Laila Pedro's title of her review of We Buy Gold's first show, "Threads of Fire and Water and Gold."

When are you the happiest?

I'm happiest when I'm with my sisters. Building a community of women around me, whether they be artists, art workers, or otherwise, has proven to be so vital for

"We all have a right to be here—specifically the right to be here without feeling diminished."

▲ Bellorado-Samuels's pretty array of luxe scents.

▶ A sleek corner in Bellorado-Samuels's bedroom, including art by Malick Sidibé and Shellyne Rodriguez.

me. Looking back over my ten-plus years in this field, it has been those relationships that have sustained me, encouraged me, and kept me from feeling isolated or out of place. My sisters bring me such joy, and when one of us celebrates a small or large victory, we all win.

What is your favorite color?

This is an impossible question, but I keep coming back to black—always back to black. Some say it's the absence of color, but I think of it as all colors at once. Black always feels like home.

At the Jack Shainman Gallery, you support prominent POC artists who are impacting culture. As a facilitator collaborating alongside them, do you feel that you are also able to contribute to the culture?

In a way, yes. I really see my role as that of a conduit, as someone who is assisting in facilitating cultural production. So in that way, I do contribute to culture, just by being there to help move things along in the day-to-day process. At the end of the day, it's always all about the artists. It's always about how we, as those of us working within the ecosystem of this art world, can be of service to those who are making the work.

A few years ago, you founded We Buy Gold, an indie roving art space, to center POC artists. What have been some fulfilling proud moments with this art venture?

Mounting exhibitions from conception through the de-install is certainly not easy, and maintaining a sensitivity to each artist's wants and needs throughout that process adds another layer of necessary thought and intention. Just having secured the space and resources to present multiple exhibitions makes me proud. Seeing how those shows have helped to further dialogues around artists who I deeply admire and respect is what's most fulfilling. I will always encourage others to be bold, to expect more from yourself and others, and know there will be an audience, there will be folks who are waiting to hear an allied voice.

ERIN CHRISTOVALE

**Associate Curator, Hammer Museum
& Co-Founder, Black Radical Imagination**

Los Angeles-based curator Erin Christovale is deeply in tune with the voices, issues, and urgency of Black Los Angeles. She listens closely, highlighting those narratives in her curatorial endeavors. Christovale knows both sides of the art coin, operating indie or within a major institution. A USC alumna with a bachelor's degree in film studies, she emerged as an independent curator, participating in collectives who organized pop-up shows and film screenings. She co-founded the annual short film program Black Radical Imagination with Amir George, exploring complex storylines on Blackness. As the associate curator at UCLA's Hammer Museum, an idea can become a future show, and with the institutional resources to make it happen. Christovale is just getting started and her cultural imprint in LA is imminent.

When did you know that you finally made it?

There have been so many affirmations throughout the years, but a highlight was being invited to co-curate *Made in L.A. 2018* at the Hammer Museum. I never thought I'd be considered to do something of that magnitude.

Who is your favorite fictional character?

Calafia. She is a character from the novel *Las Sergas de Esplandián* written in the 1500s. She is a Black warrior queen who reigns over the fictional Island of California and enlists a fleet of women to battle with

◀ The radiant and radical Erin Christovale at the Hammer Museum in Los Angeles.

her on a flock of trained griffins. She's often known as the Goddess of California, embodied in various artistic depictions up and down the coast, and represents the natural beauty and vibrancy of the state.

What is your favorite color?

I don't have a favorite color, but I often think about the significance of the color purple and its allegiance to Blackness.

What kind of art world do you want to see in the future?

I want to see an art world that doesn't abuse words like "diversity" or "inclusion" but actually embodies them from top

"I want to see an art world that doesn't abuse words like 'diversity' or 'inclusion' but actually embodies them from top to bottom."

▲ Colorful details on Christovale's desk.

▶ (top left) Dopeness in the details. (top right and bottom left) Important reads on Christovale's desk. (bottom right) Black art excellence at its best.

of color, particularly Black folks, are being pushed out, so what is feeling most urgent at the moment is to reflect the legacy and creative production of Black Angelenos in the museum.

You love the moving image. You studied film and went on to co-found Black Radical Imagination. Can you talk about championing queer and POC filmmakers?

Yes. Black Radical Imagination, which I co-founded with Amir George, is an ongoing program of touring experimental films by filmmakers and visual artists within the African Diaspora. It came out of a deep desire to prioritize artists who were taking on the moving image in innovative ways that speak to the myriad of experiences and modes Black people embody around the world. I think cinema can only move forward as a medium when we refuse the stereotypes the entertainment industry often feeds us. Championing queer and POC artists who take on the medium in challenging and dynamic ways excites me and builds bridges toward the future of storytelling.

to bottom. I also want to see an art world that prioritizes the dissemination of art as it relates to culture, not as it responds to wealth or the art market.

You were raised in LA and your stance on art centers on race, access, and inclusion. In an ever-changing LA, how do you keep that curatorial focus at the Hammer Museum?

I see my curatorial role at the Hammer as that of a civil servant. My job is to respond and be in dialogue with the city and its various publics, so for me that means focusing on projects that speak to sociopolitical issues that are happening both locally and beyond. LA is in the midst of a massive shift, and its identity is changing both culturally and infrastructurally. A lot of people

Erin

PANTONE
9320

Almost
Everyone

CULTURE

hooks belonging a culture of place routledge

WAYWARD LIVES, BEAUTIFUL EXPERIMENTS INTIMATE HISTORIES OF SOCIAL UPHEAVAL SAIDIYA HARTMAN NORTON

BLACK CALIFORNIA

Adrian Piper ESCAPE TO BERLIN
A Travel Memoir

PAULO NAZARETH ARTE CONTEMPORÂNEA / LTDA Cobogó

PREMIO PIPA · PIPA PRIZE · 2018

ANIMAL THAT DOESN'T EXIST

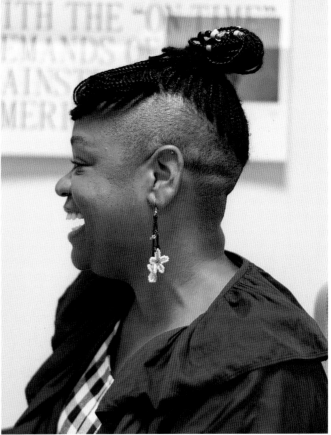

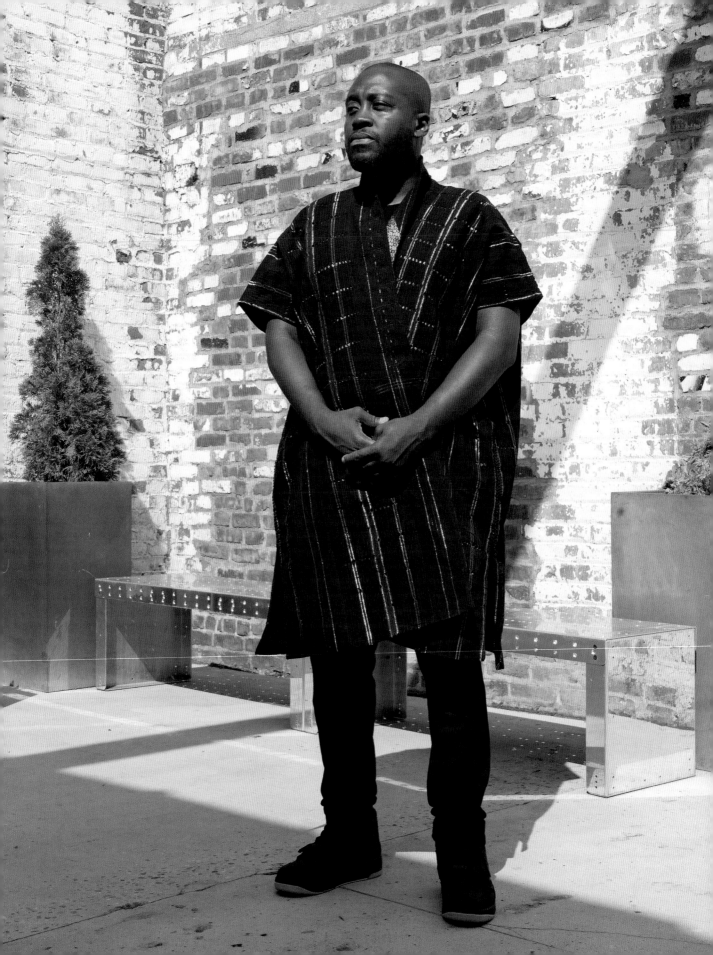

LARRY OSSEI-MENSAH

Curator & Co-Founder of ARTNOIR

For Bronx native Larry Ossei-Mensah, his art agenda is very simple: Art is for all. The Ghanian-American curator and cultural critic designs his life and impressive career with a foundational focus on the art world being approachable. Based in New York but traversing the world, the self-made Ossei-Mensah manages a multilayered career amplifying Black and Brown artist voices. As co-founder of ARTNOIR, he crafts culturally compelling experiences for diverse audiences. Whether curating art across the globe or locally in New York, Ossei-Mensah is a true Bronx original.

What is the best piece of advice that has always stuck with you?

Plan your work and work your plan. The harder you work, the luckier you get.

How are you actively changing the art world?

I'm actively working to change the art world by advocating not only for artists, but for fellow curators, critics, and collectors of color. No one is successful on their own, so I do my best to be of service. With the work that we do with ARTNOIR, we've been able to open doors and cultivate experiences that have changed hundreds of lives. We not only support dope artists of color, but also cultivate the next generation of patrons who will invest in our creative capital.

When are you happiest?

When I'm swimming. Firstly, because it relaxes me, and secondly, it's a metaphor for life. Swimming teaches you the importance of going with the flow, trusting nature and the universe, but also trusting your own abilities. It's a reminder not to panic, that everything will be okay with trust, faith, and concentration with the task at hand. I didn't learn how to properly swim until I was thirty-five, so the experience was also a reminder that you are never too old to learn new skills.

◀ Larry Ossei-Mensah, global curator extraordinaire, at A/D/O by MINI in Brooklyn.

Who is your favorite fictional character?

Santiago, who is the main character in the book *The Alchemist* by Paulo Coelho. He reminds me that the journey and adventure is the true treasure in life, not superficial things.

POSTCARD FROM NEW YORK - PART II

DERRICK ADAMS, FIRELEI BÁEZ, ABIGAIL DEVILLE, ALEXANDRIA SMITH, PAUL ANTHONY SMITH, WILLIAM VILLALONGO

a cura di Larry Ossei-Mensah e Serena Trizzino

LYNETTE YIADOM-BOAKYE
Larry Ossei-Mensah

▲ (above and opposite) A selection of Ossei-Mensah's curatorial projects and writings.

What is your favorite color?

My favorite color is blue because it is the color of royalty. I always strive to carry myself with respect and dignity. Every time I wear something blue it is a reminder of that.

You travel the globe, but you remain loyal to your Bronx roots. I know access is key for you, with the exhibitions you curate. How do you make them open to everyone?

It's imperative I remain grounded in my working-class upbringing. It's a reminder that everything I've achieved has been earned. When I'm creating an exhibition,

I'm always thinking about my fifteen and sixteen-year-old self. I wonder if it's something that he'd find interesting and engaging to experience. I always include a workshop or tour either for kids, teens, or young adults that enables them to be part of the conversation, not just a passive spectator. I'm interested in what they see and encourage them to understand that their point of view matters. The more I can use art as a tool for education, heightening someone's self-awareness and sparking a dynamic dialogue, then I feel I'm doing my job. As someone who is self-taught when it comes to curating and contemporary art, I'm aware of the potential barriers, and I work every day to break them down. Art is for everyone to enjoy.

As a co-founder of ARTNOIR, you help create dynamic programming representing Black artists and global Black culture. What has been your proudest moment so far with ARTNOIR?

The proudest moment for me with ARTNOIR is when we became a 501(c)(3) because it signaled that what we're creating is more than an idea, it's a movement. When you are functioning as a "legit" organization, it heightens the responsibility, but also amplifies the missions and why we exist. Being able to collaborate with artists, curators, galleries, institutions, and brands to tell our stories in a way that is authentic and executed with care is something that fills me with pride every day.

Harvey

...Wave Premiere...

Love to The Internet's Favorite Curator-
MICK
SAGG

Randal Buckner

Larry — What a
pleasure + an honor
to have you with
us! congrats on this
catalogue —JJ

Love working with
you on this exhibition!
Look forward to more
Elizabeth

...putting
...a great
—Rich

POSTCARD FROM NEW YORK - PART II

DERRICK ADAMS, FIRELEI BAEZ, ABIGAIL DEVILLE,
ALEXANDRIA SMITH, PAUL ANTHONY SMITH, WILLIAM VILLALONGO

a cura di Larry Ossei-Mensah e Serena Trizzino

opening
mercoledì 6 giugno 2018 ore 18:30

7 giugno - 27 luglio 2018

ANNA MARRA CONTEMPORANEA
via sant'angelo in pescheria, 32 – 00186 roma
tel. 06 97612389 | info@annamarracontemporanea.it
www.annamarracontemporanea.it

SON
...E
TON
...H

...ul T. Pfale

RIPHE

NAIMA J. KEITH

Vice President, Education & Public Programs, LACMA

Celebrating and collecting Black art have been consistent passions for Naima J. Keith since early on. An LA native and resident, Keith is an art powerhouse that has cultivated a prolific career as a curator focused on Black artists. With degrees from Spelman and UCLA, and impressive stints at major institutions like the Studio Museum in Harlem and the California African American Museum, she is the definition of Black art excellence. Currently the vice president of education and public programs at LACMA, Keith embodies leadership and grace while making those necessary power moves in the art world.

When did you know that you finally made it?
On July 31, 2014. The day my Charles Gaines exhibition, which I curated while working at the Studio Museum in Harlem, was positively reviewed in the *New York Times*.

What kind of art world do you want to see in the future?
Diverse, inclusive, equitable, and accessible.

Describe yourself in three words?
Wife. Mother. Fierce advocate. It's how I see myself.

What is your favorite color?
Blue. I love the way it looks on my skin tone.

You have carved out a stellar career, working at the Studio Museum in Harlem and the California African American Museum. How do you think your Black-centered exhibitions have shaped the art world?
They have allowed visitors to see artists of African descent as central to the thesis of an exhibition rather than just as support for political and social themes. They also allow visitors to see the diversity and range of work created by African-American artists.

◄ The cool and confident Naima J. Keith at the expansive LACMA in Los Angeles.

You grew up in Los Angeles with parents who collected art and took you to museums, which is an invaluable experience. With those early art roots and your current role at LACMA, how do you engage diverse audiences from all parts of Los Angeles?

I'm always thinking about access and how diverse communities feel in a space. I want them to feel welcome, included, and empowered. I try to create those spaces through engaging public programming, a dynamic social media strategy, and signage when they go to the institution.

▶ (top) A watercolor by artist Mark Steven Greenfield titled *Flying High* in Keith's office. (bottom) Important reads on Keith's shelf in her office, including a lovely portrait of her young family.

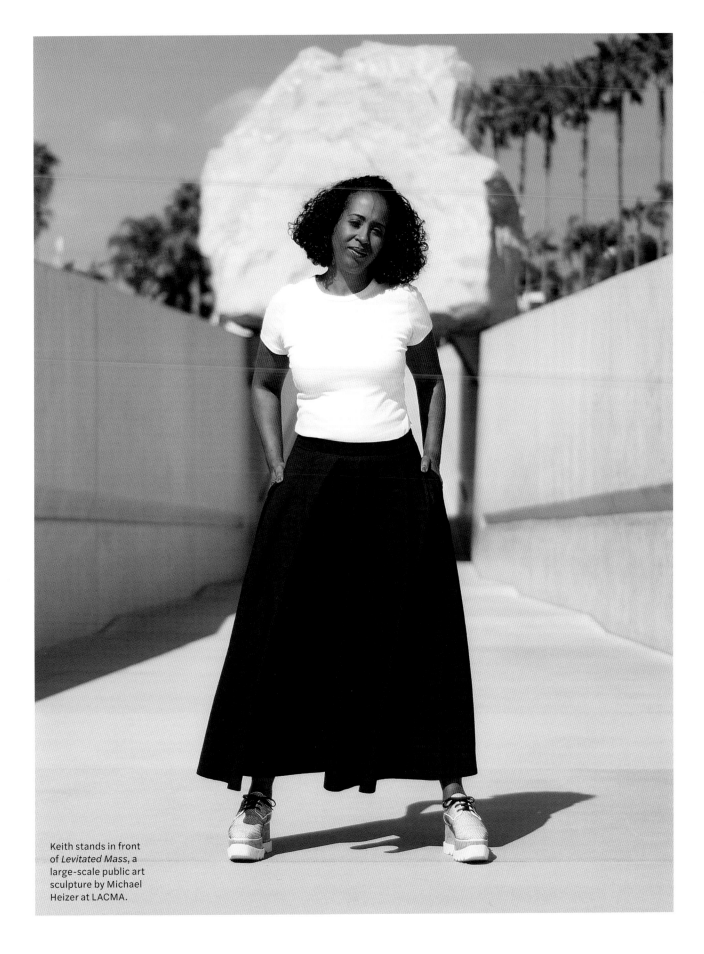

Keith stands in front of *Levitated Mass*, a large-scale public art sculpture by Michael Heizer at LACMA.

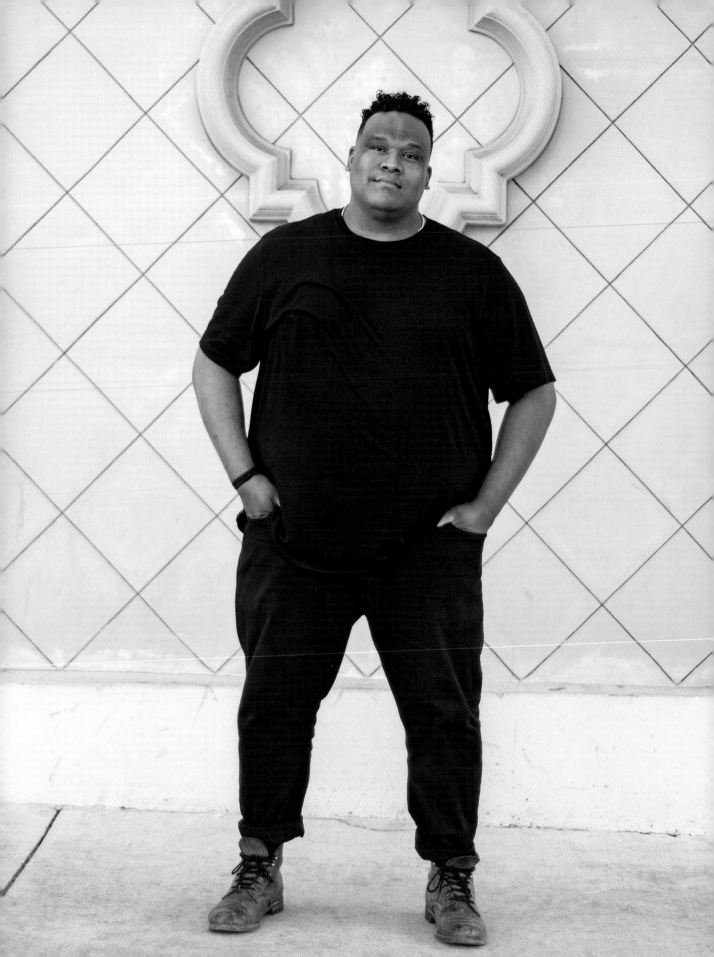

RICK GARZON

Founder & Director of Residency Art Gallery

Residency Art Gallery is a space like no other in Downtown Inglewood. Founded by Inglewood's very own Rick Garzon, who is half-Black and half-Ecuadorian, the gallery showcases nuanced, POC artist-driven exhibitions and programming. Residency Art Gallery has held shows based on the racially divided '92 LA riots, vanishing Chicanx iconography that's slowly fading out in LA, and has proudly exhibited Angeleno artists like Star Montana and Lauren Halsey. Residency Art Gallery is grassroots, indie, hyper-local, and a cultural heartbeat of South Los Angeles, created by Garzon. And that indeed is a mood.

When did you know that you finally made it?

I realized I had something special when I had non-POC gallerists request meetings with me to "pick my brain" about artists they should have in future shows. At first I took offense to it. I felt like I do the work, I do studio visits, I attend open studio visits at schools, and I'm constantly on the lookout. I wondered why they couldn't do that. It felt lazy. Then I changed my thinking on it and took it as flattery.

How has the Internet and social media been pivotal to your career?

I feel like Instagram is your business card, website, and first point of contact. Essentially it's a digital you, and you have to use it to your advantage.

How are you actively changing the art world?

I feel like our art is in high demand and yet there are none (or very few) gallery directors of color speaking about our narratives in the work. On top of that, the audience that our artwork is made for will most likely never see it. Black and Brown contemporary art should be seen in Black and Brown neighborhoods, hands down.

Describe yourself in three words.

Optimistic. Bullish. Straightforward.

Who is your favorite fictional character?

Static. It was the first comic book that I collected. He was a reluctant hero

◀ Rick Garzon in Downtown Inglewood, Los Angeles.

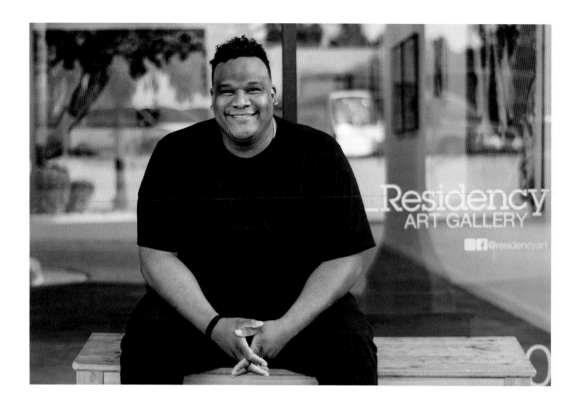

that looked like me and was what Spider-man was supposed to be, someone I could relate to. Static was also created by a Black man, Dwayne McDuffie, who saw we weren't represented in the major comic book houses and created his own shit.

When you think about community and authenticity in the context of gentrification in Inglewood, how does Residency Art Gallery fit into the equation?
I created Residency Art to have a voice in both a rapidly changing neighborhood and in the predominantly non-POC driven art community. We're sort of taking on two battles at once. How can we have programming that directly ties to community issues, and then get the LA art scene to take a gallery in South Central LA seriously? I feel like we're actually doing a great job on both fronts and look forward to what's to come.

What have been some proud moments with Residency Art Gallery so far?
I'm most proud of the openings. We have almost two hundred people spilling out of an eight hundred square foot space. It always feels like a communal, family gathering. It's such a vibe that doesn't happen at other galleries. The music is on point, the art is being absorbed and understood. It's a whole ass vibe.

"Black and Brown contemporary art should be seen in Black and Brown neighborhoods, hands down."

LUCIA HIERRO

Contemporary Artist

Native New Yorker Lucia Hierro is a Dominican-American conceptual artist working across digital media, collage, and soft sculptural objects. Raised in Washington Heights and Inwood, the Yale MFA alumna works out of her Bronx studio, using her lens to wittily comment on class, income, and privilege. Who has it. Who doesn't. Everyday objects that are universal to all, but hold a unique cultural context in Latinx households, show up frequently in Hierro's collages and oversized, soft sculptural pieces. Think plantain chips, Vicks VapoRub, Country Club orange soda, Goya canned foods, Dominican hair care products, and other essentials from your local bodega. Hierro breaks it all down whimsically, cleverly, and critically.

When did you know that you finally made it?

With the day-to-day hustle it's hard to feel that way, not to mention I still have so many unmet goals. If I had to pick a moment, it would be this one morning everyone was rushing to catch the train so they wouldn't be late to work. It was crowded and everyone was pushing to get in. I simply waited on the platform, listening to music, happy I could catch the next one. I could get to my studio at whatever time because I work for myself. And let me be honest, being featured in *Vogue*! Also, being stopped by students who have come across my work through class or research. It blows my mind!

How has the Internet and social media been pivotal to your career?

I'm an artist who likes to observe, take screenshots, and use found images from the Internet—it's a form of research and people watching, so it's actually useful for my studio practice. I actually wish it wasn't, you'd probably get better art out of me if I didn't have to worry about the interwebs.

What kind of art world do you want to see in the future?

One with less art fairs, filled with works that push important conversations about aesthetics forward. One which pays on time, one which values an artist's time

◀ Lucia Hierro at work in her Bronx studio in front of two pieces, *Platanitos* and *Chicharrones* (both 2018), from her *Racks* series.

and need for that time to create. One with less emphasis on Hollywood, real estate, Insta art stars, and more on history building and critical thought. One with more integrity.

Describe yourself in three words.
Sardonic, rooted, and curious.

What is your favorite color?
I think people would expect me to say black, because I'm often wearing it, but I love the color yellow. A soft, warm yellow. I like the way I feel when I see it and when I wear it. It's a tough yet soft color.

▼ Details in Hierro's bright and airy Bronx studio.

▶ Hierro posing next to the striking *El Costo de La Vida* (2019).

Throughout your work with digital media, collage, and soft sculptural objects, you highlight objects and nostalgia experienced in Latinx households using a Pop Art aesthetic. Why is this important in your work?
It's twofold. On the one hand, Pop Art is a way to pay homage to a culture, but on the other, it's a way to remove the nostalgia. It's a tactic to both draw you in with the familiar or the photographic, and then situate you within the populace. You are one of many, like the assembly line Warhol talked about. This opens up conversations about our identities as they relate to the economy at large.

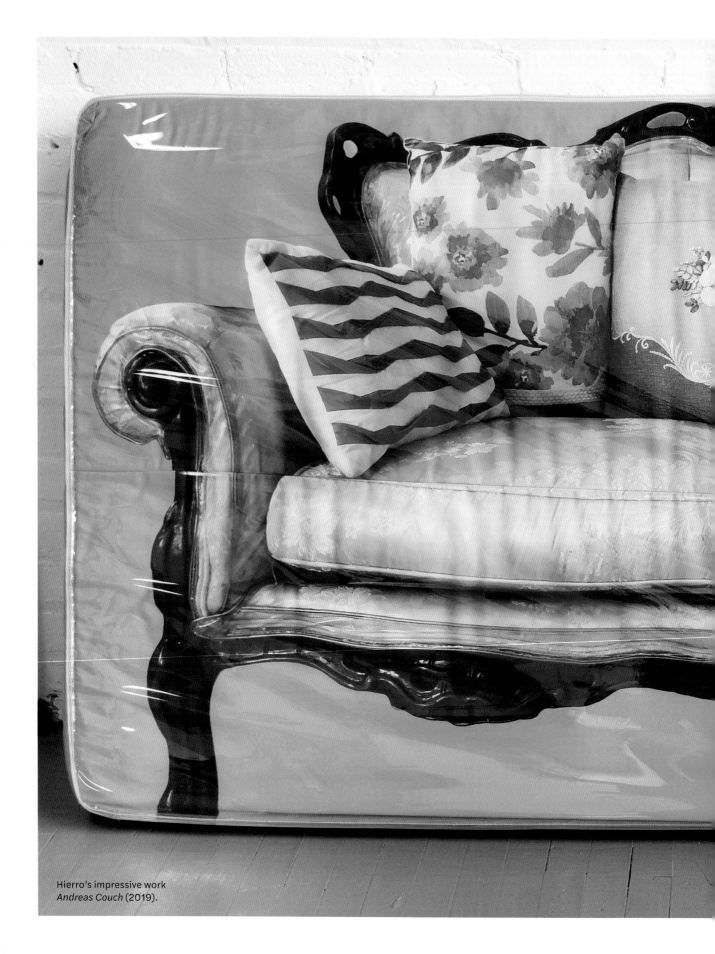

Hierro's impressive work
Andreas Couch (2019).

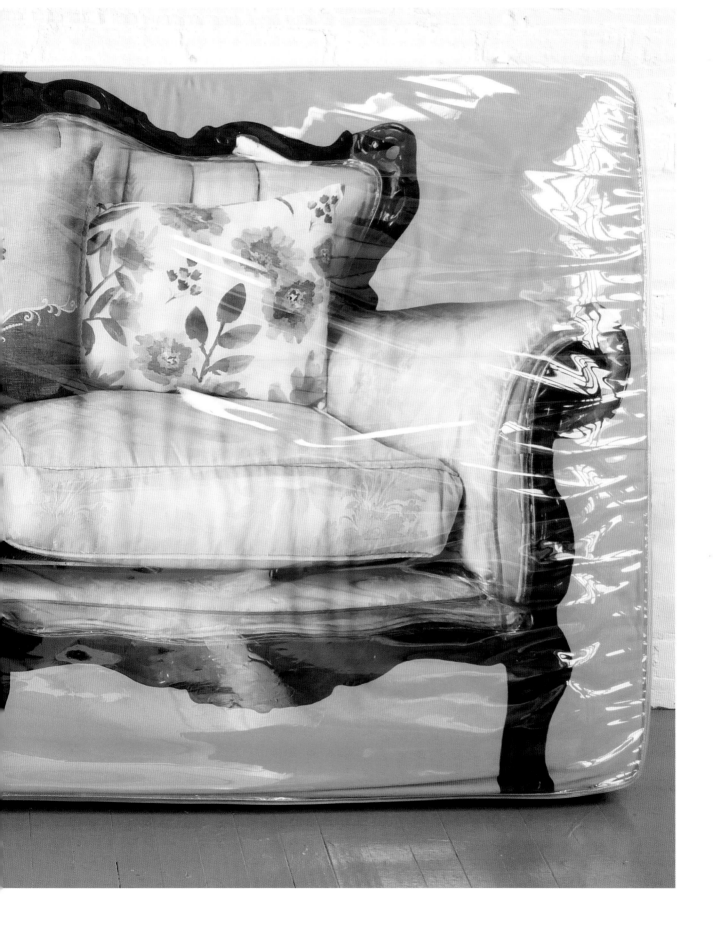

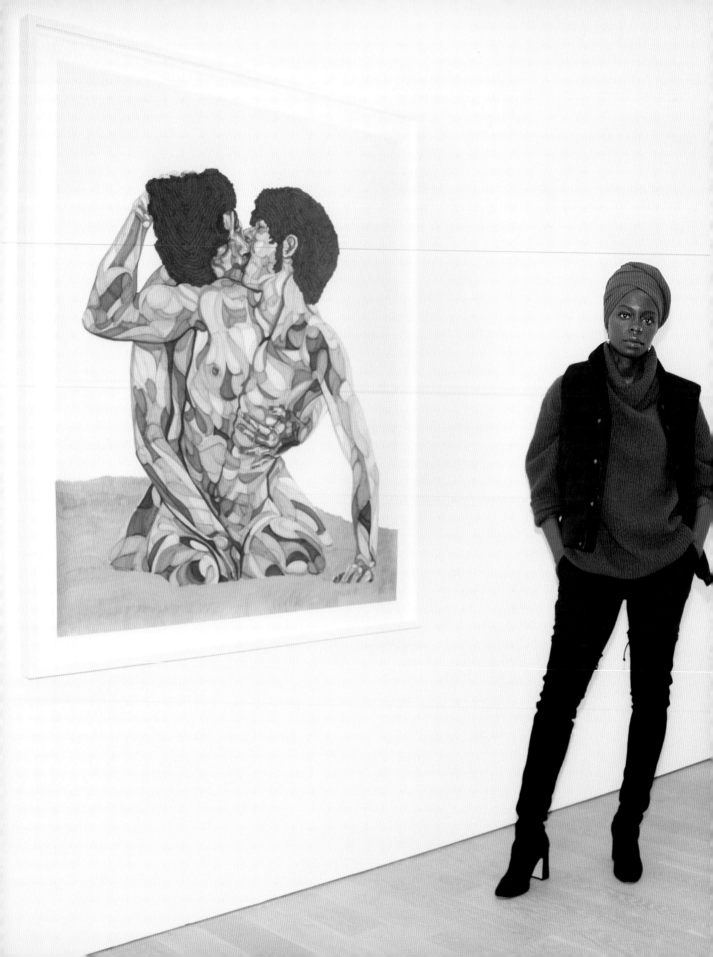

TOYIN OJIH ODUTOLA

Contemporary Artist

In Toyin Ojih Odutola's sumptuous drawings I find myself constantly fixated on these very grand yet quiet moments, which are full of luxury and solace. An elegant hand that's writing on expensive stationary at a handsome desk. A wall of family portraits, including noble ancestors and younger family members. A squad of four stylish Black womxn that resemble a fashion campaign. The New York-based, Nigerian-born artist creates vibrant drawings using materials like charcoal, pastel, and pencil, with a color palette that is both rich and royal. Ojih Odutola conveys majestic narratives on Blackness; because being Black is regal.

When did you know that you finally made it?

My work is still regarded as emerging and I often feel like the amateur in the room, so there's a strange disconnect. If I were to pick a moment that felt close, it may have been around the time of my second solo show at Jack Shainman in 2013. That was the first time I allowed myself to be called an "artist." It was a rather emotional realization—as if I was finally worthy of the title. I aimed from then on to do right by that title.

What is the best piece of advice that has always stuck with you?

Don't sweat the bad shit. It rarely, if ever, is about you. Getting caught up in perception becomes a trap. Just do what you must and

what you can to the best of your faculties with kindness to yourself and others.

How has the Internet and social media been pivotal to your career?

It's funny, my career can be cataloged on my Instagram. From my very first solo exhibition in New York, to graduating with an MFA, to all the travels that have influenced and inspired works, all the way to now. It's strange how a social media platform is a log of ten years of your career thus far—and this is not unique, for this is on every platform and affects a number of people. I find it incredibly fascinating how so many artists from a variety of fields got their start through these means of interaction and self-publication. Mine was through Tumblr, then Instagram—publicly and actively from

◀ Toyin Ojih Odutola in front of her magnificent work *The Flavor and The Intent* at the Jack Shainman Gallery in New York City.

2007 onward. The role social media plays now has changed dramatically, and I've pulled back considerably due to the shifts and for the sake of privacy; yet, I feel honored to be someone who took that shot and really didn't know what might happen.

Describe yourself in three words.
Curious. Compulsive. Intense.

Who is your favorite fictional character?
There are three that instinctively come to mind: Anyanwu, from Octavia E. Butler's novel *Wild Seed*; Amber, from another Butler novel *Patternmaster*; and Orlando, from the titular novelette by Virginia Woolf. Each character's interiority was felt on a seemingly cellular level when I first read these stories, and they are books I often reread.

What is your favorite color?
Nothing singular, but collectively, I'm attracted to neutral tones that, when combined or composed in a certain arrangement, become almost iridescent in feel.

In recent years you've created work based on two fictional, aristocratic Nigerian families. They are dashing, affluent, and live beautifully. What led you to create these characters and share their narratives over time?
It began with a series of questions of what the family might look like, of how they might present themselves, and how to go about maximizing their story in the making of the work and the materials used. To answer this question took three years of focused study and immersion. There were so many layers of how this world played out, and I'm very grateful for what the series

taught me about artmaking. I felt more confident about engaging in worldbuilding both in the drawing and the narrative, and it has indelibly altered how I go about making work since.

How do you address race and gender in your work? In what ways do you pull from your many lived experiences—born in Nigeria, raised in Alabama, educated in California, and now living in New York?
I always felt like my relationship with race came at me sideways in the sense that I was born in a country that was predominantly of one race, yet ethnically and tribally diverse, and thusly incredibly mixed, then migrated to another country where that same diversity was treated in a more segregated manner. It was off-putting and upsetting to engage with this growing up in the States, but I learned to understand it better by drawing it out—quite literally. I began drawing skin and myself, initially in order to come to an understanding. This expanded into the fictive because I was attracted to how stories create a mixture of ideas, principles, beliefs, and propensities as a means of questioning those very things. It helped me think more critically about my experiences and understand how systemically coded these elements are, that they are not indicative of individuality—which was and continues to be incredibly freeing.

▶ (top) The artist with her glorious portrait *Orlando,* a work of charcoal, pastel, and pencil on paper. (bottom) A beautiful grouping of Ojih Odutola's monographs and catalogs.

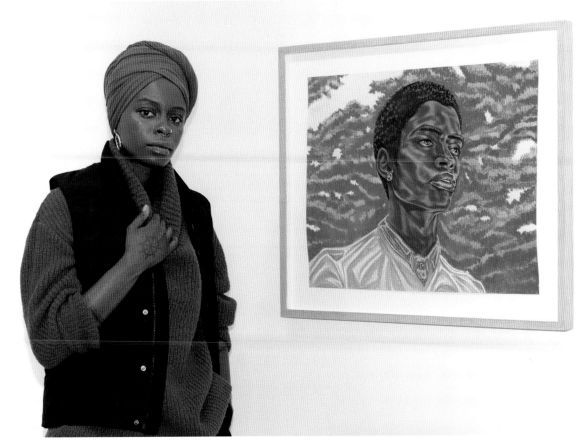

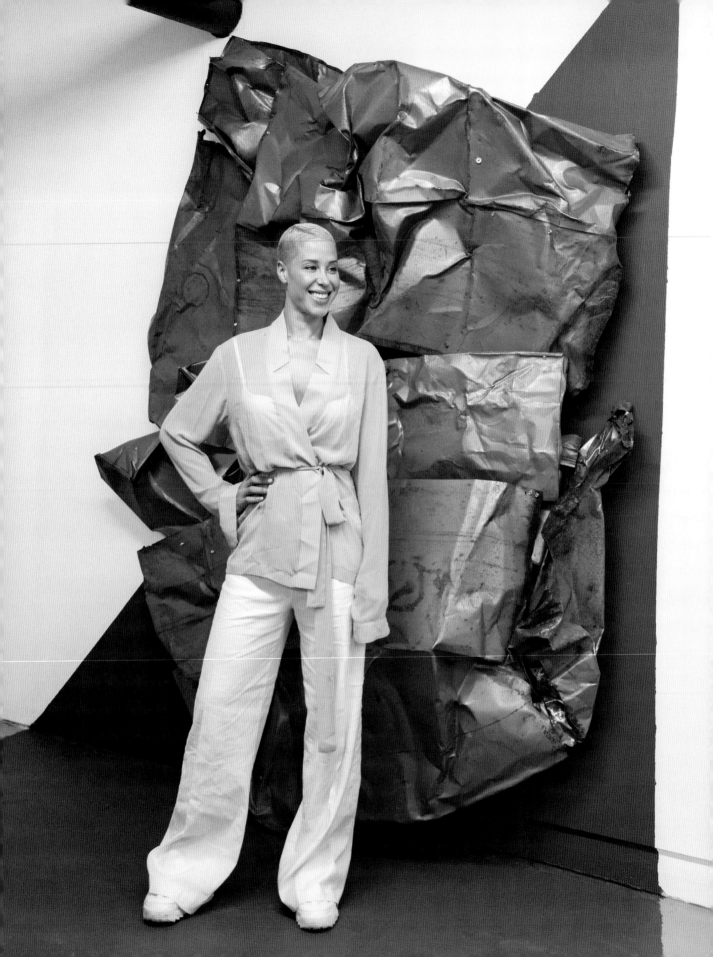

KENNEDY YANKO

Sculptor

Diving into Kennedy Yanko's world of sculpture-making is transportive. It's a journey of soothing colors, reimagined found objects, and awe-inspiring abstract forms. A St. Louis native turned Brooklyn resident, Yanko, a biracial artist, has constructed her own path on her own terms. Independently, intuitively, and organically. Her practice focuses on producing abstract sculptures and paint skins. These pieces offer a myriad of visual possibilities and, more profoundly, can be emotionally triggering for the viewer. Yanko has had a gorgeous ascent and emergence in the art world, and it will only continue to rise.

When did you know that you finally made it?

I know myself, and I know that's not actually a thing—I'll never have "made it"—but in each chapter in my life there are markers that make me say, "Hey, that was really good," which reaffirms that my instincts were leading me in the right direction. Every day when I walk into my studio, I look around and proudly know that this is mine, I created it, and that today I will make more space for the work to have as much possibility as it can bear.

What is the best piece of advice that has always stuck with you?

My aunt Gussie, who died at age 101 and whose portrait resides above the entrance of my studio door, would always say, "Don't worry about what they think, you

go on and let your firecracker pop." Then she'd bite me on the cheek.

What kind of art world do you want to see in the future?

I'm so lucky that my art world feels like family. We all look out for each other, share and exchange ideas, and collaborate. But I'm currently witnessing a major expansion, watching the "art world" grow from being very small and closed off into something that expands beyond the walls of our institutions. Art has become recognized as not only object making, but as a valid instrument for change and a career pursuit. Over the last century, we've seen evolutions in art practice and theory like never before. The world is reconsidering the place of the artist and including the artist's mind in community development initiatives.

◀ A nude mood. Kennedy Yanko in her Brooklyn studio in front of a sculpture, a work in progress.

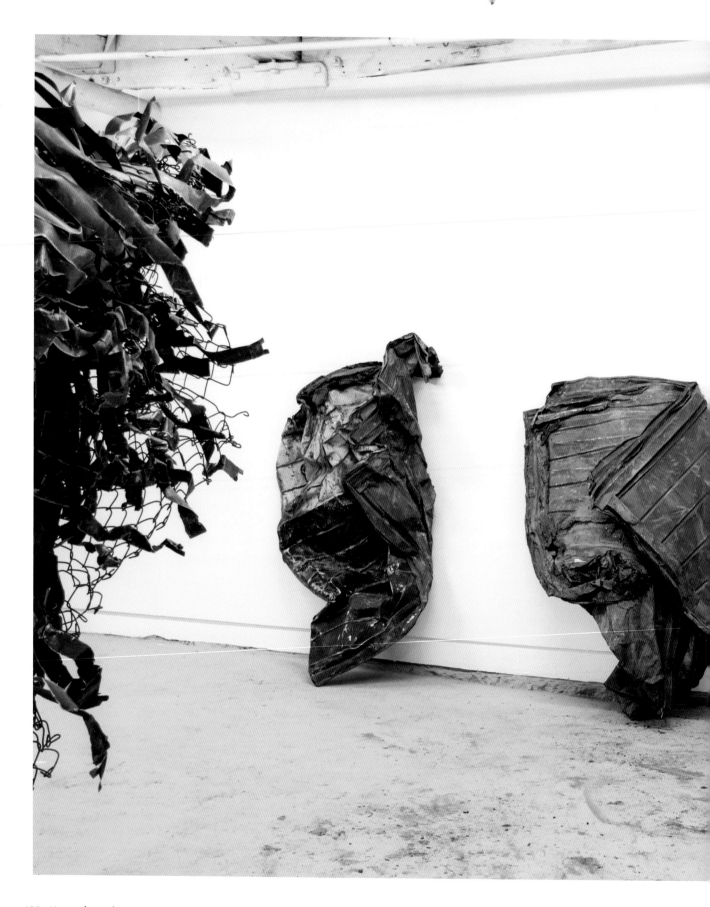

I'd like to see artists mandatorily involved in all platforms, from engineering to science and politics.

What is your favorite color?
Iridescent amethyst, and anything muted makes me swoon.

Who is your favorite fictional character?
I've never been into fiction. My heroes are people who do what needs to be done to experience their best existence. Many of those people will never be written about or recorded in history. I look for them everywhere.

Your abstract metal sculptures carry dualities, tough yet poetic, industrial but soft. What kind of narratives are you telling with these shapes?
I want the art to generate sensations within the viewer, perhaps they'll feel something like a triangle pierce their abdomen when looking at my work and they can investigate that feeling, but there's no "takeaway," per se.

The particular shapes that appear in my work are a funny thing to me. They've been with me my entire life and follow me everywhere I go. They challenge the eye, they lean and breathe and undulate. When I first started working with found metal, I intentionally bucked their "stories." I would do my best to strip any sort of figuration that might allude to their previous life, because I wanted to keep people there with

◀ Various works in progress in Yanko's studio.

▲ A detail of Yanko's industrial tools and materials.

▶ Pretty colors and pigments in Yanko's studio.

me in that moment. If there's one message I'd like to share, it's a reminder that all things are one, that all things add up to something greater than oneself and yet can also be found within oneself. I've learned through the process of creation that I'm no different than the material in front of me, that we actually mold each other.

There's an intense physicality to your art practice that's also paired with emotion. What is the joy you find in working with industrial materials? The joy is found in the challenges continually presented to me in my work.

"My heroes are people who do what needs to be done to experience their best existence."

No matter the material I'm working with, there is always something new to navigate. I get to figure out all the math equations I could never get in school, but with my hands. It's satisfying, identifying options and finding solutions; each piece I make is unlike any other. I determine how it will exist in a space and conceive of the unique hardware that will best support it. The method is different every time, but I feel immense pride in the finished work.

In the process of creating, as you might expect, there is an ebb and flow of emotions. At this point, I know what the rollercoaster looks like and, when I feel something surge within me, I can take a step back and think, "OK, I'm freaking out. This is why I'm freaking out and this is what usually happens after my freak-outs." I embrace it, sit with it, and take my experience forward.

TOURMALINE
Artist, Filmmaker & Activist

When a gifted artist like Tourmaline is of your generation, you must do everything in your power to make sure that artist succeeds. The Massachusetts native and New York-based artist, activist, writer, and filmmaker has spent years immersed in the sheer pursuit of cementing Black trans female scholarship. The Columbia graduate lionizes the mothers of the movement—foundational womxn like Mary Jones, Marsha P. Johnson, Sylvia Rivera, and Miss Major—through her breakthrough films and her critical, indispensable writing. An unapologetic advocate and visionary filmmaker, Tourmaline uses her lens to reveal and reinforce all that is magical and marvelous about Black trans womxn.

When did you know that you finally made it?

I think we're all making it together, all the time. Sometimes we're making it in ways that are just being shared within the community. There's a real power in circulating our work and our beauty with one another in the community.

Beyond that, I love witnessing the reach of my work and our collective work beyond our immediate community. It was so magical and special to be on the cover of *Out* magazine with Miss Major, and to also have *Happy Birthday, Marsha!* find an international audience that cherishes the film, finds deep meaning in it, and fiercely advocates for it.

How are you actively changing the art world?

I'm changing the art world on a few different levels. One is just bringing representation of transgender nonconforming people of color who are disabled, who move through incarceration, who create care networks with each other, and who are unruly to the status quo, and really shining a light on the beauty and power of that. Another is by saying that art exists in so many places beyond the so called "art world." I'm also questioning the limitation of representation: When is it important to not be represented? When is it important to name representation as extraction rather than something beneficial? And when is it important to soak up all the shine?

◀ The fierce and resilient Tourmaline at A/D/O by MINI in Brooklyn.

Describe yourself in three words.
Storm queen shygirl

What is your favorite color?
Iridescent everything. It's shiny and not static.

Your films exalt Black trans female icons like Marsha P. Johnson and Miss Major. What kind of freedom do you find in telling their stories and in filmmaking as a medium?
I find a big freedom in falling through time and folding time, whether it's the 1969 Stonewall Riots with Marsha P. Johnson or 1855 with Mary Jones. I get so much joy in creating art that acts as a portal to the past, art that helps us fall through and step out of time. This is important to me because the violences that have shaped Marsha's, Mary's, and Miss Major's lives are often named as over, but we know these large violences of anti-Blackness, the gender binary, or ableism continue to haunt our landscapes. The only way to transform them is to speak directly to them. The film work that I do seeks to act as a portal to our healing.

In *Happy Birthday, Marsha!* and *Atlantic is a Sea of Bones*, both lead actresses, Mya Taylor and Egyptt LaBeija respectively, are beautifully lit. Your use of dreamlike, surrealist sequences are breathtaking as well. Can you expand on this?
For me, it's so important that our beauty is reflected back on screen. So often, when we are named at all, it's in a litany of the violence that has happened to us. I want to shine a light on our glamour and how our glamour can change the world. In 1969, Stonewall was raided and people were arrested under the guise of anti-crossdressing laws. The state was enforcing a moral code around the gender binary. This was a very real and very violent regulation of our aesthetic. There is power in our aesthetic sensibility, and the state feared it. It undermines and shows the falseness of this morality. So when I shine a light back on our superficiality, back on our glamour, back on our beauty, it's for two reasons. One, it's about just how beautiful and full of dreams we are. And two, to remind us of the deep, deep power of things that are supposedly just on the surface.

▼ Elevating Black trans womxn is central to Tourmaline's artistry and activism.

▶ (top) Prints of stills from *Happy Birthday, Marsha!*, a film co-directed by Tourmaline and Sasha Wortzel. (bottom) A print of a still from *Happy Birthday, Marsha!* and a copy of *Trap Door: Trans Cultural Production and the Politics of Visibility*, a book co-edited by Tourmaline.

KIA LABEIJA

Photographer & Performance Artist

Kia LaBeija's art pulsates with passion and style and centers a narrative that prioritizes WOC. An Afro-Filipina and native New Yorker who works in the realms of photography, film, and performance art, LaBeija executes all three disciplines on the most authentic level. The New School alumna creates true-to-life self-portraits pulled from her reality, which are vulnerable, yet gutsy, and showcase her winning. As the former Overall Mother of the Royal House of LaBeija, her performance art is rooted in voguing, and ballroom has served as a foundational step in her artistry. Alongside LaBeija's art practice is her HIV/AIDS activism, where she advocates for underrepresented groups living with the disease. LaBeija's phenomenal and fearless work speaks volumes.

When did you know that you finally made it?

I think "made it" implies there is somewhere to be, an ending point, some great expectation to be met that signifies success. I hope to always feel successful throughout my lifetime, and by this I mean experiencing all the joys, transformations, and lessons from the work I put into all of my creative endeavors.

What is the best piece of advice that has always stuck with you?

"Everyone has a story, and if you don't tell yours someone else will, and they will tell it wrong."

How has the Internet and social media been pivotal to your career?

When I first shared images from my series 24 online, I gained a great deal of interest before the images were even in print. I received so much love and warm feedback. People really acknowledged the work. It's wild to comprehend the privilege of being able to share our art on a platform where anyone anywhere in the world can engage with it instantly. I don't have to wait for a gallery or institution to validate my existence. I can reach those who need to see my visibility the most.

How are you actively changing the art world?

I'm actively doing my part to shift it by not staying silent and by being present. There are many parts of the "art world" that are kind of shitty, so I put my focus in my creativity and stay close to those who have a deep love for the arts. I'm doing things my own way, as I always have. You have to lead by example.

◀ Kia LaBeija during her residency at Performance Space New York in the East Village, New York City.

Describe yourself in three words.
Dreamy. Magical. Strong.

When are you happiest?
Some of my happiest times are the simplest. Swimming in the ocean, laughing so hard I lose my breath, catching the sunset over the city, or breathing deeply under the full moon. Dancing with my lover, listening to jazz, and making art. Playing dress up, disappearing in a dimly lit club, being with other energies that sync up with my own.

▼ A print titled *In My Room* from LaBeija's debut series *24* (2014).

▶ LaBeija, the young artist and performer, giving you body and life.

"Voguing holds a special place in my heart because it was the first movement vocabulary I felt free in."

Your autobiographical self-portraits reveal other narratives of people living with HIV, specifically young WOC. Why has this been important to show in your work?
I use the work I've created around HIV to expand a narrative that historically has left out women, children born with HIV, and the effects on families. So many of the images I saw growing up did not reflect my experience, so I made some. The stigmas around living with this virus can be so debilitating, especially for women. It can shift the way you navigate in the world, how you feel about yourself, how you conduct relationships with others. It can alter the perception of your own beauty, isolate you, run you. So it's important that I share myself, my story, and my fight so that others can also feel empowered.

Voguing occupies a very significant part of your life. Can you talk about how voguing has enriched your life and work?
Movement is vital to human survival and livelihood, period. It's how we communicate, how we express the deepest parts of our being. Voguing holds a special place in my heart because it was the first movement vocabulary I felt free in. For the first time, I could translate what existed in my brain through my body and into the world. I learned a great deal from the time I was heavily involved in the ballroom scene. I've had the privilege to be a part of a community that is so resilient, so alive, and continues to evolve. Anyone who has practiced the art of voguing knows it's more than just a dance, it's how we tell our stories. It's a highly individual practice that thrives off the uniqueness of each person's voice. Over many years, I've made it my own, and that's something no one could ever take from me.

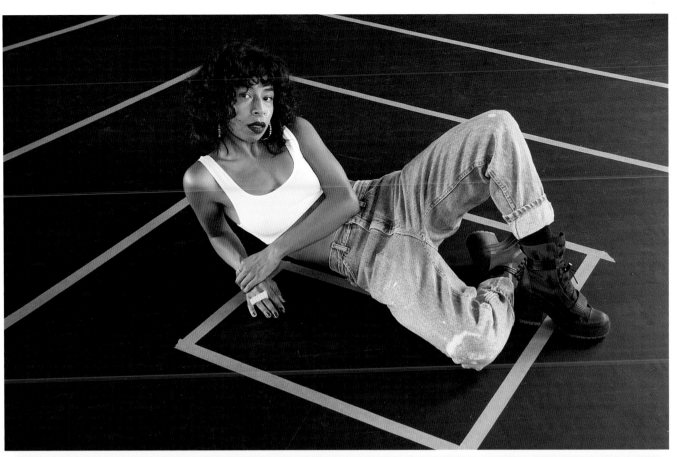
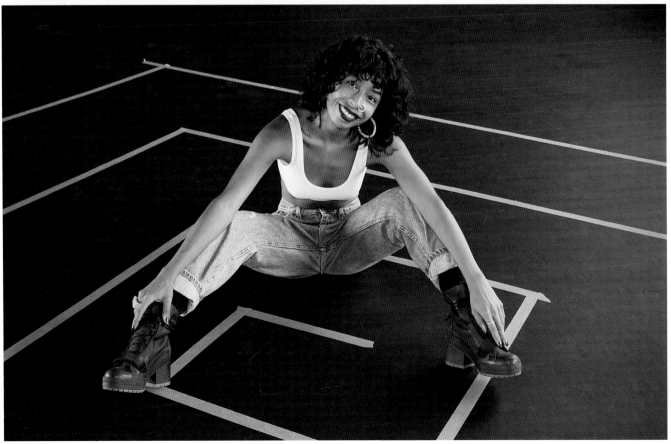

► *Mourning Sickness*
(2014), a print from
LaBeija's debut series, *24*

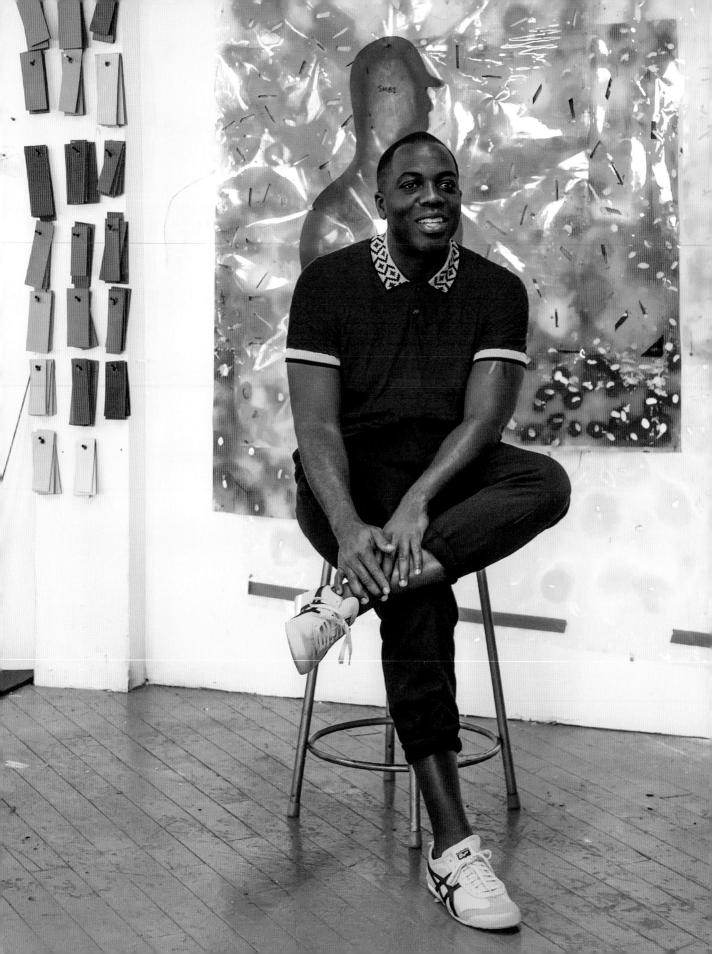

DEREK FORDJOUR

Contemporary Artist

Derek Fordjour is a Memphis-born, New York-based artist who creates sweeping and uplifting narratives commemorating African-American culture, while also incorporating his Ghanaian background. Fordjour's disciplines range from painting and sculpture to installation, and through these mediums joyful scenes are played out. Fordjour's paintings display the fanfare of exuberant band members decked out in regalia or a row of vibrantly dressed cheerleaders, sitting down in a split under a rain of confetti. Whether creating art for an MTA commission at the 145th Street subway station in Harlem or exhibiting globally, Fordjour's work is rooted in exalting Blackness.

How are you actively changing the art world?
I'm not certain that I am, however I do hope that my presence is unique enough to change what existed before me somehow.

Who is your favorite fictional character?
Young Goodman Brown from Nathaniel Hawthorne's 1835 short story that bears the same title.

When are you happiest?
When I'm barefoot because I don't like shoes.

Describe yourself in three words.
Far. Too. Reductionist.

You use a cheery, playful visual language—carnivals, parades, marching bands—to communicate serious issues like gun violence, race, and inequality. Why do you use this approach in your work?
I'm generally interested in the seduction of pageantry and celebration. I'm also interested in the emotional toil and personal expense of the celebrated.

◀ Derek Fordjour with a colorful work in progress in his Bronx studio.

How does living in Harlem and working out of the Bronx influence those messages in your work?
Making work from the vantage point of a lived experience lends authenticity and contemporaneity to my work. It's important to remain connected to the communities that inform my work in a very real and practical way.

◀ Vibrant details in Fordjour's studio.

▲ Various works in progress in Fordjour's splashy Bronx studio.

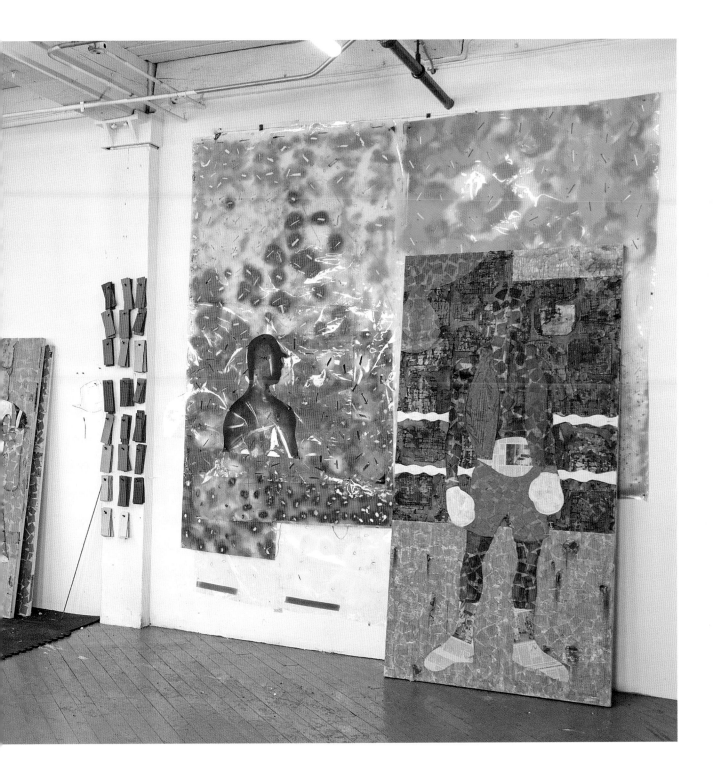

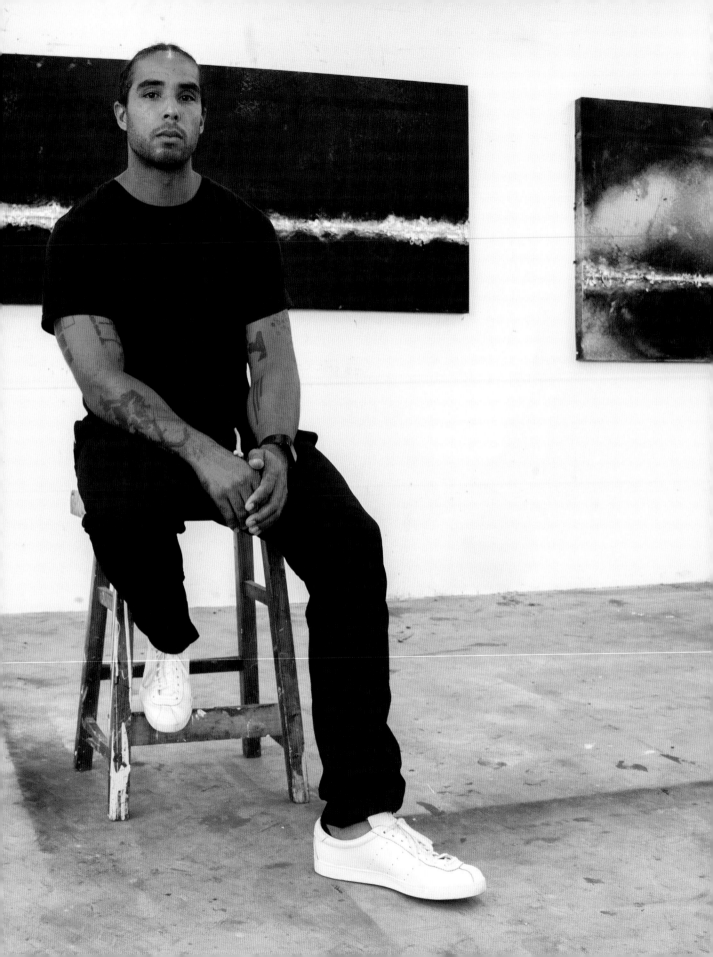

HUGO MCCLOUD

Contemporary Artist

Hugo McCloud's sleek metal paintings evoke a quiet storm of emotions, stillness, and power. Based between Mexico and New York, the Palo Alto native pivoted from a career in industrial and furniture design to contemporary art. McCloud, a self-taught artist, has carved out a career turning his gaze to the urban landscape, finding unexpected elegance in discarded and neglected objects. Pairing hard-edged materials—aluminum sheets, tar paper, copper, metal, steel, and bronze—with vivid color pigments and artisanal woodblock printing, McCloud refines these elements into striking multihued canvases. McCloud keenly observes humanity, life, and the world, both locally in Brooklyn and beyond, and lays it all out on the canvas.

How has the Internet and social media been pivotal to your career?

Social media and the Internet is a continual battle of too much or too little. It's a world that is still being figured out. An artist should have some level of mystery to them, but there is also value in the ability to expose yourself to an audience that would otherwise be unreachable.

What kind of art world do you want to see in the near future?

I personally want to see an art world where artists are artists and not producers.

Describe yourself in three words.

Grateful, driven, and confused.

What is your favorite color?

I honestly don't have one because I'm continually coming into contact with new colors and combinations. I feel I go through seasons, darks, lights, hues. It really changes based upon what I'm creating, and in that moment, those are my favorites.

Your paintings find beauty in unexpected places. Deconstructing, layering, and beautifying industrial materials; leading to an impressive abstraction. Why has this been a driving force in your practice?

When I started this career I gravitated toward these industrial, material processes and uncommon ways of creating art because of my past career as a designer

◀ Hugo McCloud with his works *#5* and *Intercept* (both from 2019) in his Brooklyn studio.

"I personally want to see an art
world where artists are artists
and not producers."

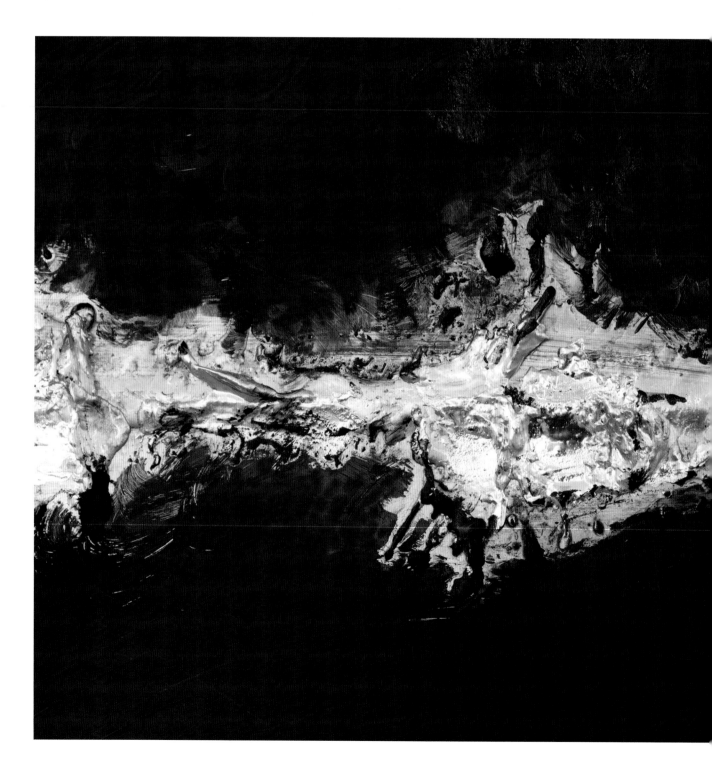

and fabricator. Now I really believe these materials and processes are attractive to me because I see them in direct relation to humanity and the self. Process demands order and acceptance is a choice, so finding attractiveness in things that would otherwise be found unappealing is a matter of changing your point of view.

Your canvases explore notions of value, labor, commerce, waste, and so on, all observed from your daily life and your travels to Asia, Africa, and Latin America. How do you form connections between these ideas in your work?

I'm interested in how people do things, regular things, and how survival plays a big part in this. Labor, commerce, waste, and so on, all relate to each individual differently depending on what they value or need, because all of these are based on value and humility.

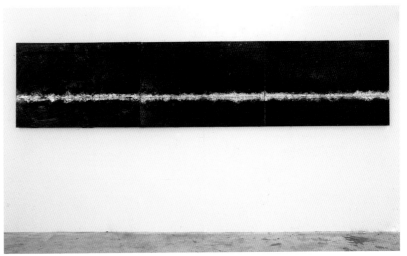

Dopeness in the details. A close up (left) and full view (above) of #5, made of patina mix media on bronze metal (2019).

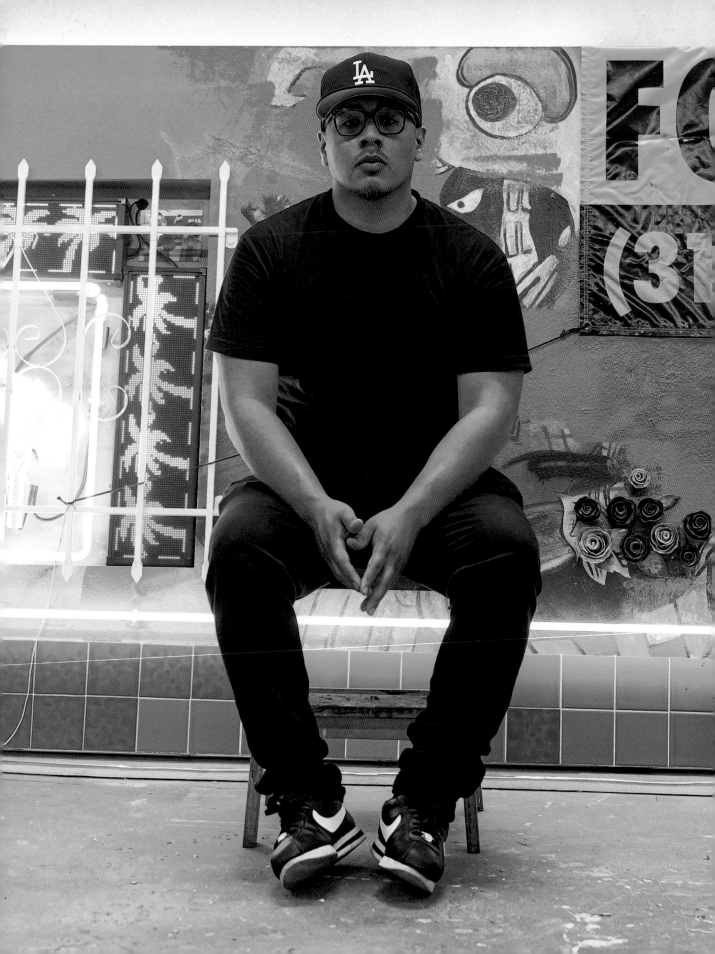

PATRICK MARTINEZ

Contemporary Artist

You won't find a glossy version of Los Angeles full of palm trees and flashy convertibles in a Patrick Martinez canvas. Instead, Martinez goes beyond the glitz to offer the brutal authenticity of his beloved city. An LA native of Mexican, Filipinx, and Native American descent, Martinez works out of his DTLA studio producing mixed media canvases, neon sculptures, and installations depicting the grit, guts, and complexities of LA. From the rapid gentrification that's infiltrating to marginalized groups facing exclusion, Martinez chronicles this reality, while constantly keeping Black and Brown narratives at the forefront.

When did you know that you finally made it?

When I had the ability to pay for my living space, bills, studio, along with financing my own art projects through the sales of my work. For me, "making it" is an ongoing idea that evolves every day. These days it's more about being happy, trying not to participate in patriarchy, creating, community, family, contributing to great causes, helping people, and challenging my work in the studio.

What is the best piece of advice that has always stuck with you?

The truth never goes out of style.

How are you actively changing the art world?

Hopefully by adding to the conversation of art in a real way, not being redundant by producing work that is similar to the artists that came before me, or capitalizing on contemporary aesthetic art trends. I truly hope that I'm creating space for people of color in the context of art museums and galleries which in turn shifts the narrative. I want my friends, family, brother, mother, father, and my ancestors to be seen in those spaces. Inclusion will create change in the art world. I want kids of color that aspire to become visual artists to feel like they have a place and enough space to speak in the art world.

When are you happiest?

Working on new pieces in solitude at a steady pace without outside pressures of deadlines. It really takes me back to my childhood, being so still while working on a drawing or sculpture. There was no endgame, just pure passion to produce something that once wasn't there. I try and

◀ Patrick Martinez in front of his epic mixed media piece, *Paradise Lost*, in his Los Angeles studio.

keep that innocence close to me because it's why I started making art in the first place. I would honestly make art even if I couldn't make a career from it. It's a very autotelic experience for me.

Who is your favorite fictional character?

I'm an eighties baby, so Optimus Prime from *Transformers*. He was a good moral dude, and I always enjoyed the fact that he could transform into something else. Evolving or having layers to ourselves is a must. I understand people are many different things and I celebrate that.

You're a native Angeleno, and you represent your city so truthfully in your art—its beauty, its flaws, its complications. Can you describe this process?

Through the production and presentation of my work, I tell the stories of the communities, people, and establishments that create the signs and symbols that so distinctly characterize LA. I look to uncover the individuals that are both serving and served by our communities; the people who construct them, work for them, migrate to them, commute through them, vandalize them, maintain them, and renovate them. My art practice is one of an archivist, memorializing the acts, sentiments, and populaces that have made LA, in spite of the city's wavering interest. My persistent interrogation of the materials and stories of LA produce the foundation for an approachable, transparent, and consequential investigation of myself, my process, my city, and my country. The landscapes, people, and languages of LA are the essence of my work.

Your neon sculptures are so powerful and speak volumes. What drove you to work with neon and address social justice issues?

I'm inspired by liquor stores, laundromats, and check cashing storefront signs. My neon sculptures replace the language of advertising with the language of protests, politics, and optimism. These works are meant to be inspirational, but also serve as warnings to the devastating consequences of misused power. These works evolved from sculptural light pieces to using language that spoke to a rap generation/hip-hop subculture, to protest posters speaking to Americans during this current political climate.

◀ Dopeness in the details. A close-up of Martinez at work.

▲ A full view of Martinez's *Paradise Lost* in his studio.

"I want kids of color that aspire to become visual artists to feel like they have a place and enough space to speak in the art world."

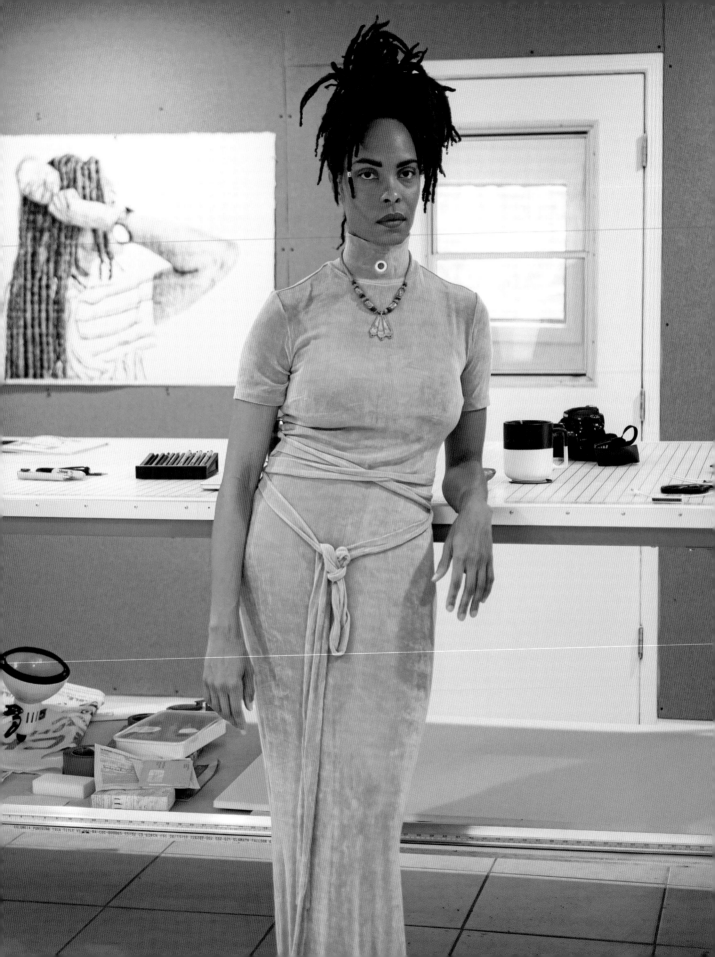

KENTURAH DAVIS

Visual Artist

Kenturah Davis's intimate and hazy portraits feature friends and peers, people key to her universe, fused with text. She uses a range of oil paint, sumi ink, charcoal, stamp letters, and handwritten text on assorted Japanese papers like kōzo, Gampi, and Mohachi. Davis's portraits are blurred, with tender layers of emotions left to be unraveled by the viewer. The Occidental College and Yale School of Art alumna navigates her artistry while creating in three different locales: Los Angeles, New Haven, and Accra. Davis uses language to cloud notions of representation and identity in her drawings, photographs, and public art.

When did you know that you finally made it?

I still feel like I'm at the beginning of a long journey, but I can say that one special moment was when Ava DuVernay came for a studio visit with her friend Oprah Winfrey. Another was the opening of my first solo show at Matthew Brown Los Angeles, after finishing grad school at Yale School of Art. So many people were there to embrace the new work, it was overwhelming.

Describe yourself in three words.

Full of contradictions.

When are you happiest?

I'm happiest on a beach in western Ghana. I usually have my camera, a plate of freshly caught lobster, and a book that I pretend to read while I'm actually just daydreaming. I can swim out into the warm water, feel the power of nature, and see the stars at night.

Who is your favorite fictional character?

My favorite character, Flying Snow, is an assassin who navigates love and duty in a beautiful and fantastical way in the Chinese martial arts film *Hero*. I admire her stoicism and commitment to her cause, but she is also just so intensely fierce and elegant at the same time. The film is brilliantly sequenced and shot to create a compelling character.

◄ Kenturah Davis, gorgeous and glowing, in her neutral-colored studio in Los Angeles.

Black. It's the most mysterious and complicated color to describe. It embodies so many contradictions in the ways we've put it to use.

It started when I noticed a page in my notebook where some writing overlapped a sketch. I realized the quality of the written lines were not any different from that of the drawn line, except that the written lines were marks we've assigned meaning to. I was curious if I could manage to write a portrait in which every mark has meaning. Ultimately, I began to explore the human relationship with language, so that making portraits by writing text became a metaphor for how we absorb and embody ideas expressed with language.

The people in my drawings belong to communities that are central to my world, so I don't approach these portraits as marginalized subjects who need me to persuade others of their complexity or humanity. To quote my North Star, Toni Morrison, "I stood at the border, stood at the edge and claimed it as central, and let the rest of the world move over to where I was." While each portrait has its own character, they all remark on the complicated ways we use language to categorize, to describe, to evade, to articulate, to record, to blur, to enforce, to create, etc. I'm invested in this effort to explore meta concepts via the representation of POC subjects, Black women in particular.

▽ Davis in front of *In Praise of Shadows*.

▷ A detail of a visually-arresting work in progress.

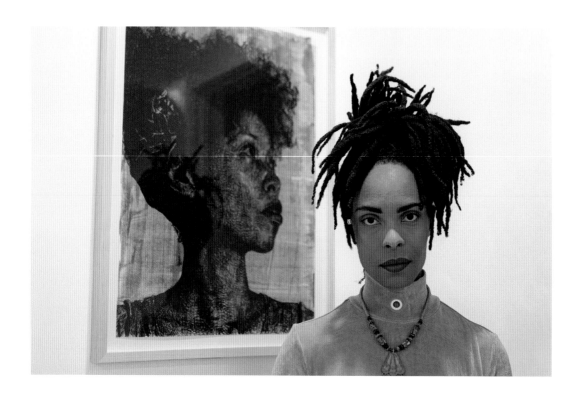

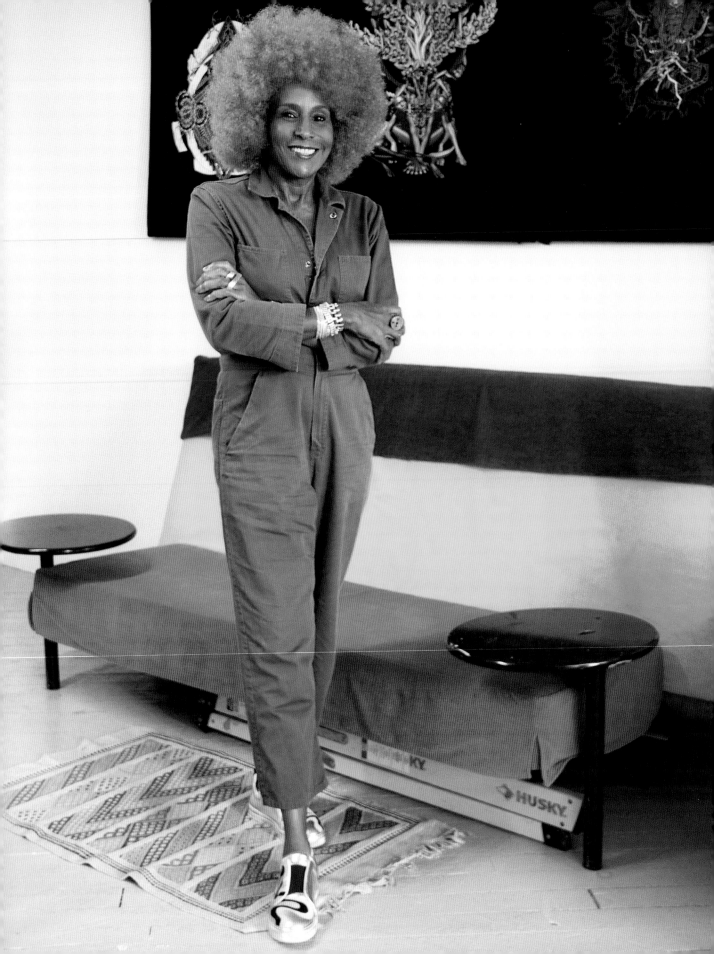

RENEE COX

Contemporary Artist Using the Medium of Photography

Renee Cox is a supreme Black feminist artist. In her provocative, stimulating, and enthralling images, Cox places the Black female body in a myriad of stances: triumphant, maternal, seductive, omnipotent, and bougie. A native of Jamaica based in New York, the Syracuse University and School of Visual Arts alumna crystallizes the richness of Blackness—especially Black feminin-ity. In her photography, Cox has portrayed herself as an Afrofuturist superhero sitting atop Lady Liberty, as a Black Madonna with child, and as Jesus Christ at the center of a recreated Last Supper scene surrounded by Black disciples and a white Judas. Cox's spectacular body has been the vessel to tell these visual narratives so masterfully. An artist, photographer, activist, and professor, Cox's photographs, collages, and installations affirm Black womxn's beauty and our many superpowers.

What is the best piece of advice that has always stuck with you?

Do what you know how to do best. Create from the heart, the soul, and from the inner being. That is the domain of creation. Then use the brain for all logistical executions.

How are you actively changing the art world?

I don't think I'm changing the art world, I just think my message has been very consis-tent over the years. My main concern is the glorification and empowerment of people of color who have historically been misrep-resented as buffoons, criminals, the most feared, and any other negative thing you can think of. My mission is to turn this false way of thinking over to a positive view.

◀ The iconic Renee Cox in her Bronx studio in front of a triptych from her 2018 series, *Soul Culture.*

Describe yourself in a few words.

I am that I am.

Who is your favorite fictional character?

Once I came up with the concept for a Black superhero named Raje, I dove into research, finding author William Moulton Marston, the creator of Wonder Woman. I immediately read all the Wonder Woman comics from the 1960s and eventually discovered the character Nubia, Wonder Woman's Black sister who even appeared on a few covers in the 1970s. I took artis-tic license and created Raje to be of this lineage, establishing Nubia as her grand-mother. This link gives Raje a solid plat-form. Her mission is to fight racism and

▲ An inspirational view of Cox's Bronx studio, featuring a triptych from her 2018 *Soul Culture* series.

▶ A close-up of Cox's *ELEMENTAL ENTITIES*, from her 2018 *Soul Culture* series. A three-dimensional, hand-cut, archival, inkjet print that is collaged.

put clothes on, the garments start to speak. For me, being nude was a very powerful act. When you're nude, people have to deal with you directly. In nudity, there is a great deal of strength.

You've inhabited fierce figures in your photography—a Black female Jesus Christ, a social justice superhero named Raje, and Jamaica's national heroine, Queen Nanny of the Maroons. Can you talk about being a boundary-breaker and what motivated these bodies of work? There is a very distinct motivation behind Raje. She came out of the search for superhero characters for my kids, which lead to the discovery that there were no Black superheroes, which is really weird. The only way I knew how to correct this was to create my own character. So that's what I did. Queen Nanny is another singular figure as the only female national hero in Jamaica. Surprisingly enough, no artist had really investigated or created anything around her. I thought, *Great, that's wide open. Jump right in.* And I did.

When I was in Catholic elementary school, they taught from the Bible, which says we're all created in the likeness of God. There was nothing that specified he was a white male. You don't even think about it. I took that to heart as a kid. As an adult, I've discovered other practices, such as Buddhism, where we are all God and it's up to us to find our godlike state in this life. In my work, I'm interested in creating my own propaganda, and to cultivate awareness in the process. It doesn't come from a hostile place, it comes from a point of initiating a conversation about these histories that need to be discussed.

break down the misconceptions and stereotypes associated with Black and Brown people, figures like Uncle Ben and Aunt Jemima.

What is your favorite color? Purple is the color I aspire to. It's the highest chakra color, representing pure consciousness.

In your self-portraiture, you present yourself nude, and you've been instrumental in how Black female bodies are perceived. Can you talk about this consistent celebration of Black womxn? It has to be a constant celebration because I am a Black woman until death. The Black female body has been trampled on for centuries, so it's absolutely vital that these bodies are celebrated and that there is a feeling of ownership there. In terms of using nudity, it was a means of being truthful, of being myself without judgement. Once you

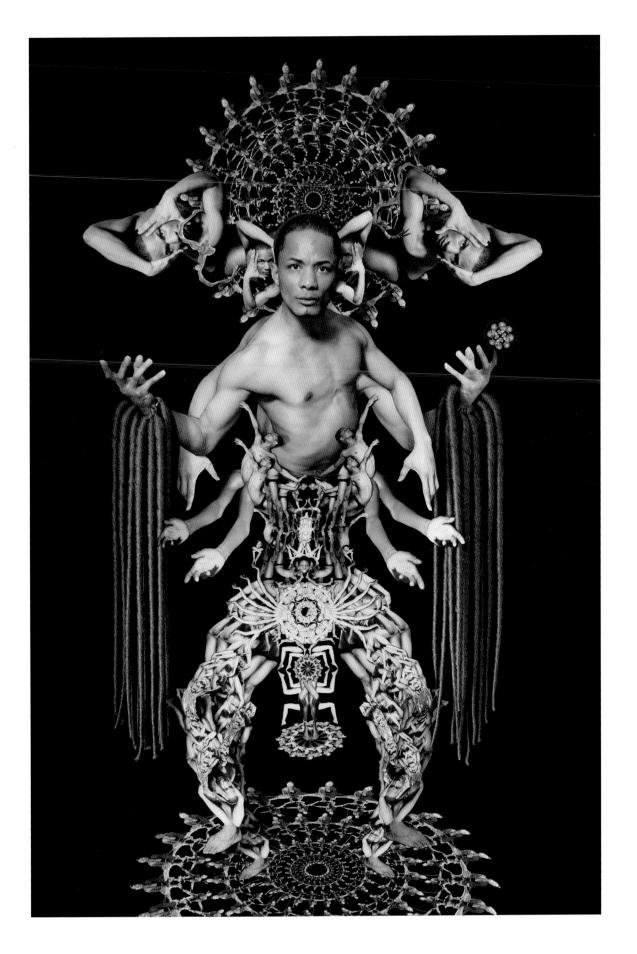

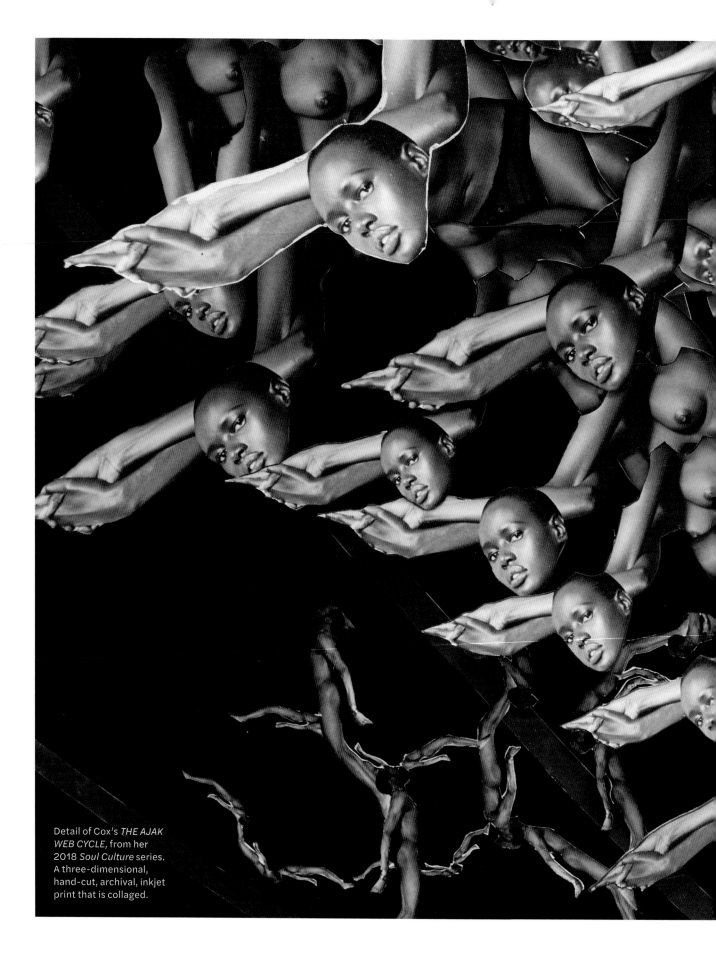

Detail of Cox's *THE AJAK WEB CYCLE*, from her 2018 *Soul Culture* series. A three-dimensional, hand-cut, archival, inkjet print that is collaged.

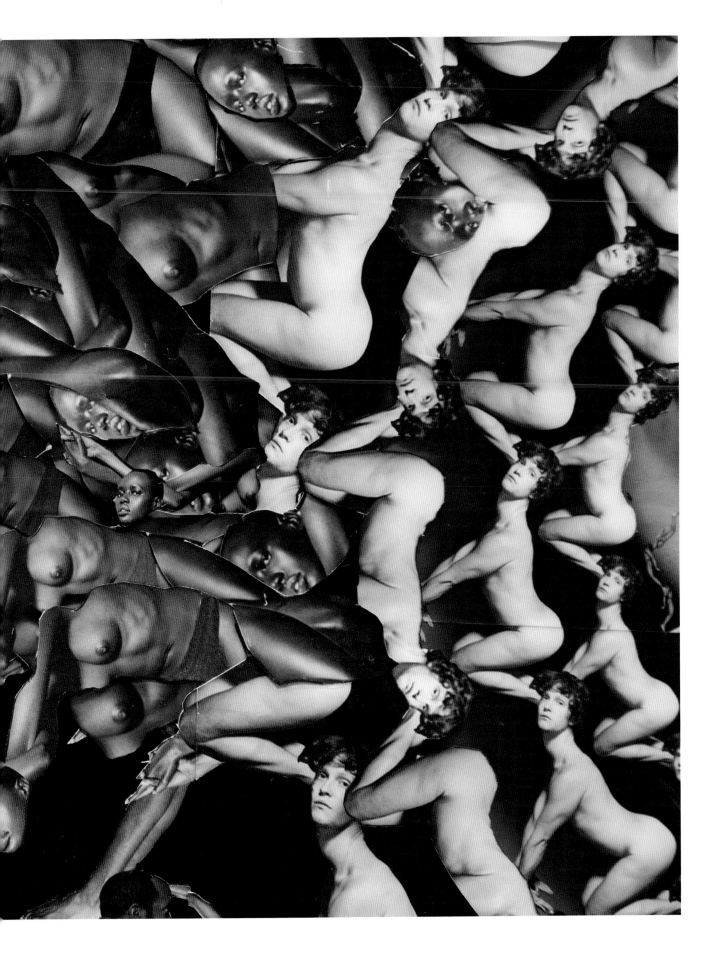

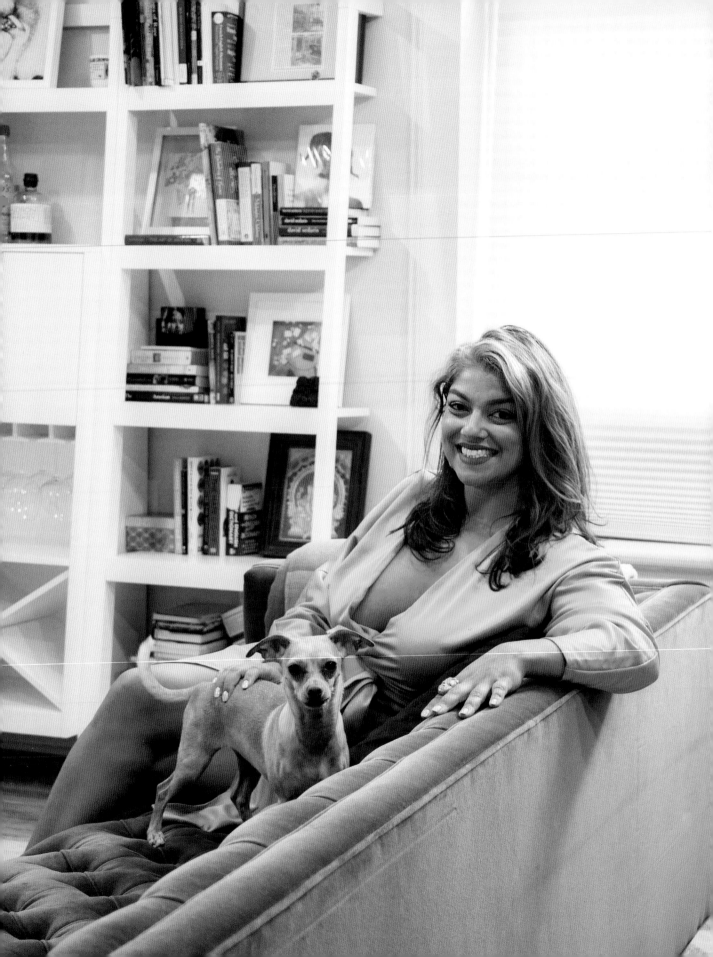

JASMINE WAHI

**Founder & Co-Director, Project for Empty Space
& Holly Block Social Justice Curator, Bronx Museum**

Jasmine Wahi is one of the baddest womxn around in the art world. A fact. The New York-based curator, speaker, writer, and professor is fully immersed and committed to honoring WOC, POC, female-identifying, queer, trans, and nonbinary artists through her plethora of curatorial and activist endeavors. Her curatorial adventures have taken her to Brooklyn, Miami, and Japan. As the founder and co-director of Project for Empty Space, an exhibition venue and artists' studio complex in Newark, New Jersey, and in her curatorial role at the Bronx Museum, Wahi strives for local and global impact with binary-breaking and boundary-pushing artists and exhibits.

How has the Internet and social media been pivotal to your career?

There are a few ways that social media has been important to my development as a curator, particularly as a curator with an interest in creating visibility and conversations around social equity. The thing with invisibility is it's hard to find what's invisible, except when on the Internet! So it has first helped me to facilitate a community. I've connected with so many people (some of whom I still haven't met in real life, but still feel like part of my community) who share my curatorial interests—people who, through the visibility and vulnerability of our posts, are sending out a kind of signal. Social media and the Internet has also benefited my career in the accessibility and exposure of artists. I'm a voracious consumer of creative culture—that's why I'm

a curator. The Internet has allowed for an unprecedented access to new work that I may never have seen otherwise. So many of the artists I work with I have found online. In that same vein, I think social media, Instagram in particular and Facebook to an extent, have also allowed for artists to more easily reach me and know about the type of work I do.

What kind of art world do you want to see in the future?

I have to start by clarifying that I don't think there is one art world. I think that's a hegemonic idea. However, there is a more "mainstream" art market that transcends the industry into the larger cultural zeitgeist (household names like Picasso, Jeff Koons, etc.). So what would I want to see from that? Simply, more of us. When I say "us,"

◀ Jasmine Wahi and her sweet dog Momo in her elegant Brooklyn home.

"I take my own experiences, my traumas, my sorrows, my joys, I take all of it and push them into a space of community and visibility."

▶ (top) From left to right: a hot pink David from Florence; coasters featuring old Bollywood stars, like actress Rekha in the classic *Umrao Jaan*; Alexander McQueen shoes; a tiny Ganesh ji; a mug from the Skowhegan benefit featuring Lorraine O'Grady's work; a wood block from India; and a Venetian lace fan. (bottom) A photograph of Wahi's grandmother, Sarla Vohra; print from Theaster Gates's 2018 exhibition *Black Madonna* at Kunstmuseum Basel; limited edition risograph print *Selling My Black Rage* (2018) by Kameelah Rasheed, created with Wahi for the VOLTA art fair; a gifted piece by an unknown artist.

I mean people who historically have been on the margins; who have been historically and systemically erased, made invisible, and written out of art history. If art is meant to reflect society and society is meant to reflect art, then I want to see all of us—Black, Brown, queer, Asian, trans, femme, poor, ambiguously racial, amputated, colored, indigenous, nonbinary, etc.—in the future, and not just represented on the walls for the consumption by others and ourselves. But I want to see us in positions of power—curators, gallery owners, docents, educators, academics. This is not to say that I want to see white people, particularly white men, disappear, but that there needs to be more of us shaping the conversations. And I want to see us have value. Market value, yes, but also discourse and intellectual value.

Describe yourself in three words.
Brown. Girl. Curator.

What is your favorite color?
Black has always been a staple in my adult life, but Black technically isn't a color. Currently it's YInMn Blue (an inorganic electric blue color that looks like a 21st century version of Yves Klein blue) and saffron yellow. YInMn Blue because it's simply so vibrant. Saffron yellow because, as cliche as it sounds, it makes me think of South Asia. There's an element of nostalgia in that color and a warmth that is found both in the summer sun and in the dusk of an autumn day. It makes me think of dressing up as Krishna when I was a child, my parents maintaining a sense of cultural heritage for my sister and I. It also reminds me of one of my first Kuchipudi (a form of classical Indian dance) costumes. So, nostalgia is why I love saffron yellow.

At the forefront of your curatorial work is celebrating the intersectionality of womxn. Can you talk about how you've strived for this throughout your career?
Even when I wasn't able to articulate it, I think intersectionality and social equity have been at the root of my work. A lot of this stems from a selfish place, the need to see myself in the world as a WOC. I take my own experiences, my traumas, my sorrows, my joys, I take all of it and push them into a space of community and visibility. That selfishness translates to a kind of drive embedded in empathy, to see other people like me be seen and un-erased. Since I first started curating, probably ninety-five percent of the exhibitions I have done were oriented around social discourse and equity. I stand by the belief that all good art is inherently sociopolitical, so all of my exhibitions are comprised of art in that vein.

I've deliberately picked artists of color, particularly women and femme-identified artists, as the people whose work I want to show; this includes art from my personal collection. I think all the work I have curated is incredible, but it often goes unseen in the wider world, so it's important for me to use my position to highlight this work wherever I can. People say that art reflects society and vice versa. Well, if that's true, we need to see more of who is part of this society in every facet.

At Project for Empty Space, you serve as founder and co-director of a socially engaged, cultural space in Newark, New Jersey. What has been some proud moments with PES over the years?

There are so many proud moments! The opening of our first project on the Lower East Side with Tehniyet Masood, the day we officially opened PES Newark with over twenty artists addressing the idea of racial politics and belonging, or the time during that same exhibition when a large group of Newark Arts High School students engaged with jc lenochan's work *Public Protest Post* and spontaneously broke out into an a cappella aria. The time another small group of high school students came into PES Newark's space and thanked us because they (POC) felt seen in our space. Being present and seen at the Women's March in 2017. Putting up a large sign in our window that declared "ABORTION IS NORMAL" in 2019.

▶ Wahi's living room, which includes a bright pink Rico Gatson work featuring American hero Harriet Tubman.

LAUREN ARGENTINA ZELAYA

Director of Public Programs at the Brooklyn Museum & Cultural Producer

Lauren Argentina Zelaya is a fashionable, fierce, and focused young woman making waves at the Brooklyn Museum and beyond. The Brooklyn-based cultural producer, curator, and DJ of Honduran and Palestinian descent serves as the museum's director of public programs, producing inclusive, and vigorous events open to all. Zelaya's point of view is urgent and electric. Her programs are rooted in film and performance, and magnify LGBTQIA+ and immigrant voices. Past curated projects include Feminist Film Night, Black Queer Brooklyn on Film, and *yasiin bey: Negus*, all of which uplifts, empowers, and motivates audiences. As the producer and host of Queer Art Radio, her radio show that spotlights young queer creators, she continues to ignite the culture.

When did you know that you finally made it?

The first time I knew I made it was when I was able to see my vision realized in programs and exhibitions. Later, I began receiving recognition for those creative choices and cultural shifts in the field. My first review in *Art in America* for a film series I curated was a huge moment for me. Reading a positive review for the exhibition I co-organized called *Nobody Promised You Tomorrow: Art 50 Years After Stonewall*, published on the front page of the *New York Times* Arts section was affirming and

◀ The stylish and exuberant Lauren Argentina Zelaya at her desk at the Brooklyn Museum.

world-shifting. Still, nothing compares to when artists, friends, and others in my community acknowledge my work and thank me for my service. This has been the most validating signal of my success.

What is the best piece of advice that has always stuck with you?

At whatever place in your career, in whatever position in the hierarchy, whether inside or outside an institution, you can always find a way to share power. My friend and mentor Keonna Hendrick has taught me a lot about what this looks like. Toni

Morrison also has a great quote about this: "I tell my students, 'When you get these jobs that you have been so brilliantly trained for, just remember that your real job is that if you are free, you need to free somebody else. If you have some power, then your job is to empower somebody else.'"

How are you actively changing the art world?

By prioritizing joy and amplifying art by artists who have marginalized identities or who are from central Brooklyn. I believe in giving our local creators shine because we know the rest of the world is taking note. I did not grow up with anyone in my family working in the arts. It wasn't necessarily presented to me as a career path, but one I discovered and dared to dream about. Because of this I value transparency, and my approach to curating is always with an aim to demystify the inner workings of the institution and to center art forms that have not been traditionally collected or shown in encyclopedic art museums. I know that I am building on a legacy that others have started in terms of making museums more equitable and sustainable for all of our communities.

Who is your favorite fictional character?

I admire all of the female protagonists in Pedro Almodóvar's films.

What is your favorite color?

This changes all the time and usually corresponds to whatever I have on my nails. Right now, let's say green and beige.

In your role at the Brooklyn Museum, you center QTPOC, womxn, and immigrant artists in the programming you curate. Can you discuss using your agency to highlight these communities and connecting with museum audiences?

Brooklyn is one of the most diverse and populated places in the world. If I didn't curate exhibitions and programs that reflect that, I wouldn't be doing my job. People crave access to art and culture that speaks to them, reflects their lived experiences, and provides a gateway to learning about the world. The people of Brooklyn never cease to amaze and inspire me. Brooklyn is globally relevant. From nightlife and hip-hop to performance and painting, all of it has a place in the museum, and I do my best to leverage the space and resources we have to amplify the artistic production that happens here.

You created Queer Art Radio, which amplifies young, queer artists. Why is it important to document and broadcast your peers?

I started my radio show as an avenue to kick back, relax, and catch up with friends and creatives in my community who I think are doing interesting work. I'm also a DJ and love music, so it's fun to catch up with artists and listen to music together. I spend so much of my time in an institution. Don't get it twisted, I love my job, but I realized I craved something DIY. I spend so much of my time supporting the creativity of others in a formal setting and wanted to do something creative for myself and my community that didn't have to be polished or marketed in a serious way. Truthfully, I do it for fun, and if it serves as a means to document this specific time in the queer creative community in Brooklyn, that's a beautiful outcome.

LEGACY RUSSELL

Associate Curator, Exhibitions at the Studio Museum in Harlem, Curator & Author

Curator, writer, and author Legacy Russell is a gem. The native New Yorker, former London transplant, and Brooklyn resident is a splendid force in the art world who continually makes space for Black artists in her curatorial work, both inside and outside museum walls. The Goldsmiths alumna has accumulated notable experiences at the Brooklyn Museum, the Whitney Museum, Creative Time, and further amplified Artsy, the global online art platform, to larger audiences in the UK and Europe. In her writing and curatorial projects, Russell's voice is fearless, passionate, and resolute in centering ideas on gender, performance, digital feminism, and new media. As the current associate curator of exhibitions at the Studio Museum in Harlem, Russell's legacy to Black art and artists will only continue to shine.

When did you know that you finally made it?
Anyone who suggests they've "made it" in the art world is fronting. The journey is the destination.

How has the Internet and social media been pivotal to your career?
It's been a meeting place, a site of dialogue and exchange. It's also a space where the intersection of Black x queer performativity and creative cultural production has proliferated, opening up a whole new chapter of what performance looks like within and apart from the framework of visual culture and art history as we know it. This is most exciting to me.

Who is your favorite fictional character?
Rrose Sélavy. Hello Kitty. Polly Pocket.

What is your favorite color?
Anything that can be found on a Sam Gilliam canvas. Those works contain so much movement, expression, and gesture. The presence of the artist's body and hand and labor is generous, powerful, and stunning.

◀ Legacy Russell in a colorful corner next to her personal library in her Brooklyn home.

You are the founding theorist behind Glitch Feminism and have written extensive digital scholarship around it. What are some proud moments from seeing Glitch Feminism received by the world, online and offline?

I've just finished a book on this topic, which will be released next year. Throughout the years of doing this work and research, I've had the honor and pleasure of speaking at institutions, art spaces, symposiums, and festivals across the world. In 2019, I became a recipient of the Carl & Marilynn Thoma Art Foundation's Arts Writing Award in Digital Arts as an emerging writer with significant contributions to the scholarship surrounding new media and digital art practice. As part of this award in 2020, I'll also participate in the Robert Rauschenberg Residency as a Thoma Foundation Fellow. When I began theorizing about Glitch Feminism throughout 2012 and 2013, discussing how the Internet has shaped performative practice and provided new ways to push back against the gender binary, it was a leap for many people.

▼ An Elizabeth Peyton portrait of the Obamas, a photograph of Russell's partner's mother as a young woman, and important reads.

▶ More primary colors and art books fill Russell's living room.

As an East Village native, living in Brooklyn, and working at various museums in Manhattan, how does New York shape your curating and writing?

Growing up in the East Village, I spent time as a tween and teen going to Performance Space 122, CBGB, Theater for the New City, Danspace, Poetry Project, The Clemente Soto Vélez Cultural and Educational Center, Joe's Pub (where I saw my first Toshi Reagon show), and Stingy Lulu's (where I saw my first drag show). In Tompkins Square Park there was the yearly HOWL! Festival, Charlie Parker Jazz Festival, and Wigstock. These are the spaces and experiences that showed me how performance can be programmed, most particularly in making the link between an increasingly vanishing Black and queer nightlife in downtown New York, and how cultural production can play a critical role in the preservation of these important spaces, communities, histories, and futures. I want to ask hard questions about what has brought us here, whose history deserves to be told. What sparks my drive is being committed to occupying space across an exclusionary art history, one filled with so many blind spots. I want to occupy art history as a territory, and push it to its breaking point. If that's what being a curator is, if that's what being a writer is, then that's what I want to be.

"I want to ask hard questions about what has brought us here, whose history deserves to be told."

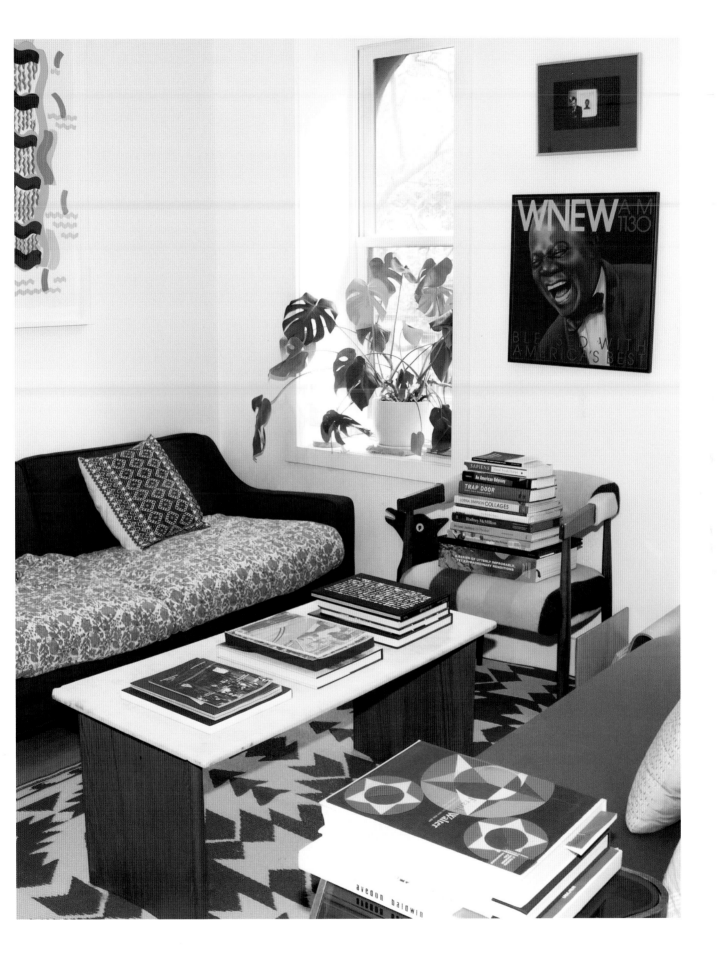

◄ Russell in the vivid living room of her Brooklyn home.

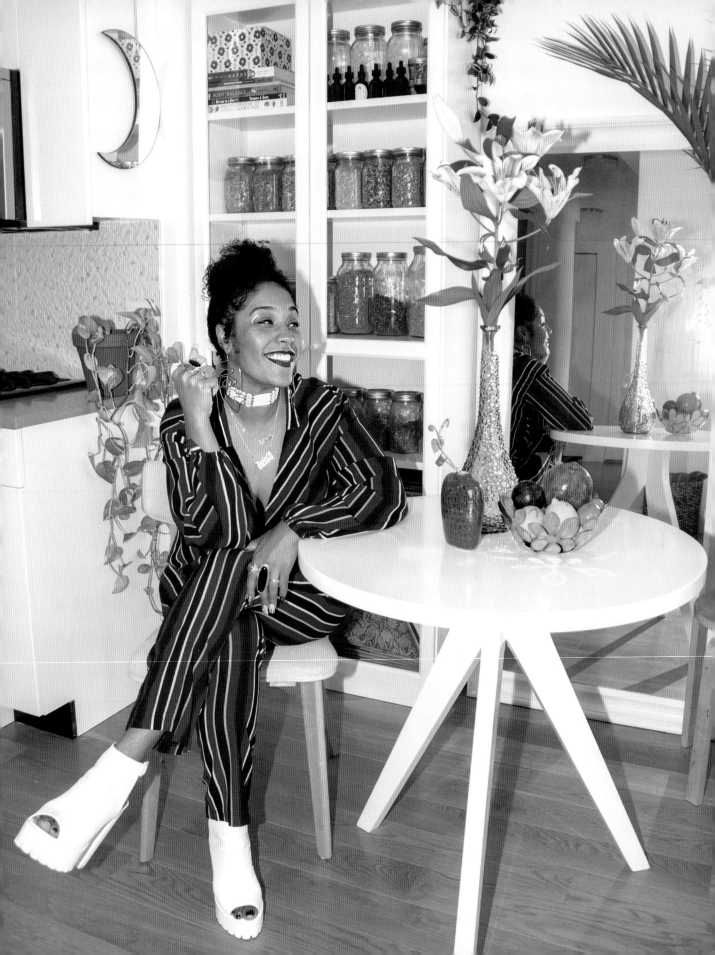

SUHALY BAUTISTA-CAROLINA

Senior Managing Educator, Audience Development and Engagement at the Metropolitan Museum of Art & Founder of Moon Mother Apothecary

Suhaly Bautista-Carolina is a New York City-born, Afro-Dominicanx arts administrator, organizer, and educator, fiercely impassioned about community-building and culture-making. The Brooklyn-based arts maven and New York University alumna thrives and shines in preserving Black community histories. Her many roles in cultural production have led her to Creative Time, the Caribbean Cultural Center African Diaspora Institute, the Brooklyn Museum, and now the Metropolitan Museum of Art, with a focus on equity and accessibility. Bautista-Carolina is also an herbalist and founder of Moon Mother Apothecary, which highlights the practice of spiritual herbalism. Her plant medicine brand invokes influences from the moon, her ancestors, and her young daughter. Bautista-Carolina is both an unforgettable Moon Mother and arts advocate.

When did you know that you finally made it?

A part of me hopes I'll never think I've made it, not with absolute finality, at least. I want to stay hungry. I never expected to be where I am, so now I'm curious about what else I'm capable of. I come up with new questions, new challenges, and new goals every season, which all illuminate the infinite possibilities ahead of me. It's a game to me. Once I unlock one level, I want to move to the next one. There have been many notable and memorable moments on my journey, and I feel so grateful and proud of each one, but I want to keep that special "it" on the horizon, always.

How are you actively changing the art world?

I just want to be here and do me. That has been my most effective approach throughout the years. I don't know that I'm changing the art world as much as I'm being changed by being in it, like in Octavia Butler's *Parable*

◀ Gorgeous in red, Suhaly Bautista-Carolina is surrounded by plants and herbs in her bright Brooklyn apartment.

191

of the Sower, "All that you touch You Change. All that you Change Changes you. The only lasting truth Is Change." I've always been invested in people, communities, and culture. I came to the arts because I understood very early on that it's essential to be connected to our cultures—to see, to touch, to taste who we are, who our ancestors are. I also understood that not all people had access to the transformative experiences the arts could offer, even when we were the makers ourselves. I want to do everything in my position of power to bridge that gap, and to challenge myself and the spaces I occupy to do better.

Who is your favorite fictional character?

Hermione Jean Granger from the Harry Potter series by J.K. Rowling. I see so much of myself in Hermione. She has a bossy, confident attitude and is the type of friend you always want to have on your side. She is profoundly loyal, annoyingly logical, and committed to justice (she goes on to work at the "Department of Magical Law

Enforcement, where she is a progressive voice who ensured the eradication of oppressive, pro-pureblood laws"). She is a lover of books and an insufferable perfectionist. Her deepest fear is failure. We share the bushy hair and brown eyes, plus she is a quintessential Virgo, like me!

What is your favorite color?

Yellow! It's a color full of life and vibrancy, as well as the color of so many of my favorite things: the sun, sunflowers, and honey. Yellow is also my favorite color to dress in. There is just so much joy and power in this color.

You've built an impressive career at institutions like Creative Time, CCCADI, Brooklyn Museum, and now the Met Museum. What are some valuable lessons that you've learned while working at these art spaces and institutions?

Listen. There is no one way to do any one thing.

As a queer Afro-Latinx cultural producer, what do you bring to the art world conversation?

Urgency, respect, and care. These ingredients are just as much a part of my identity, if not more, as "queer" or "Afro-Latinx." This is what I bring to my relationships, so what I bring to my work in the art world is no different. Urgency around the importance I place on our issues. Respect for the legacy of this work, for the communities and organizations I have the privilege of working with. Care for the way I move and work, and for the people, artists, places, and communities I serve. This is a really decisive moment for the art world. I feel a great sense of responsibility to my work, but also to all of the communities I am working and collaborating with and to myself.

▼ The iconic faceless Dominican dolls called Muñecas Limé nestled beside some plants.

▶ (top) Bautista-Carolina's light-filled living room includes artwork by Jazmine Hayes and festive Frida Kahlo pillows purchased at the *Frida Kahlo: Appearances Can Be Deceiving* exhibit (2019) at the Brooklyn Museum. (bottom) This photo of Thailand is a five-year wedding anniversary gift from Bautista-Carolina's close friend Regina Bultrón Bengoa, given to her and her partner Naiema.

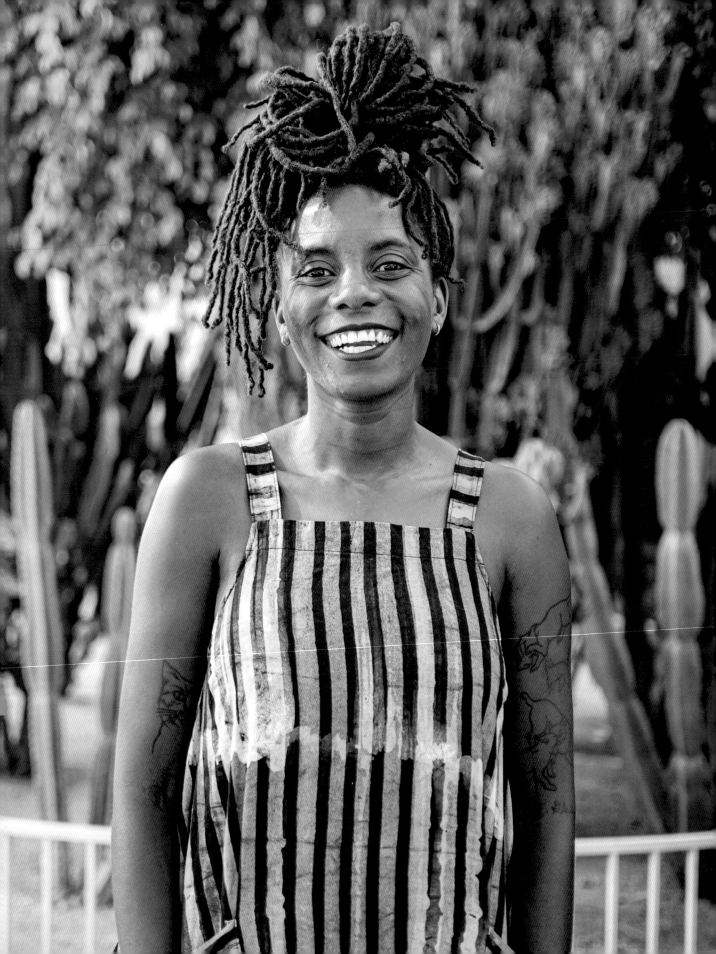

ESSENCE HARDEN

Independent Curator & Arts Writer

Essence Harden is a young, gifted, and Black curator, art writer, and PhD candidate living and thriving in Los Angeles. The Oakland native and UC Berkeley alum conceives, produces, and organizes radical and exuberant exhibitions on artists like Charles White and Shinique Smith. Harden was awarded a writing grant by Creative Capital and the Andy Warhol Foundation, on joint scholarship researched by them and Olivia K. Young, which highlighted the historic relationship between Black artists creating art in the US west. Harden's pursuit in seeking and spotlighting Black artmaking, California, and its documentation, holds extraordinary weight.

When did you know that you finally made it?

I'm not sure I'm ever at a state of satisfaction or completion, so the notion of success totally eludes me. I know I'm on the right path due to the incredible support, opportunities, and reminders I have that yes it is art, yes it is Cali, yes it is scholarship, and yes storytelling is the means by which to do this.

What is the best piece of advice that has always stuck with you?

I've got two! One from my life homie Esti's abuelo who said, "If you want to go to a movie, go to a movie," which I love because pleasure and rest are vital to counteract what often becomes the drudgery of life. The other is from my undergrad and committee member Waldo Martin, who said,

"There are good dissertations, there are bad dissertations, but mostly there are just done dissertations." I get distracted by my own hand-wringing and misconceptions about how to get projects done, so these little reminders help me move.

What kind of art world do you want to see in the future?

One where the whole of Black people are paid well to rest, for the labor done and for what they decide to create on their own now. A world where Black people don't have to shuck and jive for what's theirs.

Describe yourself in three words.

Black, Taurus, Oakland. These things are certain parts of my truths, locating me in ways that feel substantial.

◀ Black joy at its finest. Essence Harden outside their Los Angeles home.

When are you happiest?

Eating a delicious thing, listening to *Ptah, the El Daoud*, or *A Date with Lee*, or reading a sci-fi book for the first time next to Jihaari and my cat, Sir. I love productive rest and adore my love Jihaari and my cat.

What is your favorite color?

The ranges in brown have always been my beloved. My own skin is richly brown, and I love to make little worlds with my textiles, interior space, and garden that highlight and allow for brownness to reign supreme.

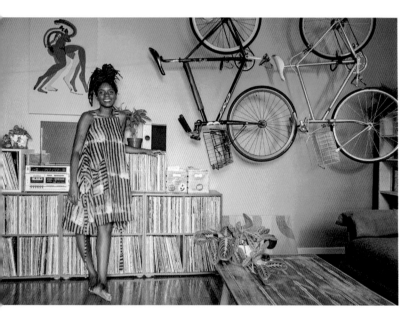

▲ Harden in their living room, which features a dope record collection and a warm shade of peach on the wall.

▶ Harden's impressive record collection in their Los Angeles home.

You're an award-winning arts writer who explores Black artists making work in the western US. Being from Oakland, CA, can you talk about your focus on Black artists and the West?

I'm a third-generation East Bay person. I was born in Oakland and raised between West Berkeley and East Oakland. My parents are from West Berkeley and North/East Oakland, and two grandparents were raised in Oakland. I share all this to say that being from California and having an extensive Black family history in two cities that nudge on top of the other (especially pre-2000 for Black people who traveled across the Berkeley/Oakland divide with ease) that my investment in the west is in large part a recognition of what has been so severely truncated it has seemingly disappeared.

Intergenerational Black families, art practices and traditions outside of the Panthers, mundane experiences in the arts, conceptual-based practices, visual archiving, literature, dance, and music, these are things I reveled in growing up and have found such solace in being here in LA. I love how Black people make art here (in California specifically and the western US more broadly) and the ways the geography informs possibilities about a breadth of practices.

In the endless desire to designate California a space without Black people (from Black and non-Black people alike), niggaz still here, still maintaining and assuring a legacy.

You curate through a Black feminist lens. Can you talk about your vision with the exhibits you organize and engaging younger audiences?

My sensibilities are invested in an inherent Black center, one that assumes Blackness as whole, complex subject and doesn't gesture to the idea that it would be otherwise. The hope for me is both rigorous engagement with the materiality of the work being presented, and in the affective swells being offered by each artist. I always want younger folks, older folks, and everyone in between to see the breadth of possibilities and the wealth of Black artistry; both what happened before and what is our now.

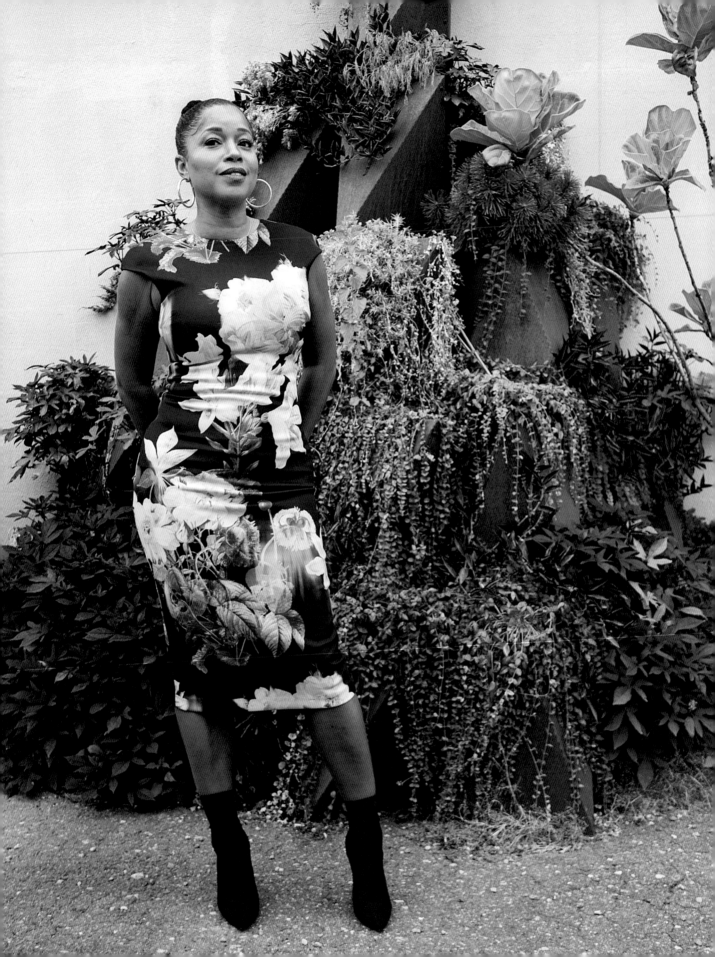

MASHONDA TIFRERE

Founder of ArtLeadHER, Curator & Author

Mashonda Tifrere founded the womxn-centric art platform ArtLeadHER to expand opportunities for female artists. Tifrere, the New York-based curator, singer/songwriter, art collector, and author, has shifted powerfully into art. Through Tifrere's visionary eye, ArtLeadHER has exhibited badass artists like Delphine Diallo, SWOON, and Tawny Chatmon at galleries in New York and beyond. Whether organizing ArtLeadHER's international shows, speaking at panels, or exhibiting in art fairs, Tifrere is focused and firm. Pushing womxn artists to the front. All the way to the front.

What is the best piece of advice that has always stuck with you?

My West Indian grandmother poured endless wisdom into me when I was a child. "Feed people with a long spoon," she would say. Extend yourself, be kind, but also be discerning and careful.

How are you actively changing the art world?

I'm creating platforms and networks for creative women to utilize and thrive within the art world. I'm empowering women every day to stay focused on their craft and never give up.

Describe yourself in three words.

Resilient, because I'm willing to bend, but I won't break. Loyal; loyalty starts with self, and I'm able to stand in it and exemplify it to those in my circle. Honest; I don't like lies or liars.

When are you happiest?

I'm my happiest when my son is his happiest. He is my hero.

What is your favorite color?

Cobalt blue. It looks like and gives a feel of electricity.

◀ Mashonda Tifrere in front of a lush backdrop at A/D/O by MINI in Brooklyn.

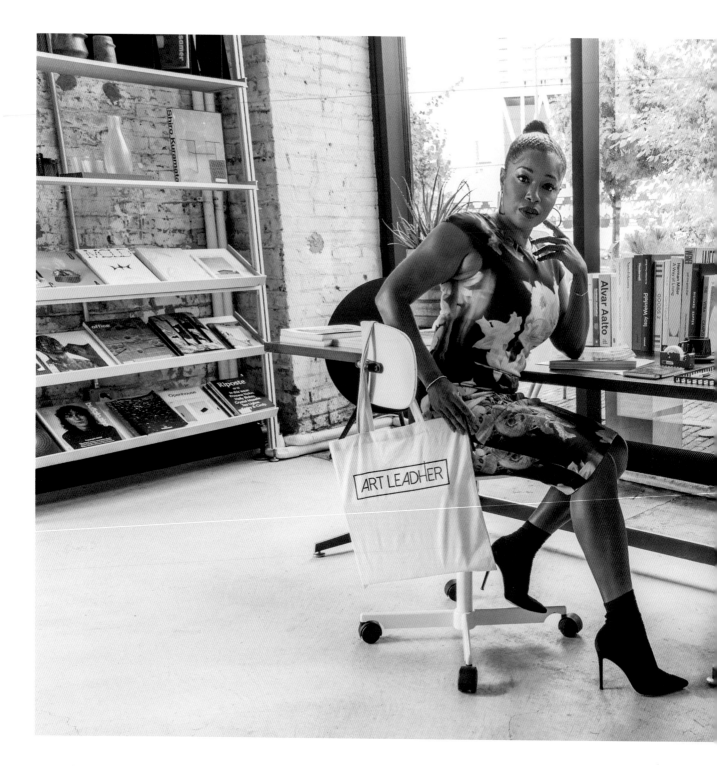

You founded ArtLeadHER, a platform to provide equity for womxn artists. What are some successful moments that you can share?

Partnering with Donna Karan for two consecutive years to celebrate International Women's Day at Urban Zen. I was able to provide wall space and a valuable experience to twenty emerging female artists.

As a POC using your agency in navigating the art world, what are immediate structural changes you want to implement?

I want to dismantle the structure of how museums and galleries operate, from who they hire to which artists they show. I want to see more WOC running galleries and working in museums. I want to see more women and Black and Brown artists on the walls.

◀ Tifrere assumes a boss stance at A/D/O by MINI in Brooklyn.

▲ Tifrere founded ArtLeadHER, which had its timely launch on International Women's Day in 2016.

DIYA VIJ
Associate Curator, Creative Time & Cultural Producer

In New York City's community of cultural changemakers, Diya Vij is one of its brightest stars. The Connecticut-raised, Brooklyn-based art worker and style chameleon has moved and innovated through New York's most vital museums, government agencies, and cultural spaces. The former Associate Curator of Public Programs at the High Line has utilized her talents in incisive, meaningful, and powerful ways. How can artists get more funding? How can the city support momentous public projects for artists? How can all audiences enjoy public art in the city? Vij has been and continues to be centrally invested in these ideas, and is never apologetic.

How has the Internet and social media been pivotal to your career?
Social media began my career. I was six months into my Curatorial Fellowship at the Queens Museum when a full-time position opened in social media, which I had never used previously. It was an incredible platform that gave me the opportunity to produce programs online, including a then-widely used weekly chat on critical topics in arts education, often lead by practitioners. Social media also expanded my network exponentially and quickly. I met so many people working in the arts through various social media meetups like #ArtsTech. I began to build my community of artists and art workers of color online, particularly those who share an urgency to fight for equity within our field. These relationships are life-sustaining for me as we all navigate the difficult work of institutional change.

Describe yourself in three words.
An unapologetic Aquarius.

When are you happiest?
I grew up with a lot of family. For every holiday, we were crammed into someone's house, twenty people sleeping on couches and the floor. We're Punjabi, so everyone is a storyteller and loves to tell jokes. There was always an endless supply of aloo parathas and aam ka achaar. We barely left the house when we were together. Since then, I've found my own chosen family. I'm always happiest when surrounded by friends and family, with nowhere to be and nothing to do, and endless jokes to tell.

◀ Diya Vij in her Brooklyn home. Behind her hangs a poster for a Mierle Laderman Ukeles exhibit at the Queens Museum.

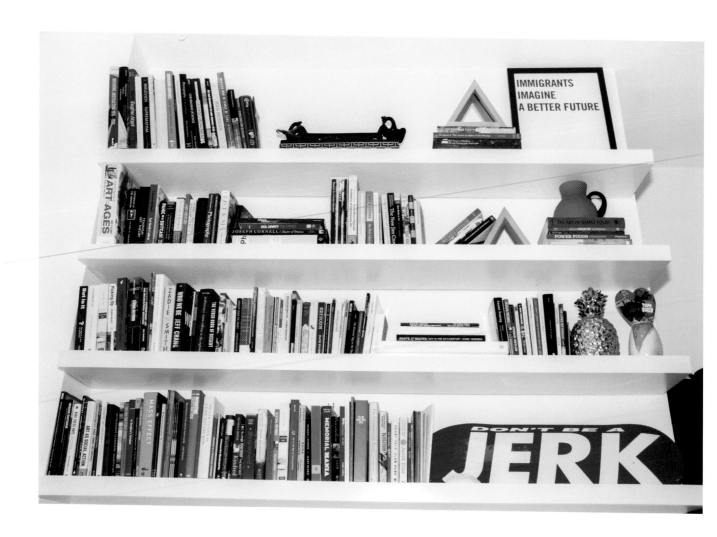

IMMIGRANTS IMAGINE A BETTER FUTURE

DON'T BE A JERK

▲ Vij's personal library and other cool objects like a Barbara Kruger *Don't Be a Jerk* skateboard deck (2017), a Tania Bruguera *Immigrants Imagine a Better Future* protest poster from Immigrant Movement International's march at Occupy Wall Street (2011), and a Papi Juice party fan (2018).

▶ Eclectic details on Vij's tabletop include a fish vase from Wing On Wo & Co. in Chinatown, New York City, and a *Protect Sacred Water* sticker by Ernesto Yerena that benefits the Owe Aku organization.

Who is your favorite fictional character?

When I first started working at the New York City Department of Cultural Affairs, I changed my social media profiles to say "Olivia Pope of NYC Art." That alter ego still makes me smile. While I have to admit that I drifted off *Scandal* after the first couple of seasons, I love thinking, *What would an art world fixer do?* But a fixer for good, not for the wealthy and powerful.

What is your favorite color?

Gold. It reminds me of my ancestors and shines off my melanin.

A big part of your career has to do with being a change agent. With your roles at the High Line and New York City Department of Cultural Affairs, how do you feel that you are actively changing the art world?

I've worked with so many amazing artists and practitioners and have been able to work on some cultural policy as well. I'm proud of a lot of that work and hope it cumulatively has an impact on the art world. I think a lot about the role of artists in an expanded idea of public space. A lot of my work is also about building bridges between civic life and art practice, finding platforms for what artist Tania Bruguera calls *Arte Útil*, art that is a tool for political,

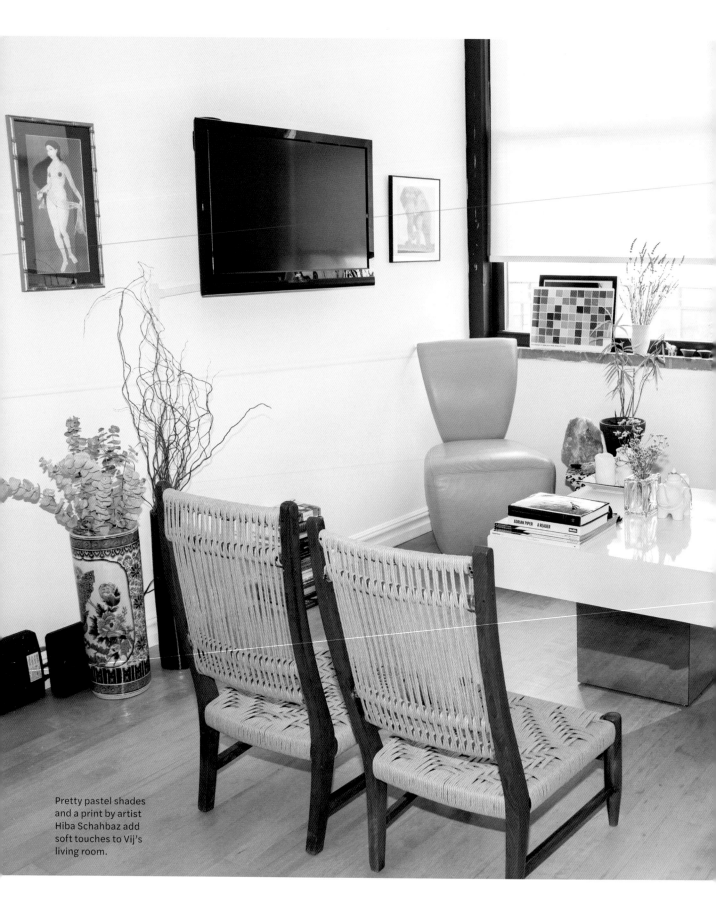

Pretty pastel shades and a print by artist Hiba Schahbaz add soft touches to Vij's living room.

economic, and social change. I also try to do everything through an equity lens. The Department of Cultural Affairs' Public Artists in Residence program has created more pathways for artists to work inside government to affect change, and programs like CUNY Cultural Corps really do change the landscape of art workers and board members in the future. I also feel confident that the High Line walkers who stumbled into A.R.M.'s *Blood Fountain*, a bold anti-memorial performance to HIV/AIDS and gentrification, left feeling more aware of the history and context of their surroundings.

Outside of your main roles at art organizations, what are some independent projects that you're proud of?
I've been a founder or member of a few informal groups of creatives of color, and I'm always grateful for those gatherings. I've also organized with friends and peers for various immigrant rights campaigns and political groups. I'm proud of all of that, but I'm really proud I completed my masters at Hunter College while working more than full time. While there, I wrote my thesis on artist Mierle Laderman Ukeles's forty-year residency with the New York City Department of Sanitation (DSNY). I spent countless late-night hours combing through her archives in her DSNY studio downtown. I read memos, looked through photographs, watched videos, and touched collections of dust and props from past performances. Art workers wear many hats within institutions and have a lot of work to do on short timelines, so having the opportunity to take my time with one artist's work was a true highlight of my career.

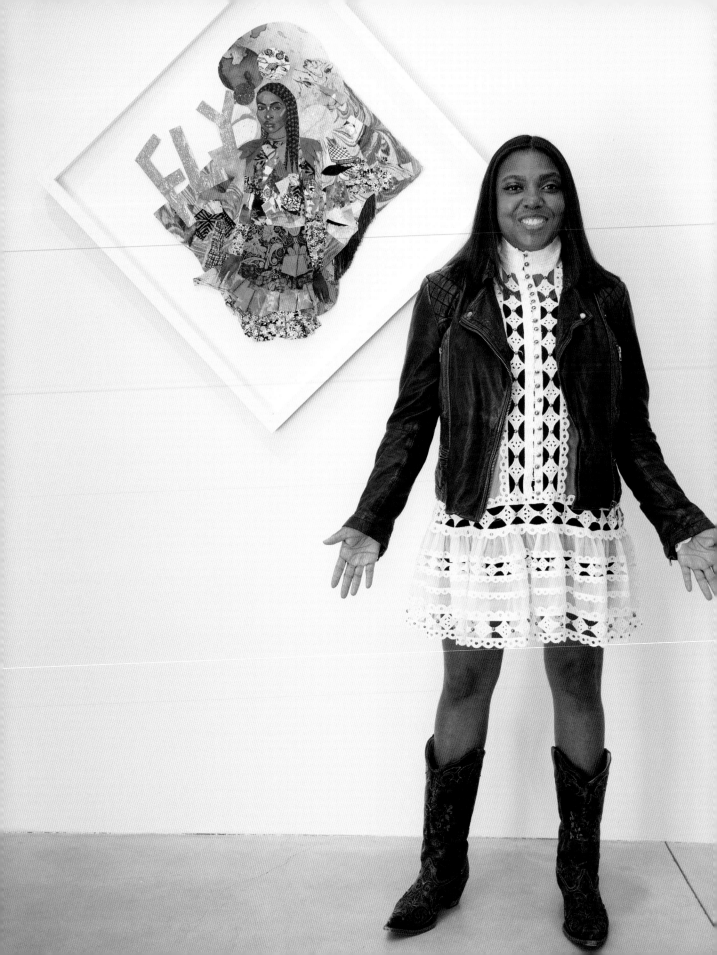

JAMEA RICHMOND-EDWARDS

Contemporary Artist

Jamea Richmond-Edwards is a Detroit native and DC-based artist who creates scintillating mixed-media collages with young, hyper-stylish Black girls front and center. In Richmond-Edwards's multidimensional collages, her Black female subjects are savvy arbiters of taste and culture who don't follow trends. They create their own fashionable world, since the fashion community has historically excluded us. Richmond-Edwards shares parts of her life on the canvas, from her Detroit fashion roots to her organic love of hip-hop style, to being a proud HBCU graduate. The Howard University MFA alumna is a fly girl, making art about fly girls, for fly girls.

When did you know that you finally made it?

I felt like I made it when I had the opportunity to be an illustrator for the *Jackson Free Press* in Jackson, Mississippi, while attending Jackson State University. It was the first time I knew that something I created would reach a large audience.

What is the best piece of advice that has always stuck with you?

"This too shall pass." It's something my mother first said to me when I was in labor with my first-born son. The pain was so excruciating, I felt like I couldn't get through it. I've used this mantra in the most challenging and overwhelming moments

in my life as a reminder that it's essentially going to be okay.

What kind of art world do you want to see in the future?

I want to see more horror and sci-fi movies through the Black Americana lens. I really want to know what happens when a spaceship lands in Atlanta or Harlem. Who's the Black hero that's going to save us from the aliens? I want to see more historical fiction outside of slavery. I want to see Native Americans from the Southeast tell their story. There's a very rich history that lives in the soil and earthen mounds of the Southeastern parts of the US.

◄ The stylish and expressive Jamea Richmond-Edwards stands in front of her work *Fly Girl* (2019) at the Kravets Wehby Gallery in New York City.

Who is your favorite fictional character?

Moana is my fave at the moment. She's a fearless indigenous woman who honors her heritage and family legacy. She's the first movie character I honestly connected with. Growing up, I was never interested in any of the fairy-tale princesses. They didn't look like me, and none of them embodied anything I aspired to be as a young woman.

▼ A splashy arrangement of Richmond-Edwards's materials, an exhibition card, and a catalog.

▶ Detail of *Untitled* (2019), made with ink, acrylic, spray paint, and cut paper collage on canvas.

The subjects in your collages are young Black girls, and they always wear fly braids. Who are these girls and what is your intent in their presentation?

The girls in my paintings are me. They're the women in my family. They're the young women I've taught over the past thirteen years. I've had the privilege of discovering my family's genealogy that dates back many generations, and I feel that it's imperative to contribute my family's version of American history. These paintings present women who have a deeply rich and complicated history.

Talk to me about your relationship with fashion, specifically Black style?

I'm intrigued by the fashion politics within Black Americana and how each community has their own visual language. The car industry enabled many Black Americans middle-class access, which is a major contributor to why Detroiters developed a reputation for being fashionable with expensive taste. I attended a high school in the city known as a "fashion catwalk." Our trends were informed by the latest in hip-hop and what we saw our parents wearing. That environment encouraged me to be very intentional about how I presented myself to my peers. The fashion aesthetics in my paintings are a direct reflection of my upbringing. The subjects are in a variety of scenarios, but they're usually clad in their most expensive outfit.

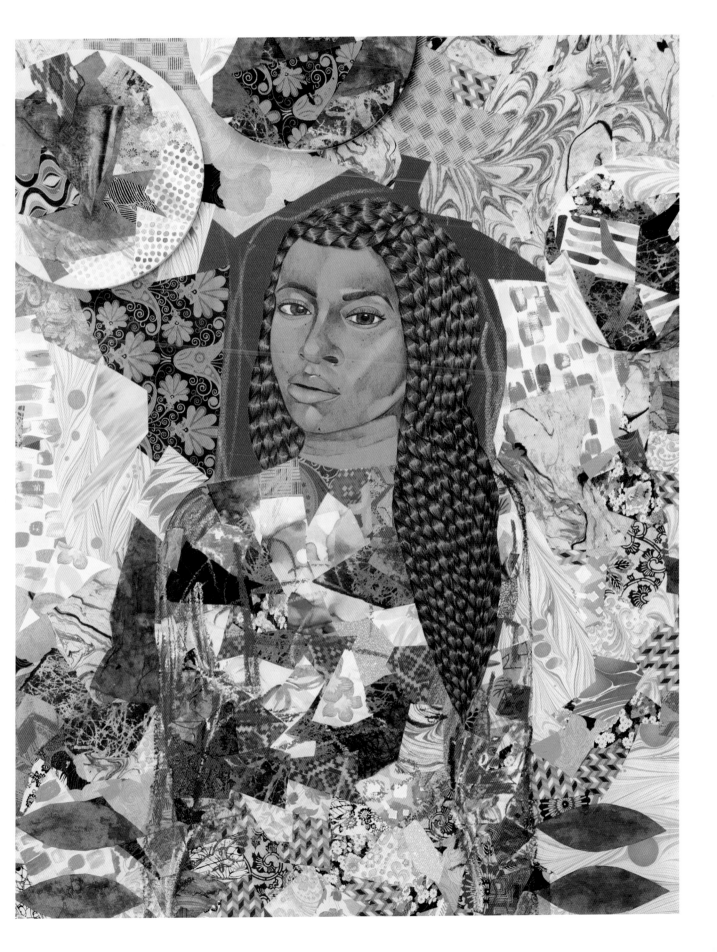

FELIPE BAEZA

Contemporary Artist

Felipe Baeza's collages and works on paper present visual conversations on queerness and Brown masculinity in the most hypnotizing ways. Born in Guanajuato, Mexico, and based between New Haven and New York, the Yale MFA alum creates mesmerizing narratives exploring otherness, queer male intimacy, and exoduses. There's both a sense of newness and antiquity present in his work—contemporary porn images are fused with Mesoamerican figures or young men are enveloped in vines, invoking mythological scenes. Baeza's art places queer sexuality, Brown representation, and the immigrant experience, in a definitive and unshakeable stance.

What is the best piece of advice that has always stuck with you?

After grad school, I was at a get-together with my peers where we all gave each other advice about the next steps in our trajectory. One mentioned, "Do not forget to enjoy this process, we get to be artists." It's easy to get lost in the superficial noise that consumes our practice. Part of finding joy in my work is to stay true to myself while taking risks.

How are you actively changing the art world?

I hope my art practice centers a different lens and story while exploring the themes in my work that are important to me, such as migration, queerness, and sexuality. I hope the objects I create offer the viewer a return to places, histories, and visions of the past that might otherwise be forgotten. I hope my work allows people to see themselves in their full humanity, not just in the present, but in a future that is free from boundaries.

Describe yourself in three words.

Work in progress.

Who is your favorite fictional character?

I've always been fascinated with shape-shifters. The power to change into anything in order to escape or adapt to a threatening situation is an extraordinary ability, and one that speaks to my lived experience as an immigrant to the USA from Mexico.

◀ Felipe Baeza in his Brooklyn home surrounded by his art, including a work in progress hanging on the wall.

What is your favorite color?

Cochineal red is a striking natural color that dates back to before the conquest of Mexico. This dark red color holds a lot of history, and I try to replicate the color in the bodies and figures in my work.

How does your work explore urgent topics like immigration, displacement, and racism in your use of allegory?

Color and allegory function as a trap in my work, pulling the viewer in and, as the work reveals itself, forcing them to engage with such topics. It's important to me to make work that is accessible, so anyone can meet me halfway. Together we can engage in a fruitful dialogue.

Queer narratives are front and center in your canvases, presented in very soul-moving ways. What are you wishing to share with the viewer?

It's important to me to affirm my own experience, as well as those that are similar to mine, in my work. When we are front and center, we are not only able to creatively reimagine our queer past, but can also develop expansive visions of our queer futures, as well as broader notions of being and belonging.

▼ Baeza's *Ahuehuete Dormido* (2016), made with ink, watercolor, charcoal, collage, cut paper, egg tempera, hand embroidery, and interference powder on paper.

▶ A detail of Baeza's *Avistamiento Fantasmagórico 1* (2018), made with ink, watercolor, collage, cut paper, and egg tempera on panel.

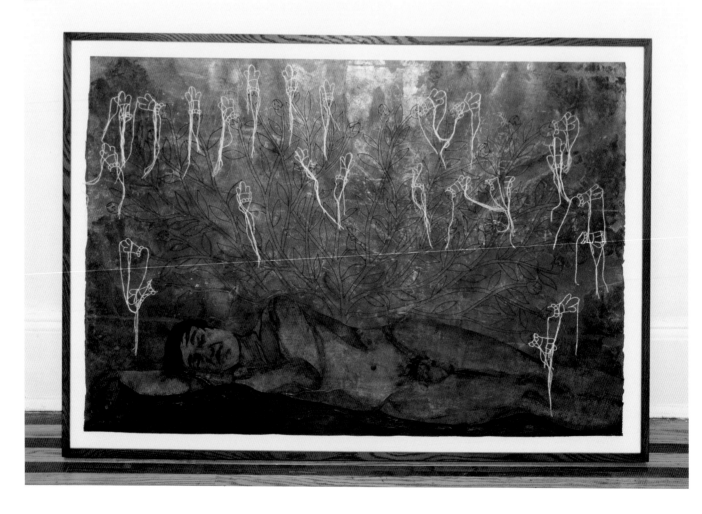

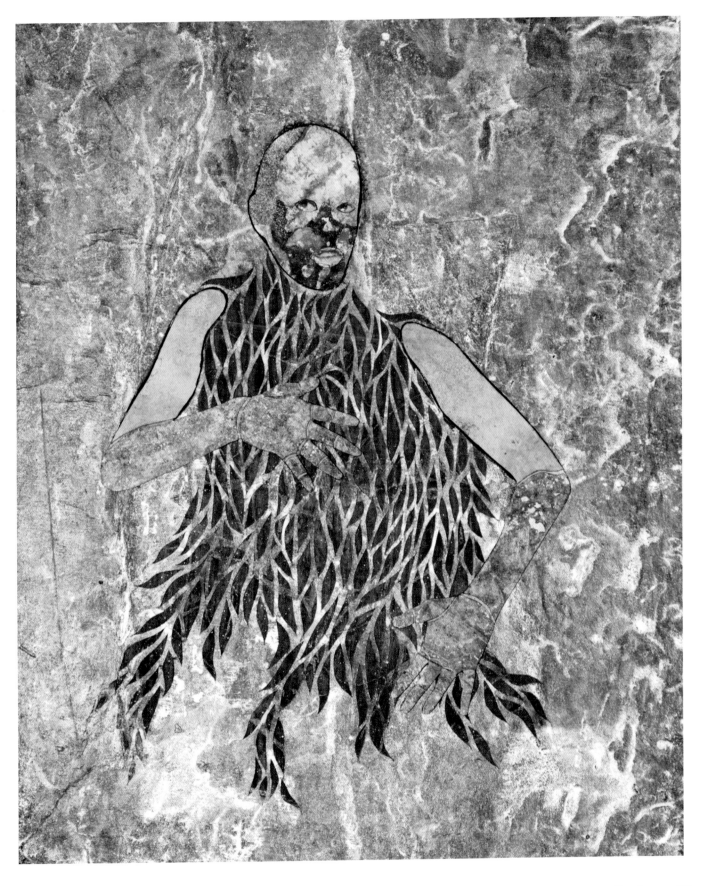

LUNA LUIS ORTIZ

Photographer, Activist & Contemporary Artist

Luna Luis Ortiz fears no limits and has made a remarkable journey into photography. A native New Yorker born to Puerto Rican parents, Ortiz has used his lens for over thirty years to capture himself, his peers, and queer youth of color. Ortiz's photographs are incredibly cinematic and glam. The queer and trans subjects of color in his images shift between sensuous, moody, flamboyant, and mysterious. His art and HIV/AIDS community activism go hand in hand. Ortiz has been integral in the New York ballroom scene for decades. As the founder of the House of Khan, a key organizer in the annual Latex Ball, a program coordinator with GMHC, and his various other mentoring commitments, Ortiz simply thrives and survives.

When did you know that you finally made it?

I started photography in 1986 at the age of fourteen. I didn't realize what I was creating was art until I met photographer Lisa Ross in 1989. Lisa Ross created a photography program at the Hetrick-Martin Institute, an agency that protects and supports LGBTQ+ youth. I took classes with her, learning how to print and develop film, and it was the best experience I've ever had. It changed my life. Lisa invited Nan Goldin to our first exhibition in 1993, and she really loved my work. Nan said my work reminded her of her own earlier work. Over time, Nan Goldin attended exhibitions I participated in and even helped me get into New York City's School of Visual Arts by writing a reference letter. The gorgeous painter George Towne

was working in admissions at the time and was impressed with Nan's letter. He asked me, "You know Nan Goldin?"

What is the best piece of advice that has always stuck with you?

My father told me in Spanish, "Photography is proof, so shoot everything." It's my motto.

Describe yourself in three words.

Authentic. Genuine. Legendary.

Your photographs of yourself and QTPOC youth are inspired by classic Hollywood studio portraiture. How did you develop this style?

I love Josef von Sternberg, he discovered Marlene Dietrich and directed several films starring her. Josef truly was a genius with

◀ Luna Luis Ortiz next to his personal library in his home in Washington Heights, New York City.

his lighting and filming techniques. After discovering him, I started to study books by photographers George Hurrell, Robert Mapplethorpe, Peter Hujar, Richard Avedon, and Helmut Newton. I love all the greats, really.

Your presence in the ballroom community for the past three decades is a very significant one. How do you use your art and activism to inspire queer and trans youth of color today?
Ballroom influenced my art and my art influenced my ballroom life. There is a ton of creativity in ballroom and I had the privilege of working with some of the best

talent in Black and Latino LGBTQ+ life. In ballroom, we learned to make something out of nothing. Being able to express that on a runway and be judged was the ultimate high. My ballroom activism is very simple. In my ballroom-walking days, the mere act of pumping the runway was activism. I helped break HIV stigma at a time it was most needed, the early nineties. Those in the community knew of my HIV status, and when I was walking my "Butch Queen Face" category, I was sending a message. It wasn't about winning the trophy, it was about people seeing me and judging *my beautiful HIV face.*

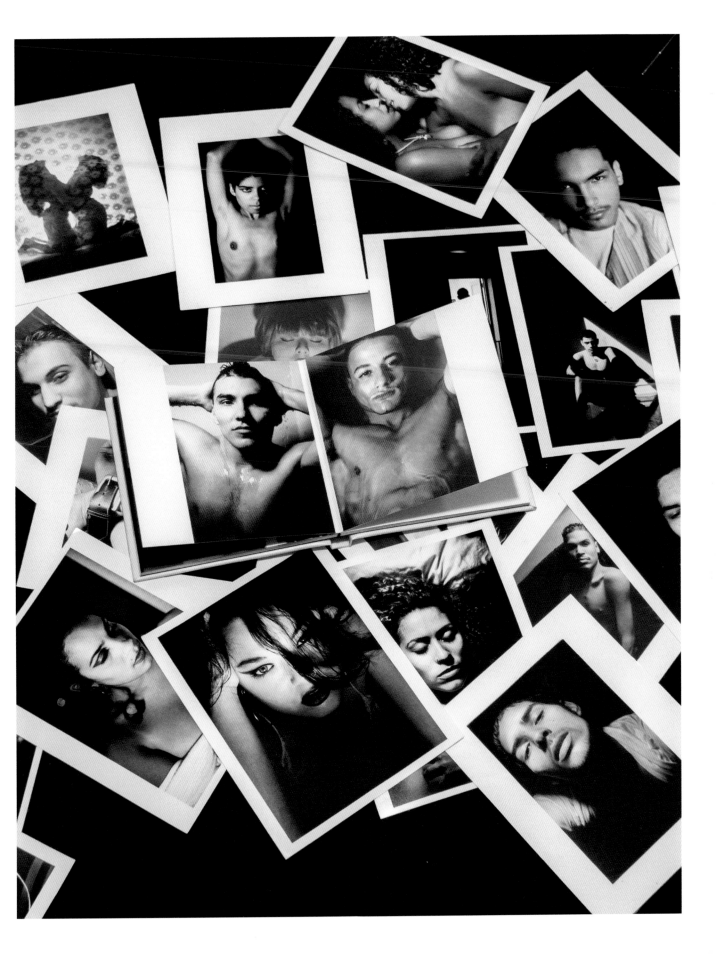

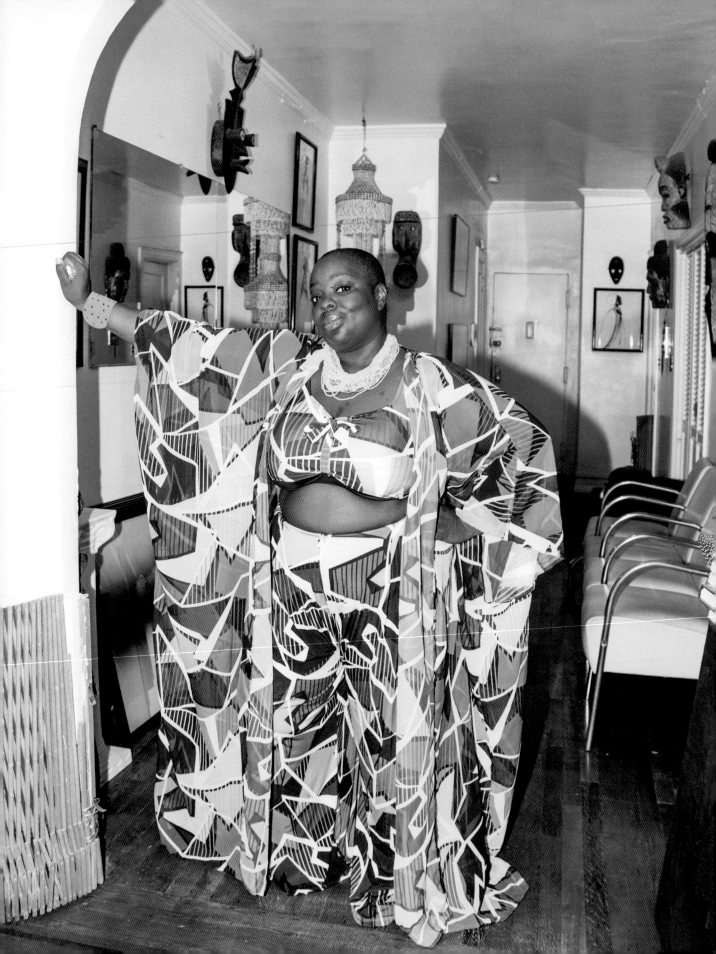

NONA FAUSTINE

Photographer & Visual Artist

New York-based photographer and visual artist Nona Faustine creates thrilling imagery of the Black female body that pierces the mind and shakes your soul. For her seminal photography series, *White Shoes*, the native Brookynite dug deep into New York's immoral history as a slave-owning city, capturing herself nude in nothing but white pumps at former slave sites in Lower Manhattan and Brooklyn. Faustine's images of her powerful body speak loudly and truthfully, and will echo long after we're gone.

When did you know that you finally made it?
Ask me that if I ever win the MacArthur Fellowship.

Describe yourself in three words.
Underdog—all my life people have under-estimated me. Sensitive—I'm deeply affected by what goes on around me; even a commercial can make me cry. Warrior—that's how my mama raised me.

When are you happiest?
I'm my happiest when I've made a success-ful image, particularly that part where a chosen image rolls off the printer and the colors are all luscious and creamy with all the fine details that you didn't see on the screen. You know that you've nailed it, and I feel accomplished.

What is your favorite color?
Red. It's the color of lifeblood, but also the symbol of anger and rage to cancel something out.

Through your self-portraiture, you showcase the glory of the Black female body. What nuances are you conveying to the viewer?
The beauty of the female body, and the incredible endurance and strength of it. We give pleasure, we carry life within us, we push that life out of us into the world. We hold great trauma, and still we function. Sometimes that trauma manifests on the body. Through time we've been handed a blueprint for survival; how to thrive, live, and succeed. When you look at us from what we have endured over the centuries, we are miracles. Each one of us.

◀ Nona Faustine in her Brooklyn home wearing a vibrant look from Rue107, with a view of her African art collection behind her.

"When you look at us from what we have endured over the centuries, we are miracles. Each one of us."

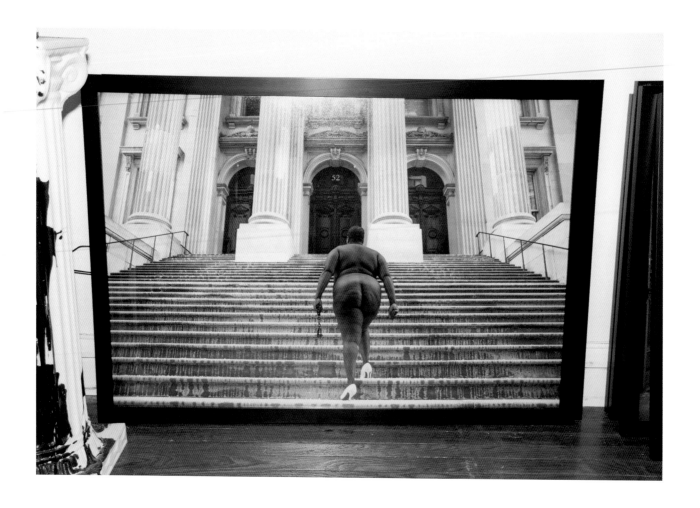

▲ Faustine's *Over My Dead Body* (2016) from her acclaimed *White Shoes* series.

▶ The main hallway in Faustine's home features *Over My Dead Body* (2016) and *Of My Body I Will Make Monuments In Your Honor* (2014) from her *White Shoes* series, as well as her African art collection.

Your series *White Shoes* unpacks New York's atrocious slave history. As a New York artist and a Black woman, can you talk about the significance of this series?
It's a love letter to Black women, New York City, and the enslaved people that built it. It's a work that remembers all those anonymous souls who survived and endured for us to be here today. It's about time travel, that all those centuries, the essence and spirit of a people is not forgotten, certainly not by me. It's to say, I was here and this is my story. New York was heavily invested in slavery. In Manhattan, you could purchase a human being on many a corner. They tried to erase us, but underneath the streets lie African souls that were worked to death. We're literally and figuratively the foundation of this city and country.

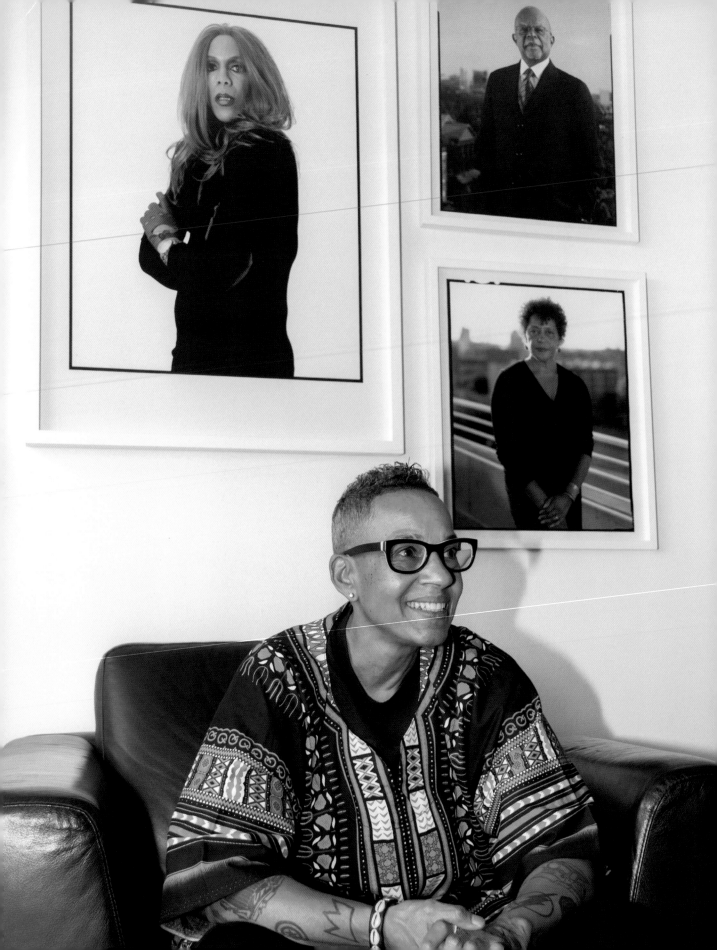

LOLA FLASH

Photographer & Activist

Lola Flash shoots the legendary, the colorful, and the underrepresented. In her three-decade career, the New York-based photographer and advocate has used her lens to document the ferocious activism of ACT UP during the HIV/AIDS crisis in the eighties and nineties, the spectrum of QTPOC, and accomplished womxn over the age of seventy. With womxn's, queer, and trans rights more urgent than ever, Flash—always a present queer voice, artist, and documentarian—reveals her power and perseverance by simply having done the work.

When did you know that you finally made it?

I don't know that I would say that I've made it. In many spaces I'm still considered an emerging artist, which does seem a bit bizarre at the age of sixty. Yet, I must admit there has been a lot of forward movement in my career. Over the past two years, I've had two major solo shows in New York and London. There are many opportunities, such as the Guggenheim Fellowship and the Whitney Biennial, that I would like to achieve. Lately, admiring fans introduce themselves, some even apologizing for being "fangirls," which is really sweet. I've been creating for so long, yet I'm not really aware of how deep, far, and wide my work has affected folks.

When are you happiest?

I'm happiest standing behind my large format camera with a warm caressing sunlight on my back. I still get nervous every time I shoot. I guess it's an anxiousness due to shooting on film, since you never really know how you've done until you pick it up from the lab.

Who is your favorite fictional character?

I have two miniatures standing in my window, Wonder Woman and Green Lantern. They both look like my parents. I decided a long time ago that if I'm a superhero, then I must come from superheroes—Wonder Woman because she is not only compassionate and caring, but will go into battle if need be, and Green Lantern because he was DC's first Black superhero (John Stewart) and he was very clever, like my dad.

What is your favorite color?

Black because Black is beautiful! Yet, even in the 21st century, we are still under attack, being senselessly murdered because of the color of our skin.

◀ Lola Flash in a bright blue dashiki in front of her portraits of Miss Kimberley, Henry Louis Gates, Jr., and Carrie Mae Weems in her live/work space in New York City.

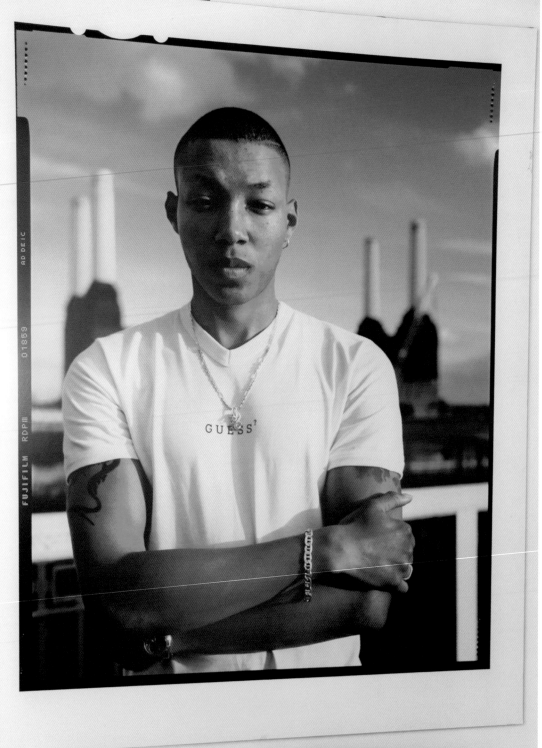

In your work, you look at cis womxn, trans womxn, and QTPOC, all over the age of fifty. Why is it important for you to focus on mature subjects?

As a photographer who revels in all of my identities—Black, queer, gender fluid, female, and now old—it's important to include everyone, you know? I have a real connection with my models. It's almost like magic, it's very hard to explain. The crux of it is that we've all experienced this idea of otherness—not dark enough, not straight enough, not young enough—and this is the narrative I want to instill.

Looking back at your thirty-year plus career, what are some risks you're glad you took with your work?

As an artist and activist who uses photography to challenge stereotypes, my work is controversial. The beauty and stance of my portraits unravel the misconceptions of our histories, and often this is not what the art world wants to embrace. My work has long been ignored, but my persistence has made it so my message can no longer be ignored. Due to more institutions including folks like me in positions of power, folks who are determined to deliver art created by "the real deal," we are finally being given a voice and a place at the table.

◀ Flash's *dean* from her *[sur]passing* series and a catalog from her three-decade career retrospective at Pen + Brush from 2018.

▼ Flash's live/work space features work from her *salt* and *Scents of Autumn* series.

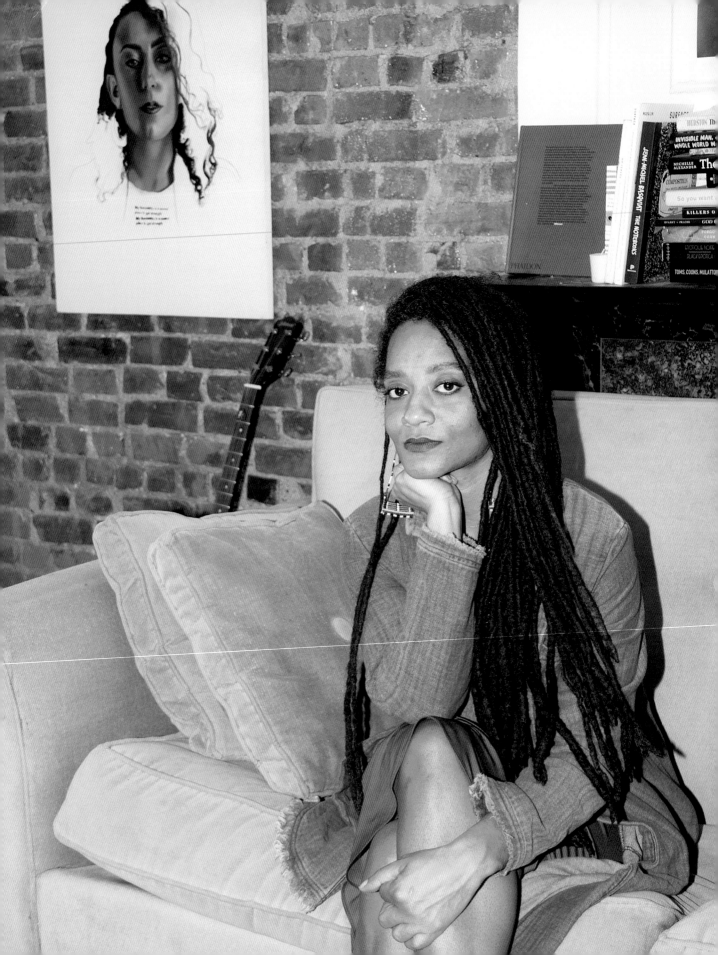

TATYANA FAZLALIZADEH

Contemporary Artist and Author

Tatyana Fazlalizadeh's art is everywhere you look and it nudges you to confront hard truths. The Brooklyn-based Black and Iranian artist and activist strongly commands QTPOC narratives in America through her artistry. Whether creating public art installations in the heart of Harlem, murals in Coney Island and Philadelphia, exhibiting in her native Oklahoma City, or having her work featured on Spike Lee's Netflix series _She's Gotta Have It_ (where she served as an art consultant), her art is palpable and potent.

Since 2012, her unapologetic, anti-street harassment project _Stop Telling Women To Smile_, a series of radical wheatpasted posters featuring a spectrum of womxn, has been plastered on the streets of Brooklyn, Mexico City, Paris, and beyond. In _STWTS_, her mostly WOC subjects speak boldly about being reduced to sexual objects. By drawing compelling black and white portraits and highlighting their fearless statements, Fazlalizadeh amplified our struggles and started a revolution in the process.

◄ Tatyana Fazlalizadeh in her Brooklyn home next to her painting *Najva*, oil on canvas (2016).

What is the best piece of advice that has always stuck with you?

My drawing teacher my first year of undergrad told me I was probably the most talented artist in the class, but since I was so quiet, my peers would easily overlook me. I was also the only Black girl in the class. She said if I spoke up, all of the other people in the class would be shook, as they should've been. I think about that often.

I interpret it as advice to be confident, bold, and loud with your talent and ability. I imagine other Black women and girls can be tempted to be quiet about who we are and how great we are, not wanting to be seen as "too much" or be too visible. But if folks are shook by your greatness, let them be. Don't shrink yourself or silence yourself for anyone. Her advice helped me to step into how great I am and to own it.

▶ Detail of Fazlalizadeh's drawings of Black womxn and girls, graphite on paper (2019), and a postcard of one of her street murals in Oklahoma City (2016).

How has the Internet and social media been pivotal to your career?

Since a lot of my work is public, it has a life within the neighborhood that it is placed. Social media allows that life to extend beyond the immediate neighborhood it is in and, inadvertently, the conversation and message also extends. A poster that I place on a wall in Brooklyn reaches an audience across the US and the world through social media. Art is no longer accessed only by going to a museum or seeing it in a book or passing it on the street. My Instagram works almost as a portfolio. When people ask to see my work, I send them there before I send them to my website.

How are you actively changing the art world?

I think my work has contributed to a shift in perspective on political and social art—particularly public art being "good" art. For a long time, I think the art world has considered art that is specifically political as generally not good art. I believe my work is an example of work that breaks that perception. I'm also a Black woman making art that represents the real faces and voices of Black women. In street art, we often see images of women painted by men, images that are very clearly created through the male gaze. I'm making work in the street that depicts real women with natural faces, paired with their own words of anger and conviction.

"Don't shrink yourself or silence yourself for anyone."

The poster in the image reads:

AMERICA IS
BLACK

IT IS NATIVE
IT WEARS A HIJAB
IT IS A SPANISH
SPEAKING TONGUE
IT IS MIGRANT
IT IS A WOMAN
IT IS HERE
HAS BEEN HERE

AND IT'S
NOT GOING
ANYWHERE

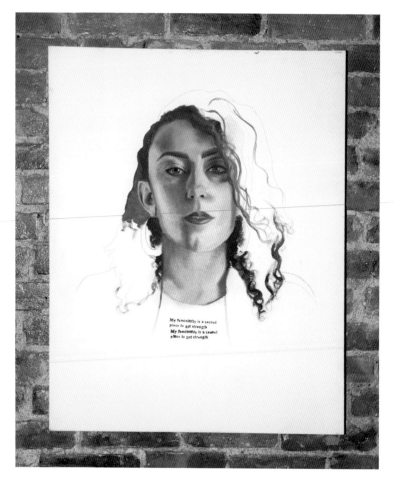

My femininity is a sacred
place to get strength
**My femininity is a sacred
place to get strength**

▲ *Najva* (2016), oil
on canvas.

▶ *RJ* (2017), oil on
canvas.

**Who is your favorite fictional
character?**

Janie Crawford from Zora Neale Hurston's
novel *Their Eyes Were Watching God*. I saw
Janie as a woman pursuing herself, eagerly,
and without apology. I like Janie and feel a
strong connection to her character.

***Stop Telling Women To Smile* resonated
globally, bringing so many womxn
together to share our experiences with
street harassment. What have been
some proud moments with the impact
STWTS created?**

I receive many notes from people describing
the way in which this project has touched
them. It's encouraging and gives me a way
to measure the cultural impact of this
work. Political and social practice art are
different from other things, I'm aiming to
create change—like policy and law. My art
is attempting to have an impact on cultural
change, to change larger societal ideas that
keep particular groups of people oppressed.
More specifically, it's trying to change how
women are treated when we walk outdoors.
I have found personal anecdotes from
people's experiences with the work to be
the most tangible form of impact.

From the perspective of looking at the
project as art, I find it most meaningful
when teachers show my work in college,
high school, and middle school classrooms.
When I see youth create their own pieces
of art inspired by this project, particularly
girls, I feel proud.

**A big part of your practice is public
art. It's brutally honest about how race,
gender, xenophobia, transphobia,
and homophobia operates in the US.
Why is public art a powerful medium
for you?**

Public art reaches people in a way that
other media cannot. When you install
public art, it immediately becomes part of
the environment—the neighborhood, the
community. It allows access to art that
doesn't involve places that can feel inacces-
sible or elitist, like a gallery or museum. But
public art is particularly powerful because
it's a confrontation. It allows me as an artist
to reach the very oppressors of a societal
issue—racism, sexism, etc.—without their
knowing or agreement. Men will walk by a
poster on the street that directly challenges
their sexist behavior and they have no
choice but to be confronted by the words,
and therefore confronted with their own
behavior.

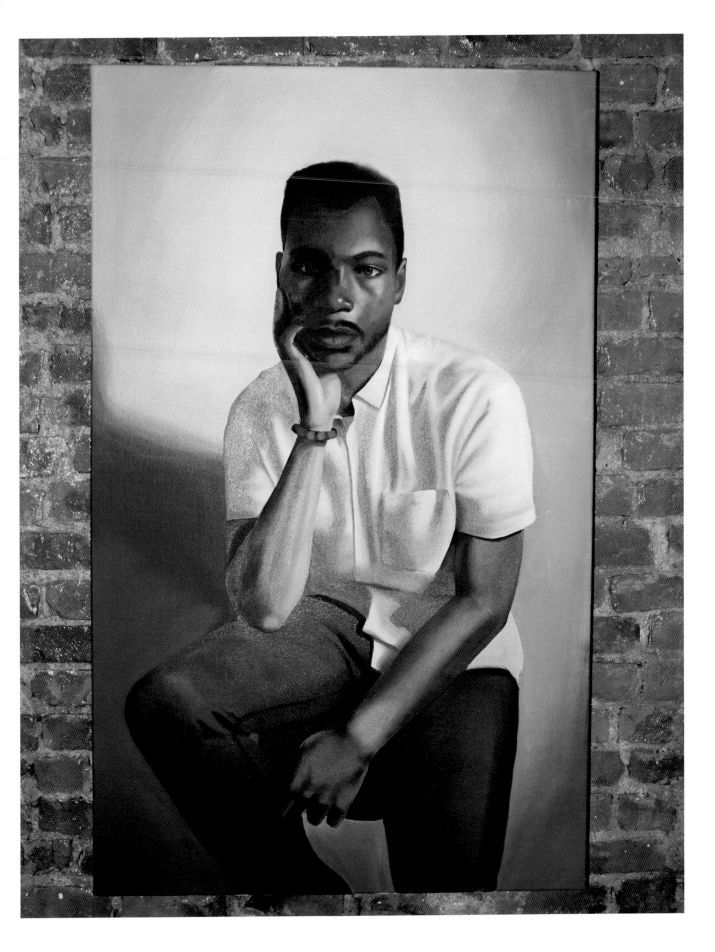

GABRIEL GARCÍA ROMÁN

Contemporary Artist & Craftsman

Gabriel García Román's highly influential *Queer Icons* series epitomizes the idea of "For Us, By Us," with a queer, Brown artist highlighting QTPOC. The acclaimed photography series features his friends, fellow artists, and activists who all collectively, strive for equality and representation of QTPOC. They are represented as venerated saints against electrifying backgrounds, exuding powerful gazes. Born in Mexico, García Román arrived in Chicago as a young child, and has now lived in Harlem for over a decade. The richness and spectrum of his life experiences and queer identity appear divinely in his work.

When did you know that you finally made it?

While I've been creating work for almost two decades, it's only been in the last five years that I've been putting my work out there. So, that moment of "I finally made it" keeps changing, and the goals get bigger. The first time I had that feeling was when the International Center of Photography approached me to purchase prints for their permanent collection. My work is now included in the historical canon of photography. My prints are collected by the same institution that owns Cindy Sherman, Weegee, and Mickalene Thomas's work. Most recently, the collaboration I did with the Leslie-Lohman Museum to bring my *Queer Icons* prints to the fiftieth anniversary

◄ Gabriel García Román sits in front of his self-portrait *I Am My Father's Son* (2016) in his live/work space in Harlem, New York City.

of Stonewall and World Pride March was a very epic event in my career.

What is the best piece of advice that has always stuck with you?

"Lean into your mistakes." When I first started creating intentionally, I found myself throwing away a piece that wasn't "perfect." I've since learned to be easy on myself and work the "error" into the piece. This has allowed my overcritical Virgo nature to move past what I once considered a "mistake."

What kind of art world do you want to see in the future?

I'd like to see a more inclusive art world. Not only more artwork created by artists of color in major arts institutions, but also

a more diverse audience in these spaces. I want to walk into an art space and feel like I'm part of something bigger, that I'm not just the exception.

When are you happiest?
I have so many small moments of happiness that it's hard to choose one. I'm happiest when I'm riding my bike downhill, feeling the wind against my face. I'm happiest when floating on my back, letting the waves push and pull me every which way. I'm happiest when I pull a print off the printing press and it came out exactly as I planned. I'm happiest when my miter cuts a perfect square. I'm happiest after a grueling yoga class.

What is your favorite color?
Chartreuse, a vibrant earth tone.

You are a queer Latinx artist who centers QTPOC as saintly icons. Can you talk about this importance?
We live in a society that is constantly silencing or erasing us from history, and I wanted to create something that celebrated our defiance and resiliency. These prints are visual affirmations so future generations can see themselves in this light. I think visual representation is so important; it gives a person a sense of belonging. Growing up I felt so isolated in my environment, I didn't grow up with role models or folks I could aspire to be. It's important to fill that void.

You were born in Zacatecas, Mexico, raised in Chicago, and have lived in Harlem for more than a decade. How have these life experiences shaped your work and identity?
I have a more worldly perspective on the human experience because of my

environments. I grew up in a very tight-knit immigrant family. We lived a very traditional life with only one language spoken at home, yet lived a very American experience outside of the home. We always had to toe the line between both worlds. I never felt like I belonged in either one. That completely changed for me when I moved to New York and experienced folks from so many cultures and perspectives. I searched for community in this big city and I found it in Harlem, where everyone greets you in the morning and looks out for you. Over a decade of living in the same home has plugged me into the neighborhood. I finally have a sense of belonging.

◀ (top) Prints from *Queer Icons* series, clockwise from left: *LOUIE, ALAN, KAY, JENNICET, BROTHER (HOOD) DANCE, JAMAL,* and *ERICKA.* (bottom) A worktable with materials including rolls of decorative paper, knives, pen, and ruler, next to a work in progress.

▲ Prints from García Román's *Defining You* series from left to right: *JANE, WILLIAM, CLAUDIA,* and *GABRIEL R.*

UZUMAKI CEPEDA

Contemporary Textile Artist

Uzumaki Cepeda is a wild card in the art world. The Afro-Dominicanx artist bypassed the more typical paths—expensive BFA and MFA degrees, artist residencies, gallery representation—and became a self-made artist through her bold hustle, smart instincts, and savvy social media presence. Cepeda's surrealist and fantasy-driven world unfolds in her faux fur installations and vibrant abstract paintings. The young artist fuses the primary colors of New York bodegas, fly acrylic nails, and the beachy colors of the Dominican Republic into her interactive installations. A Los Angeles-based artist, Cepeda crafts soft and serene safe spaces that focus on womxn, POC, and QTPOC. The native Bronxite is rewriting the rules on pursuing an artist career, and evidently her methods have been very rewarding.

What kind of art world do you want to see in the future?

I want to see an inclusive art world. I want to see less institutionalized art, if that makes sense. I want to see more from people who didn't go to school or museums. People who dedicated their entire life to art or to whatever medium. I want to see more of that. I feel like every time I'm in a space like that, those kind of elitist spaces like galleries and museums, they always fuck with, one, older people who have been doing this shit for years, or two, the very people who are a part of those institutions and show in those elite spaces. It's kind of gatekeeper-ish. I want it to be more random and accepting.

Describe yourself in three words.

I'm going to do four. I'm forgetful, I'm colorful, I'm funny, and I think I'm creative.

Who is your favorite fictional character?

I would have to say Aang from *Avatar: The Last Airbender*. I liked him a lot because he made his own way. He was a young kid with a big role to fulfill, hearing left and right what his ancestors and people who were alive thought he should do, but he always chose his own way and what he considered right.

◀ Uzumaki Cepeda surrounded by her faux fur art in her former live/work space in Downtown Los Angeles.

What is your favorite color?

I have to say, I love the rainbow. I love all colors for all different reasons. I love primary colors, primary is just *it*. I definitely like fruity colors and stuff: I love all of it, the entire spectrum. The colors represent my emotions. If I'm feeling dark, I'm going to go with some dark blues or some dark purples, but if I'm feeling happy, I'm going to pick the brightest yellow I got. I use my color palette as an emotion palette.

Your faux fur installations are safe spaces that offer both fantasy and community. What goes through your head when you are creating them?

When I'm creating them, I'm thinking of how a person is going to interact with each installation. I'm thinking, *How are they going to respond? What are they going to think?* That's what I'm thinking about, just, *What the fuck is about to happen next?*

As an Afro-Latinx female artist, what do you bring to the art world conversation?

I am creating safe spaces for women, creating safe spaces for Black and Brown people, creating safe spaces for misfits, for whatever race or religion, the people who have been exiled for whatever reason. That's the message I'm bringing. I'm bringing a whole new style, one where you can touch the art. It's something new and organic, and it's flipping the rules. You can touch everything in there. My radical side is definitely like, "Yeah I'm bringing some new shit, and people better fuck with me."

◄ Cool objects on Cepeda's shelves: her booth sign from ComplexCon (where she has been exhibiting since 2016), eclectic personal objects, and whimsical faux fur sculptures.

▲ A detail of Cepeda's *Living Room Pieces* (2018), featuring her bunny named Mochi.

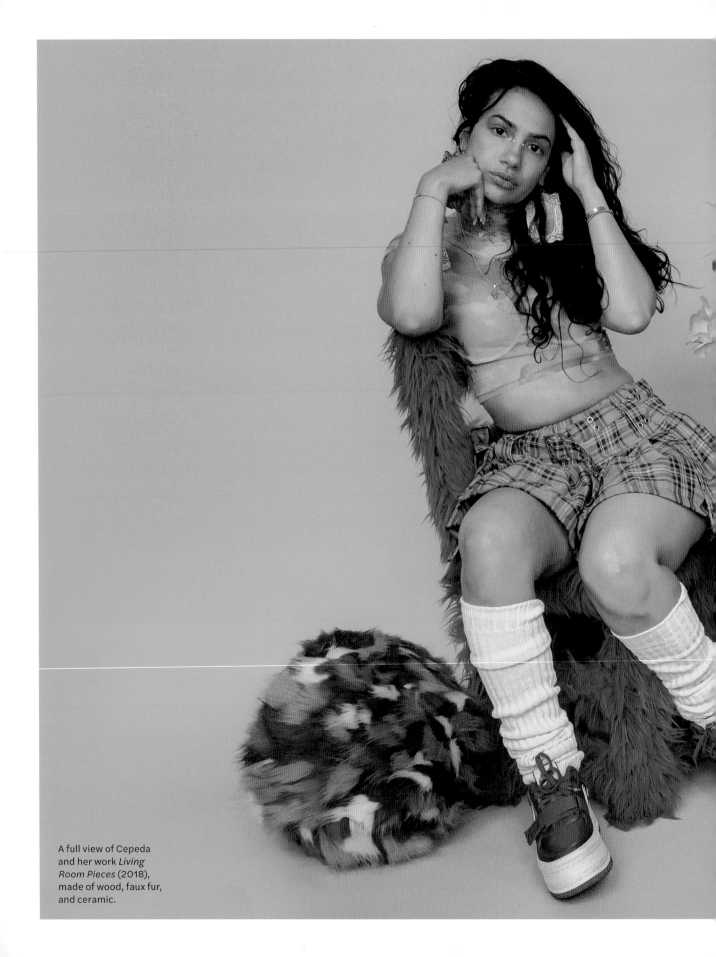

A full view of Cepeda and her work *Living Room Pieces* (2018), made of wood, faux fur, and ceramic.

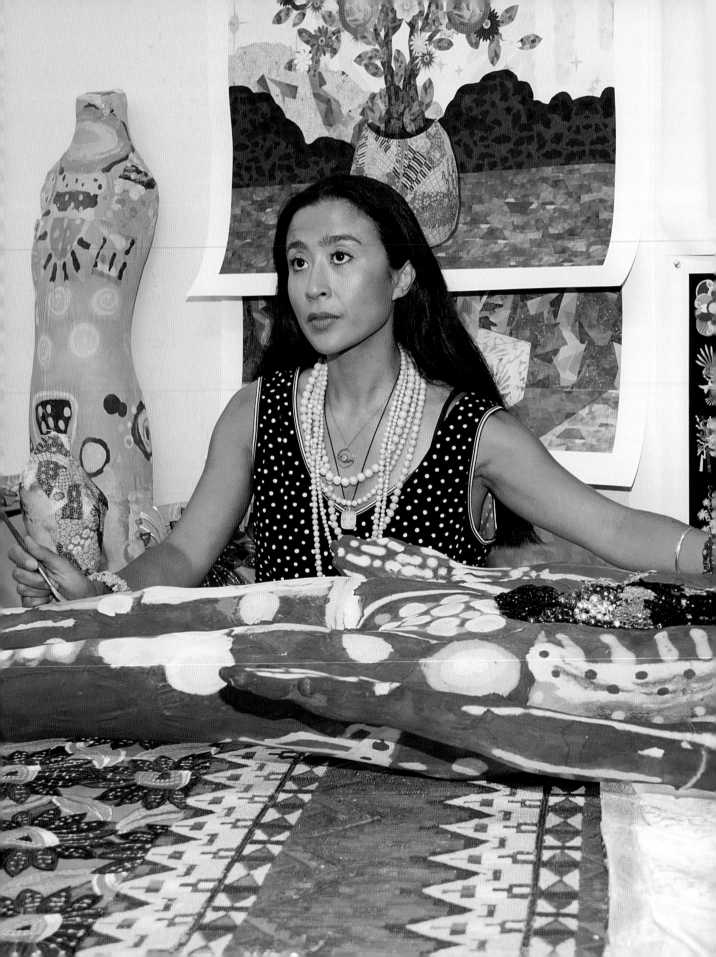

SAYA WOOLFALK

Contemporary Artist

Saya Woolfalk has long been creating a wondrous world of her own, one bursting with sci-fi elements, fashion, and feminism. The Japan-born and New York-based artist has envisioned a tech-immersed, utopian society run by the Empathics, fictional botanic female beings who can transform their DNA through nature. Combining painting, performance, textiles, video animations, sculptures, and installations, Woolfalk illuminates the universe of the Empathics and their corporate entity ChimaTEK fabulously and fiercely. Woolfalk's life-size sculptures wear bright floral prints, bold African textiles, and glittering headdresses. Being a viewer in Woolfalk's universe feels both supernatural and surreal.

What is the best piece of advice that has always stuck with you?

My mentor, painter Candida Alvarez, has always insisted that an artist follow their instincts. She taught me that an artist must cultivate these instincts over time through reading, writing, looking, wandering, wondering, and connecting with other people.

Describe yourself in three words.

Multimodal. Affect. Technologist.

When are you happiest?

I'm happiest when I collaborate with other people to bring things into the world. This extends from developing a performance project with anthropologist and dancer Aimee Meredith Cox to raising my daughter Aya with my husband Sean T. Mitchell.

Who is your favorite fictional character?

I read a lot of fiction and one of my favorite things is identifying with various characters. Depending on what I'm reading, I may find myself relating to a person who is trying to build a new civilization on Mars or a girl who has traveled alone to start a new life in a strange new country. Entering the perspective of different people through fiction is something I do every night before I go to bed.

The central themes in your work are centered on futurism, feminism, and science fiction. How do you investigate culture, gender, and intersectionality through your work?

In the tradition of the fable, my work maps the desires of people, creating narratives

◀ Saya Woolfalk at work in her studio at The Elizabeth Foundation for the Arts in New York City.

about technology, culture, gender, race, intersectionality, and the environment. From 2006-2008, I worked with anthropologist and filmmaker Rachel Lears to develop *Ethnography of No Place*, a thirty-minute video about the fictional No Place, a future constructed for the investigation of human possibilities and impossibilities. Containing configurations of biology, sociality, race, class, sexuality, and the environment, it is designed as a reflection on human life and its future. The name is derived from the English word "utopia," coined by Thomas More from the Greek "ou" (no) and "topos" (place).

With my series *The Empathics*, I shifted my focus away from the future to develop a narrative about a contemporary group in the present called the Empathics, a fictional race of humans who are able to alter their genetic makeup and fuse with plants. With each body of work, I build the narrative of these women's lives and question the utopian possibilities of hybridity.

Can you talk about using AR, VR, video projections, and digital printing to create your immersive worlds and lure in the viewer?
Technology has been a part of my work since I started making art in the late nineties. As technology changes, the kinds of technology I integrate into my work changes. I have worked with AR, video game engines, as well as projection mapping to try to immerse people in and build a believable alternative world.

▲ A detail of mannequin parts and rich, vibrant textiles.

▶ A view of Woolfalk's various works in progress, made of cotton paper, handmade linen and abaca paper, digital printed and hand painted paper and fabric, collage, silkscreen, mannequins, plastic bones, glass, plastic notions, and wood.

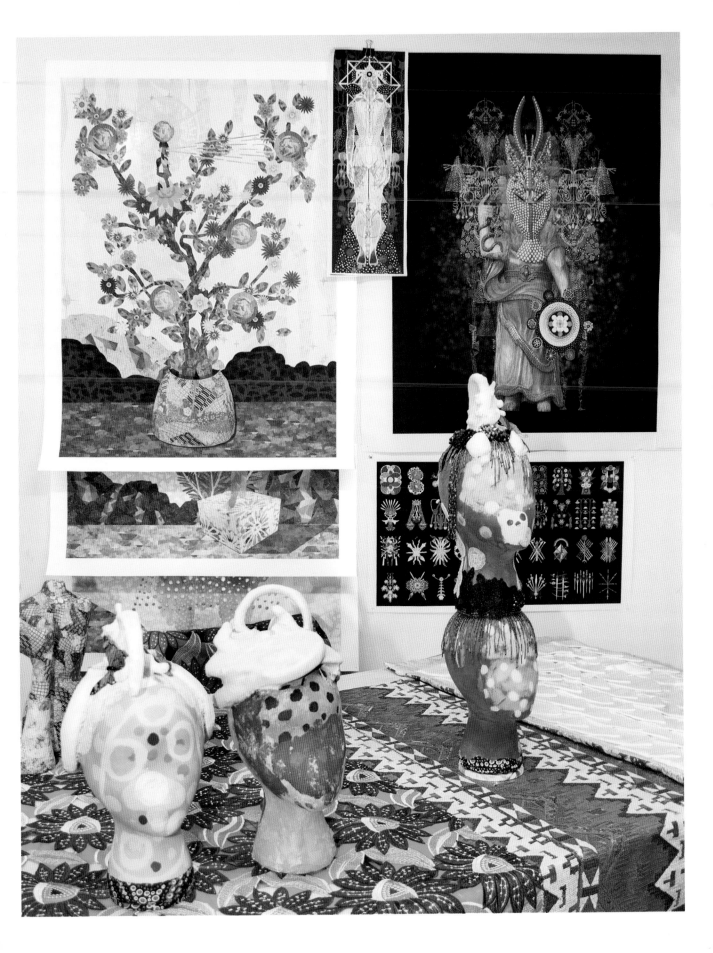

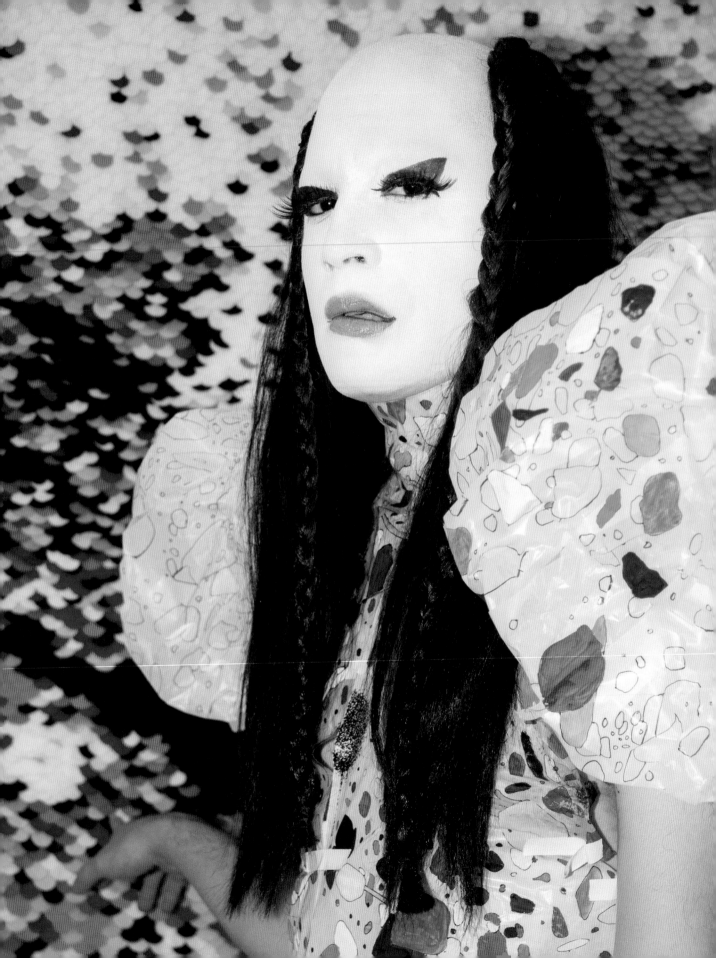

UNTITLED QUEEN

Contemporary Artist & Drag Queen

Untitled Queen is here to slay—and it's a fluid art slay. From her colorful, soul-baring drawings to her autobiographical installations, moody sculptures, and spellbinding drag performances, all of these dynamic disciplines drive her artistry. A native New Yorker born on Governors Island with a Filipinx and Puerto Rican identity, the Brooklyn-based artist unpacks post-colonial American citizenship in her work, further reflecting on the matter of having been born on an island to parents who migrated from islands. Untitled Queen is a drag superstar in the thrilling, robust Brooklyn drag scene, and a resident performer for Sasha Velour's monthly *Nightgowns* show. Aside from impacting New York City with her electrifying drag practice, Untitled Queen advocates for QTPOC causes with her annual Brooklyn Ball.

When did you know that you finally made it?

After graduate school, I had a lot of ideas of what "making it" meant; having gallery representation, residencies, reviews, a healthy studio practice, a profuse exhibiting schedule. It took some years before I started to let go of these measures of success, and a redefinition came to me most unexpectedly. It wasn't until I started doing drag in Brooklyn in 2012 that I entered a whole new creative community, one charged by the energies of queer culture that lit something inside of me, and it all began to make sense. Since incorporating drag into my art practice, I've come to see everything I do as "in process," so in a way nothing in my world feels like an endpoint. I'm just in one long flow.

What is the best piece of advice that has always stuck with you?

Don't wait. Do it. The greatest obstacle creative people face is self-doubt. It's a very clever and authoritative manifestation of fear that you are not good enough or that what you have to say is not valid. Hopefully in these moments there is a voice—a friend, a teacher, a peer, a parent, a sibling, or even yourself—that encourages you, even pushes you over the ledge to just go for it. As a tangential piece of advice, aspire to be that voice for someone else. As Maya Angelou says, "Be a rainbow in somebody else's cloud."

◀ Untitled Queen in her live/work space in Brooklyn, wearing a hand-drawn, painted, and sewn vellum dress she created during her SHIFT residency at The Elizabeth Foundation for the Arts.

2019 Brooklyn Nightlife Awards Winner
BEST VISUAL ARTIST
Untitled Queen

2015 Brooklyn Nightlife Award Winner
Drag King/Queen of the Year
Untitled Queen

▲ Awards Untitled Queen has won as a reigning queen in the Brooklyn drag scene.

▶ A full view of Untitled Queen's self-created dress in front of her work *You Don't Bring Me Flowers* (2012), made of felt, cotton, and a gold rod.

the beginning I didn't even think of as art, which was probably the thing that helped me the most. I found a form, almost like a witch's cauldron, into which I could throw everything. It took in anything I was interested in, and it was stirred not just by me, but by a whole bustling, whirling, witching crew of misfits in my nightlife community. And it was in nightlife that I found the tools to reanalyze and rewrite what art making and what success looks like.

When are you happiest?

Creating. In my kitchen/studio with the day wide open. Maybe there's rain outside and it's gray. There's less pressure when it's not sunny to accomplish things, to feel a certain way. Facing out my window covered in tree leaves and branches, I feel hidden enough with my feet perched on the gate leg of my kitchen worktable, and I can start to create my world. I feel I'm still creating even as I step into my local queer dive bar and greet my friends, fellow drag performers, the DJ, the bartender, and the babes getting a drink, joining in as one flickering blip in the electrical current.

Your art practice is a very fluid universe, you draw fantastical figures, these figures come to life when you perform, and you're wearing your actual art in your self-created costumes. Can you talk about this process?

I've come to think of my art and my life as just one big piece. From birth to now, onward to my death and beyond. I don't see my work as discrete objects or experiences. I think of it rather like a running stream you might find at the edge of a moor, with lots of bobbing twigs, bits of trash, bubblegum wrappers, old quarters, and a little fish swishing through it all. I see myself as that fish and

How are you actively changing the art world?

By actively not thinking of the art world as the art world, I challenge preconceived ideas about success, engagement, self-validation, and agency. I find American art education often teaches you to pursue and even enjoy art as a more solo endeavor, bent on refining your individual cultural context, your elevator pitch, your piece of the pie. Barry Rosenberg, a professor I had for art history, once said, "Art school will teach you how to make art, but not who to make it with." This always stuck with me in that art wasn't being expressed as something that had anything to do with communal creativity. It wasn't an intersectional thing. Drag was something I stumbled into and in

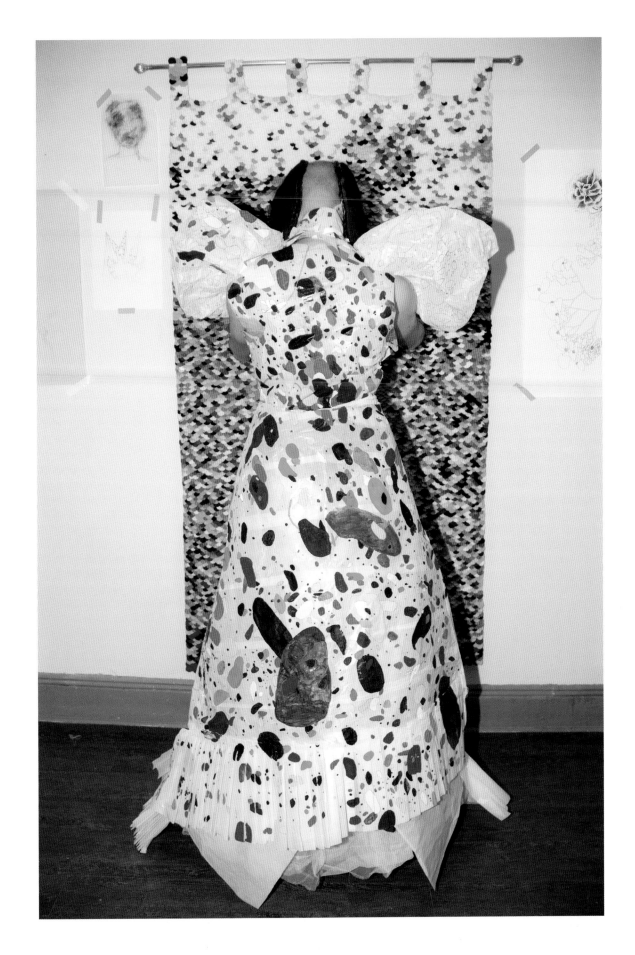

▶ Untitled Queen wears a hand-drawn, painted, and sewn vellum dress of her own design.

my practice as this body of floating objects that I can grab, rearrange, let go, combine, or destroy. When I realized drag was another medium that allowed me to cross all these divides, it opened my mind to so many possibilities of how everything could inform each other. My drawings did not have to only be two-dimensional works on walls, and performance was not limited to a stage.

Your art goes beyond performance, it's also tied to community activism, for QTPOC. Can you talk about your art and advocacy coming together?
When I started doing drag, I was thrust into a tight-knit queer community, and I began to see drag as a political act. The form allowed you to create your own narratives, your own identity, and perform your ideas. This opened a world of radical possibilities, and my voice was amplified through such high visibility. With this new found influence, I began to ask myself, *In such a dark world of cruelty, colonization, systemic oppression, and inequity, if you aren't advocating or creating a platform for the disenfranchised, what are you doing?* Drag is the medium that introduced me to communal creation, an invigoration and conversation about queer life. In many cases, queer folx are not getting support from the government or their given family. So now a big part of my work is producing events and selling artwork to contribute to and raise awareness of various charities dealing with queer health, immigration, and homelessness.

"I've come to think of my art and my life as just one big piece."

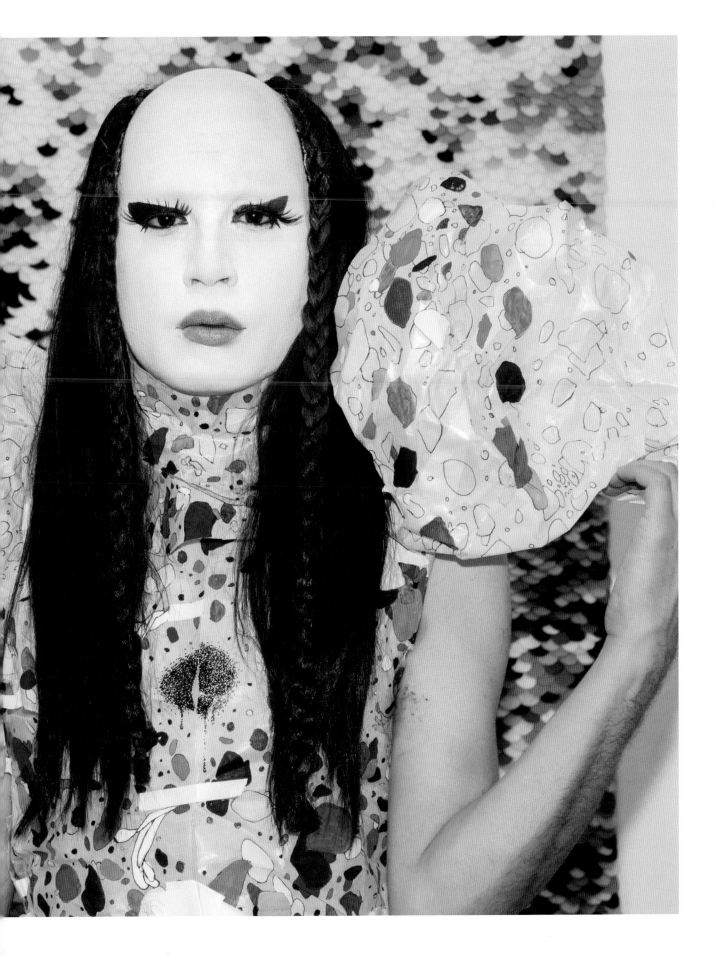

ACKNOWLEDGMENTS

With my deepest, heartfelt gratitude, I want to thank the fifty individuals who participated in this book. I'm so humbled and grateful for your labor and your time. Things are evolving out in the world because of every single one of you.

I also want to thank the gallerists, gallery assistants, studio managers, and various art workers who facilitated the artists' involvement. Thank you for your support and the ease you brought to this book.

I want to offer monumental gratitude to Swizz Beatz. You are a true ambassador of the culture and advocate for POC artists and creatives through your dedicated philanthropy with The Dean Collection and beyond. The cultural work you and Alicia Keys execute is immeasurable and world-moving. Thank you Monique Blake for your efficiency and work. And very special thanks to April Hunt for your ideas and vision.

Sunny, you brought this book to life. I will always cherish the conversations we had during photoshoots about life, art, and social justice. You've taken some unforgettable images that will stand the test of time. Jasmine, I'm so freaking glad Instagram connected us! Your eye is gorgeous, you really found a way to tap into the joy and genius of these LA artists and art influencers.

This book would not be possible without my literary ride or die, my HBIC agent JL Stermer. Our working relationship is one of the best I've ever had. We are both smart and driven; we make shit happen and we keep shit moving. I cherish it so much.

Hayley, you are a genius editor. Truly. Everything with us is so easy. That's our

Taurus energy! You fully understood it was paramount to communicate the nuance of this community and to honor POC and QTPOC voices first and foremost, and it showed in your editing. And to the entire Abrams team who helped put *We Are Here* together, your work is valued greatly.

We Are Here exists because of my art baby, Gallery Gurls. I want to thank the Gallery Gurls community, readers, followers, and all my homies in the art world. Special thanks to the contributors for pushing Gallery Gurls further out into the world and to Ann Samuels, who started this journey with me.

To fab ladies Marquita Harris, Maria Liebana, Priscilla Torres, Kamiesha Garbadawala, and Natasha Roberts, y'all are so fucking dope and I'm so lucky to have you as friends.

To my mother Luz, thank you for giving me your strength, independence, and vision to do anything without asking permission. To my brother David, my family; aunts, uncles, cousins, and my abuela Ofelia Velasquez, aka Doña Niña, thank you for all the love and letting me be me.

To my life partner Iñaki, thank you for being the most special thing in my life. There are many things that wouldn't be possible if it weren't for your love and support.

To all the Black and Brown writers, bloggers, vloggers, photographers, art babies, fashion freaks, club kids, please never fucking stop pushing the culture onward.

Finally, I'm going to pull a Snoop Dogg and thank myself for never giving up, not following the rules, never taking no for an answer, pushing through the hardest and brokest of days, and always putting in the work.

◀ Genevieve Gaignard's treasure trove of amazing reference material includes a vintage copy of *Ebony* magazine with the late, great Diahann Carroll on the cover.

Page 2-3: A collection of personal objects and sculptures not intended for sale by Uzumaki Cepeda, pictured in her former DTLA live/work space. These pieces include a pair of Cepeda's kicks transformed into a vase (2017) by the artist.

Page 4: In living color. Color palettes from various paints and oil pastels used for reference in Gabriella Sanchez's Los Angeles studio.

Editor: Hayley Salmon
Designer: Danielle Youngsmith
Production Manager: Larry Pekarek

Library of Congress Control Number: 2020931047

ISBN: 978-1-4197-4759-5
eISBN: 978-1-64700-168-1

Printed and bound in China
10 9 8 7 6 5 4 3 2 1

Abrams books are available at special discounts when purchased in quantity for premiums and promotions as well as fundraising or educational use. Special editions can also be created to specification. For details, contact specialsales@abramsbooks.com or the address below.

Abrams® is a registered trademark of Harry N. Abrams, Inc.

ABRAMS The Art of Books
195 Broadway, New York, NY 10007
abramsbooks.com